The Inspired Home

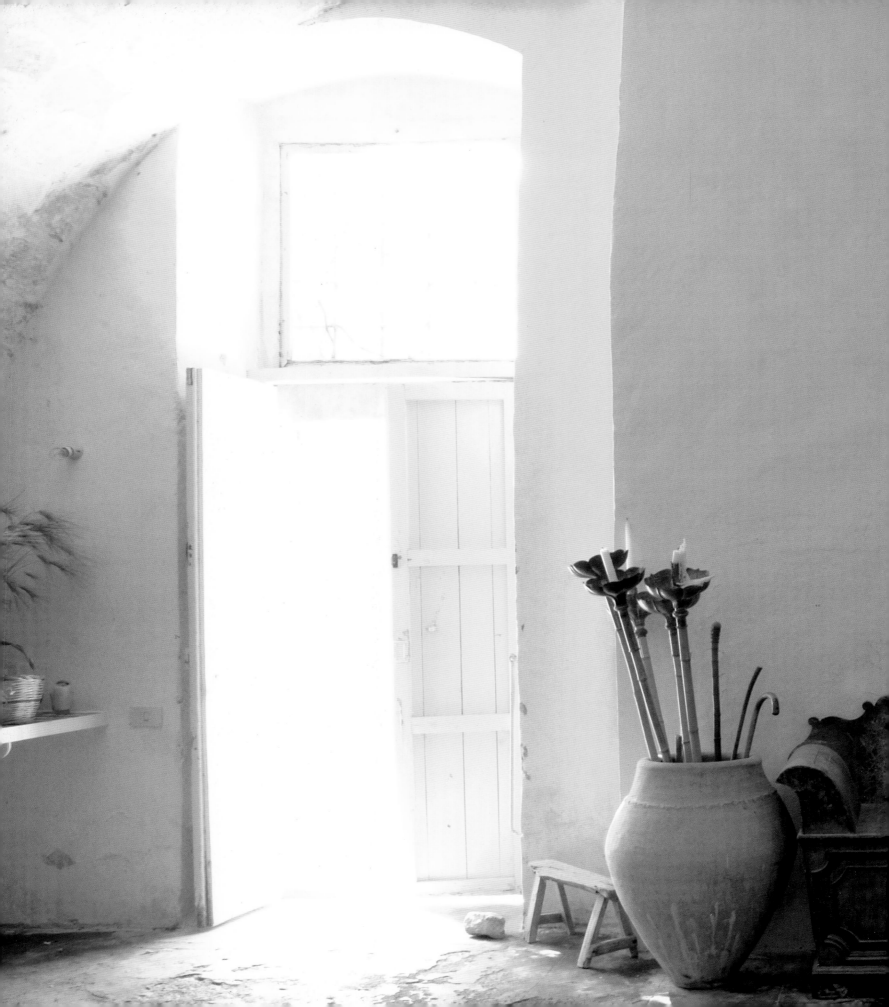

The Inspired Home

INTERIORS OF DEEP BEAUTY

KAREN LEHRMAN BLOCH

Foreword by Donna Karan

HARPER DESIGN
An Imprint of HarperCollins Publishers

PAGE I Donna Karan's dining room.

PAGES II–III The entrance to Luisa Beccaria's "flowers room," where her family makes vases, with an old painted bench.

RIGHT Luisa Beccaria designed the furniture in this tone-on-tone bathroom.

HarperCollins books may be purchased for educational, business, or sales promotional use. For information please e-mail the Special Markets Department at SPsales@harpercollins.com.

Published in 2013 by:
Harper Design
An Imprint of HarperCollins*Publishers*
195 Broadway,
New York, NY 10007
Tel (212) 207-7000
harperdesign@harpercollins.com
www.harpercollins.com

Distributed throughout the world by:
HarperCollins*Publishers*
195 Broadway,
New York, NY 10007

Library of Congress Control Number: 2012951241

ISBN: 978-0-06-212685-6

Book design by Suet Yee Chong

Manufactured in China, 2019

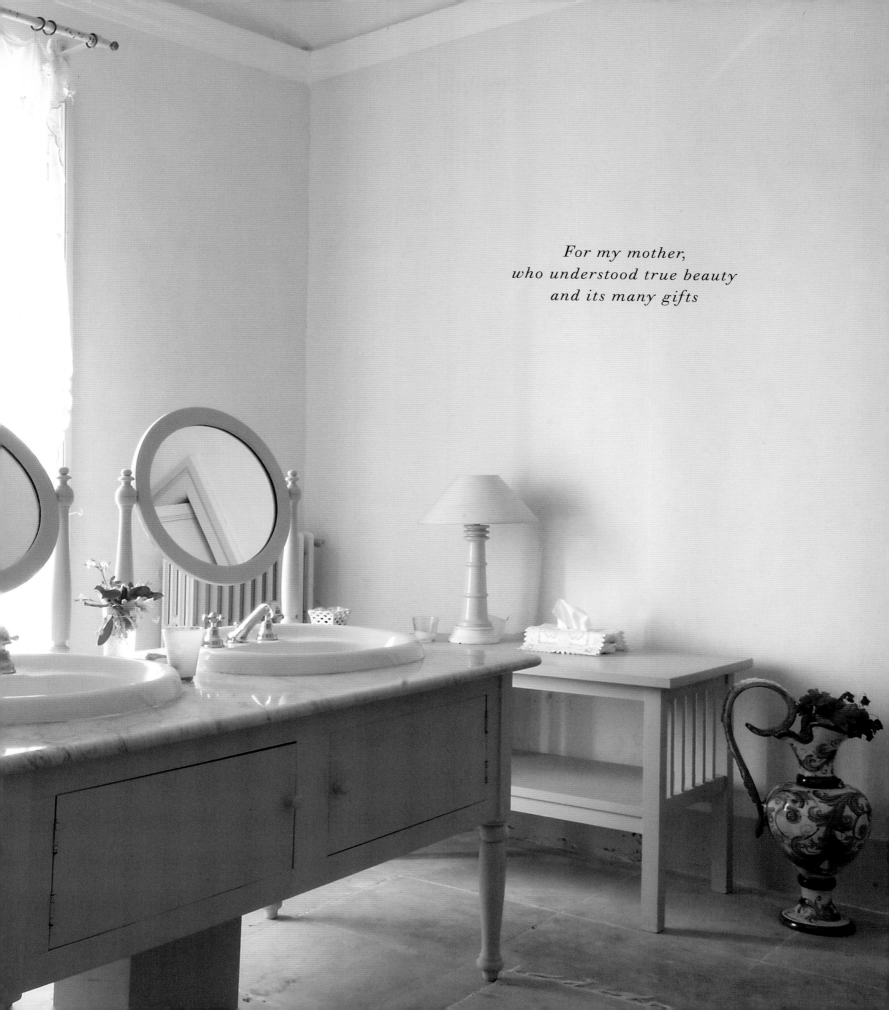

For my mother,
who understood true beauty
and its many gifts

CONTENTS

FOREWORD

What is a soulful interior? How do you create a home that feels like a retreat, a sanctuary, every time you enter? How do you find the calm within the chaos?

For me, a soulful interior is one in which I am completely relaxed, completely myself—where my mind, body, and spirit connect. A space and a place that feels open, that allows you to breathe and welcomes the light. A space that is infused with sensuality—natural woods, stone, textures—and filled with beautiful artifacts and artisan wares that tell the rich story of diverse cultures and people.

For me, a soulful interior is an extension of the self, an expression of creativity, a true invitation to experience the integration of the mind, body, and—yes—soul.

I think we are much more aware today of how our homes and offices can help us to feel centered, energized, creative: places to pause from the never-ending movement of life so that we may become grounded and focused once again. I think we also understand that each and every one of us can—actually, must—create this for ourselves; no one can really do it for us.

In fashion we have learned to mix uptown with downtown, sleek and textured—to create a personal style of individual pieces. Similarly, in our homes we have begun to hand-select, to curate individual pieces to create an interior that speaks to us on many levels.

Through the process we discover who we are—and perhaps more important, who we are becoming. Creating a home is a journey filled with pleasure.

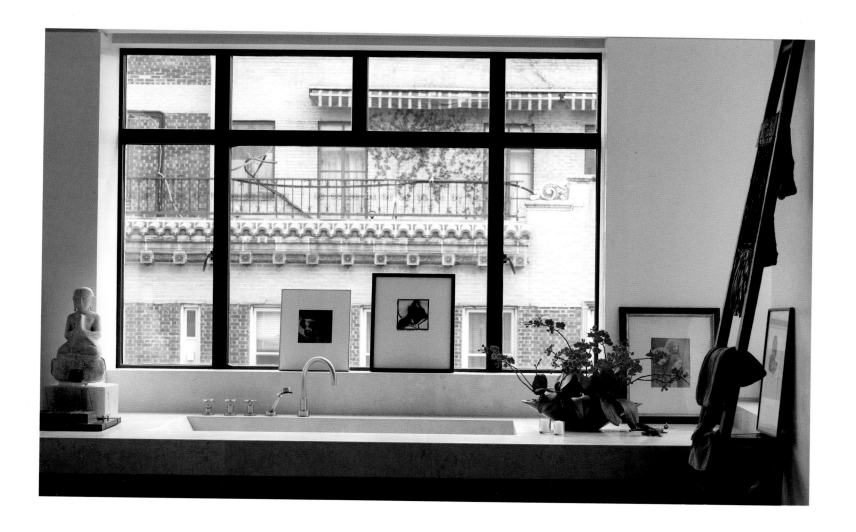

I believe in integration, in connecting the dots. Elegance and authenticity are not mutually exclusive; you do not need to give up beauty to be soulful. In fact, quite the contrary. I believe that we can create incredible change—in ourselves, in the world—through beauty.

Today we can create interiors with soul filled with the beauty of every culture, empowering both the artisans of those cultures and ourselves in the process.

—DONNA KARAN

ABOVE The open-plan bath and dressing room in Donna Karan's home is rich with sensory experience.

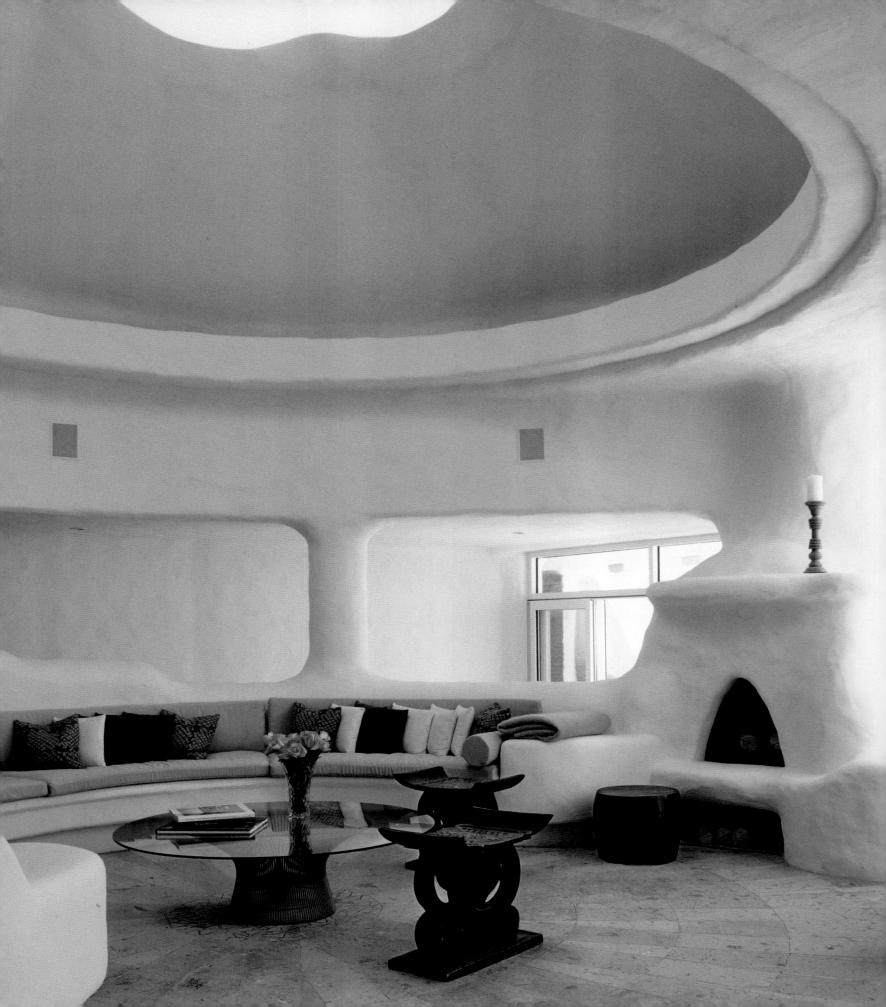

INTRODUCTION

Most of us can spend entire days going in and out of rooms that have zero effect on us. We may notice a painting here, a sofa there; we may even make a mental note of a particular floral arrangement or wall color. But the interior as a whole is instantly forgotten.

Sometimes, though, we enter a building—perhaps a museum, a house of worship, or even a grand hotel—and the effect is immediate and profound. The stresses of the day seep quickly from our consciousness. Our shoulders relax; they may even straighten a bit. We don't just feel good; we feel inspired. We don't just want to stay; we want to move in.

The idea that our surroundings can have a profound effect on our minds, bodies, and spirits is nothing new. Throughout history, buildings—especially those with a civic or religious aim—have been created with the idea that design has the capacity to touch us deeply, to elevate us both emotionally and spiritually.

It has not typically been a concept, however, that has been tied to our homes. Our interiors, the thinking has been, need to be "decorated," most often by a specific recipe—Modern or traditional; English or French; sleek or bohemian. Choose your décor, and a formulaic response is produced. You should be happy with your home, yes, but happy that you are able to achieve a particular "look," secure in the knowledge that you are beyond reproach in the decorating department.

Unfortunately, the decorated home doesn't always feel particularly good to live in. In fact, pristine period rooms, Botoxed Modernist boxes, or high-glam "designer" confabs can actually

make us feel *bad*. When life throws us that inevitable curveball, living in these environments can make us even more depressed: we can't live up to their gloss, their sheen, their "perfection."

In recent years there has been a move toward the "undecorated" home—ditching the rigid thematic approach and exploring the idea of combining contemporary pieces with a variety of antiques. This has been a great first step, and it has led to the rediscovery of artisanal work and global artifacts as well as the creation of some breathtaking interiors. But because this move has not yet been fully grounded, because it hasn't been linked to the idea of emotional and spiritual uplift, the result has often been haphazard and the impact not what it could be.

Truly connecting with our homes can have an extraordinary effect on our psyches. It can calm us, strengthen us, help us put our values in order. Our homes can offer continual sustenance by making us feel a little less isolated, a little more connected to something larger than ourselves. Just as we've learned that the clothes we wear, the people we surround ourselves with, even the products we use can have a tremendous effect on our happiness, so too can the environments we live in.

A home that "works" is deeply restorative and can even embolden and inspire. It is not just a physical space to put our things or a shelter to protect us from the elements. It is a place so steeped in beauty that it has the capacity to transform us—which in turn creates a home of even deeper beauty. So how do we create this? How do we design an interior with soul? As you will see from the variety of stories in this book, there is no specific formula, no rule book. In fact, the path (by definition) is going to be different for each of us. Yet there is an underlying set of principles—drawn from both nature and the philosophy of aesthetics—that can provide a useful guide, a guide so compelling it can enrich all aspects of our lives.

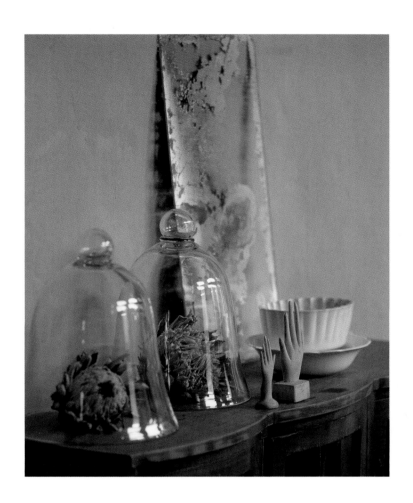

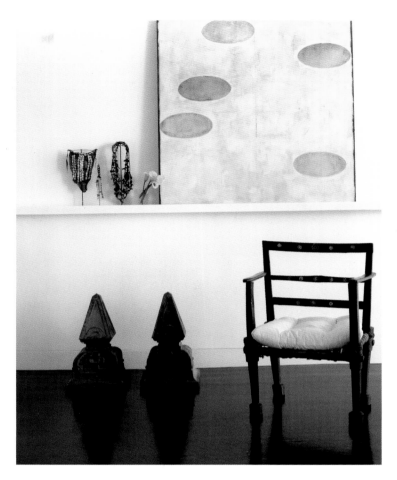

PAGE X The living room of the SPI Design home.

ABOVE, LEFT Glass bell jars and Protea flowers on a sideboard cabinet in Leoni Smit's house.

ABOVE, RIGHT In this Southampton home designed by Vicente Wolf, a picture ledge supports a contemporary painting by Andrea Shapiro, balanced by an Ethiopian chair and architectural elements.

HOME AS INSPIRATION, NOT SHOWPIECE

We begin by understanding and accepting the idea of creating a home for ourselves, as part of our personal space. We have been taught to see our homes as showpieces—to think that this sofa or that painting "says" something about me. We need to be able to say, "This piece touches me, moves me, inspires me."

Decorating for display can surely provide a sense of gratification. But it's a fleeting, superficial gratification—one that needs to be continually reinforced with newer, bigger, "better" items. Seeing your home as a source of inspiration means filling it with pieces that you want to keep for a lifetime. And you don't need a grand budget to find these pieces. In fact, limited resources often inspire the most beautiful and creative interior design: every item is chosen with care and from the heart.

Removing external motivations allows us to see each piece in our home as an extension of ourselves. In the same way that we've learned not to wear head-to-toe Chanel or "outfits" that are overly matchy, we can mix individual pieces of furniture and objects in a way that represents our individuality and inherent elegance. We can play with color and texture, size and shape; we can be artists and use our homes as our canvas.

FEEL VISUALLY

To allow beauty into our homes we need to learn to feel visually. We experience the world through our senses. Painters and sculptors learn to emote visually; musicians and dancers learn to feel music with every cell of their bodies.

Unfortunately, our visceral aesthetic reactions are often short-circuited by distractions—whether a given sofa or painting is appropriate, tasteful, or "correct." But at the end of the day it's our visceral aesthetic reactions that will lead us to choose pieces for our homes that will make them eternally uplifting, enduring mental and physical supports. The question we need to keep asking ourselves is: How does this piece make me feel?

In recent years, we've been taught that texture—sensory experience—doesn't matter. We've thrown out our books, digitalized our music, even scanned our photos—all so we can live paperless, ultraslick existences.

But of course texture does matter. Babies starve emotionally from a lack of human touch, and as adults we starve on various levels from living in overly sleek environments: our minds and bodies are wired to require sensory experience. Moreover, the intimate relationships we build with the art and design in our lives—including books and music—is almost as important as the intimate relationships we build with the people in our lives. Technology can offer us many things, and we should take full advantage of its efficiencies and effectiveness. But it can never offer us sensuality, intimacy, humanity.

NATURE AS GUIDE

Fortunately, our primary aesthetic experience—nature—can offer a great deal of help in reconnecting our homes with our senses. A day spent in the mountains can clear our heads, restore order to our psyches. A night under the stars can pull us out of our own internal dramas and reconnect us with something much larger than ourselves. Moods can change on a dime when the sun comes out.

Nature affects us acutely because we evolved to depend on healthy, vibrant environments. But many of us spend our days far from anything resembling a beach or a mountain. How, then, do we bring the serenity experienced through nature into our homes? Natural light and greenery create a great foundation, and candles or a fireplace can emit another layer of warmth and intimacy. But the challenge is to go beyond the basics—to not just mimic nature but to incorporate its essential elements into our homes.

What are the essential elements of nature? Authenticity—every aspect of nature is unique and genuine. Sensuality—nature is composed of a multitude of textures and complex colors. Simplicity—nature is well edited; it gives your mind a chance to breathe, to regroup. Balance—nature is well ordered, unified. Surprise—nature's forms continually evolve and rejuvenate. Grandeur—the proportions and mystery of nature inspire.

DEEP BEAUTY

Throughout the centuries, artists and designers have used these elements—consciously or not—as guideposts in creating the most spectacular, timeless, and universally appreciated works.

In a sense, artists and designers are nature's emissaries: they can abstract its essential principles and create work that can touch us just as deeply—sometimes even more so—than nature itself. They have the potential to create what can be called deep beauty—art and design that resonates not just emotionally but spiritually. Many of us are familiar with this experience from listening to a piece of music. You become slowly entranced by the melody and harmony. You begin to feel transported to a different space. The piece finishes and you feel somewhat restored; you can start again—stronger, wiser, more grounded.

When people hear words like "natural" or "authentic" in the context of design, they often think, "anything goes." But if you are trying to create something meaningful, anything does not go. Nature does not feel decorated or polished, but it's not random, either. Understanding proportion and balance will give your home an inherent logic and order. Structure induces calm—our emotional airwaves were built to depend upon it.

Nature's essential elements are universal yet underlying: plenty of individuality can stem from them, as you will see from the twenty-five highly original homes in this book. The irony is that when they guide us in creating an interior with soul—one that reflects the depths of our emotions and individuality—it is likely to speak to others as well, even if it doesn't completely reflect their own aesthetic preferences. Such is the power of universal principles.

What we can't do is rely on someone else (e.g., a decorator or stylist) to tell us who we are and what we feel. The best decorators can help us interpret our personalities, translate our needs. But if you want to create an interior that truly speaks to you, you need to remain the artist of your home.

SENSE OF LIFE

With the essential elements of nature as guideposts, your palette can include a wide array of objects and furnishings—old and new, textured and smooth, handmade and mass-produced—spanning a wide range of cultures and periods. Whatever the combination, the overall effect needs to have a sense of life. Nature renews itself persistently, inexorably; our homes need to feel vibrant, vital, alive.

We have heard a lot recently about the beauty of patina—the natural sheen on furnishings that comes from age and wear. And there is indeed beauty—deep beauty, in fact—in patina, in

imperfection. Because nature is not perfect (things don't line up precisely; things are nubby, not smooth), the imperfections of an object, fabric, or person are often what make them real to our brains—genuine, not artificial.

That said, nature is not a repository of the peeling and the chipped, the fraying and the disheveled. Patina needs to be balanced with vibrancy, whether through color, texture, or innovative pieces or juxtapositions. Vibrant pieces or fabrics often emit an inherent luxury, even a touch of deeply rooted glamour. This type of luxury or glamour is not antithetical to soulfulness. Indeed, pieces with an intrinsic, sensual luxury can often enhance our own inherent sense of elegance and optimism.

TIMELESS YET FRESH

Many of us stick to prescribed decorating formulas because we want a home that's timeless. Unfortunately, when doing so we often end up with exactly the opposite. A period room—whether it's twentieth-century Modern or nineteenth-century English—is by definition dated and can thus feel stale, spiritless, and stifling.

At the other extreme, many of us are so concerned with creating a home that feels of the moment that we often fill it with pieces that are far more interested in getting attention than stirring us emotionally. These pieces may be momentarily compelling, but you will probably soon tire of them.

Truly timeless homes—like the ones in this book—will continue to look and feel as fresh and vibrant as the day they were created. Why? Because they contain pieces, both old and new, that are well grounded in nature's principles, and because the pieces have then been innovatively merged to create compositions that move the trajectory of beauty forward.

MIND, BODY, SPIRIT, STYLE

Creating a soulful, inspiring home is the harder road. It's so much easier to see a room in a magazine and just copy it. To buy a work of art or piece of furniture because a decorator says it's glamorous. To insulate ourselves from our individuality and our feelings.

But if we go down this road—if we truly connect our style with our identities and our emotions—we will continually be rewarded with a deep sense of pleasure from our surroundings. It's probably unfair to say that only the elements of nature can truly nourish the soul, but there's certainly enough evidence to suggest that these elements are the most accessible—and direct—means to that end. They can teach us how to live a more meaningful existence, one in which we no longer feel susceptible to every bump and obstacle that will inevitably come our way. They can help us achieve not a superficial happiness based on show and tell but a deep, sustained happiness rooted in our individuality.

I chose the homes in this book because they inspire me—and my hope is that they will inspire you. Of course, we each have our own space limitations, not to mention our unique tastes. But my hope is that through this book you will begin to see a connection between where you live and how you feel, and that you will begin to think about style in a more substantive way.

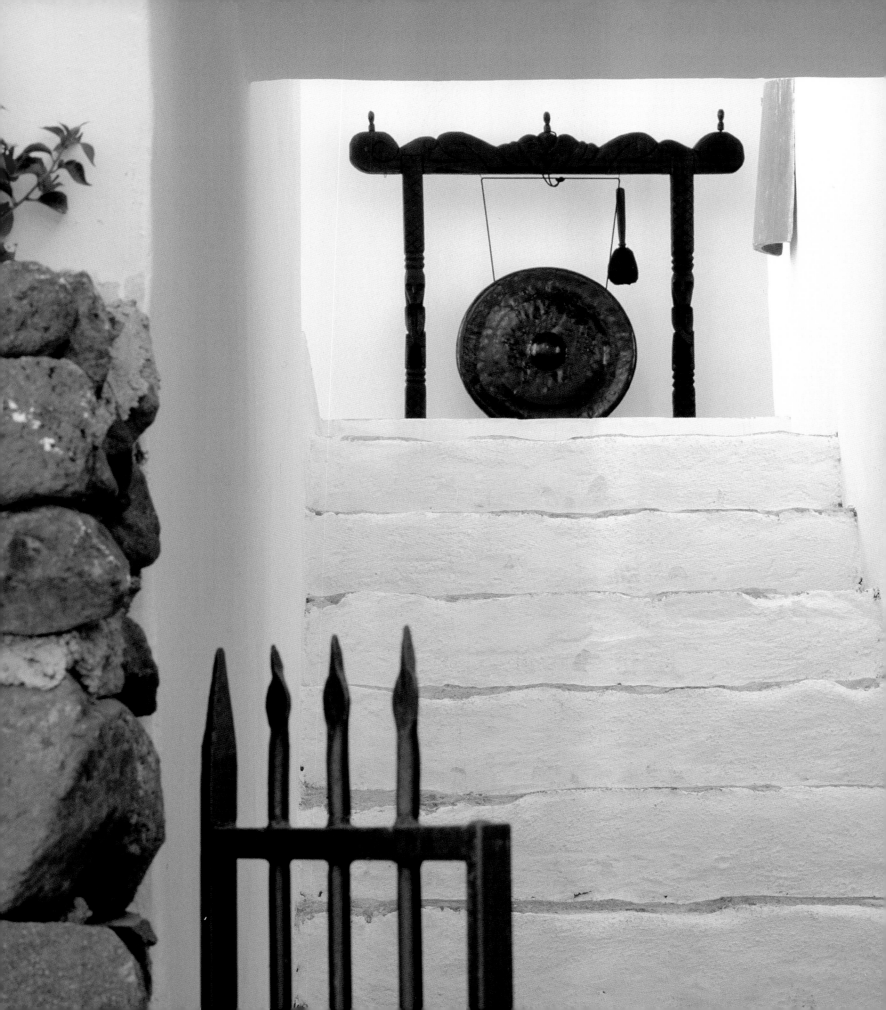

ONE

AUTHENTICITY

A bird gets up every morning and sings its song. It does not wait to hear what other birds are singing, nor does it look to see if another bird is getting more notice. It knows its song innately and sings. This is nature: knowing your own song.

—MICHELE OKA DONER

You are the artist of your home. That's it: that is at the core of creating an interior with deep beauty. You start with a thoroughly blank canvas—no preconceived ideas of what your home "should" look like—and an extraordinarily wide palette of colors, textures, periods, and cultures. And then you need to add in what is perhaps the most difficult ingredient: the confidence to create something you've never seen before.

Every facet of nature is both unique and at ease in its own skin. Every aspect of your home should feel like an extension of your personality. The days of "following"—following tradition, trends, the personal aesthetic of a decorator—are over. So is using your home to create a fantasy world or to satisfy the "expectations" of others. Any home that is "tastefully selected"—i.e., safe—is going to look and feel sanitized.

Nature's authenticity is built upon a lack of superficiality—actually, layers upon layers of subtle complexity. The colors and textures of nature reflect this complexity: they look and feel rich, deep, pure. Sensual.

Our homes do not need to be "polished to perfection." But they also don't need to be patinaed to an uncompromising imperfection—that is just as inauthentic. The goal is to be able to confidently combine the rough and the smooth, the sensual and the sleek in a way that works for you. The fact is that even with a dash of glamour in the room, the subtle imperfections of handmade work, artifacts, and antiques still implicitly convey the idea that life isn't perfect, that we aren't perfect.

Authentic homes invite you in and reveal their beauty slowly. Indeed, the first thing you feel when you enter a truly authentic space is a sense of peacefulness, tranquility. It's a subliminal, sensory reaction. The more time you spend in an authentically beautiful home, the more you discover new aspects of form, texture, and color—the more your brain is intrigued and challenged.

Optimally, you will create a home that is so fundamentally genuine that being in it is cleansing, soothing, restorative—a return to yourself.

PAGE 10 An African musical instrument in the entryway of James Cavagnari's home.

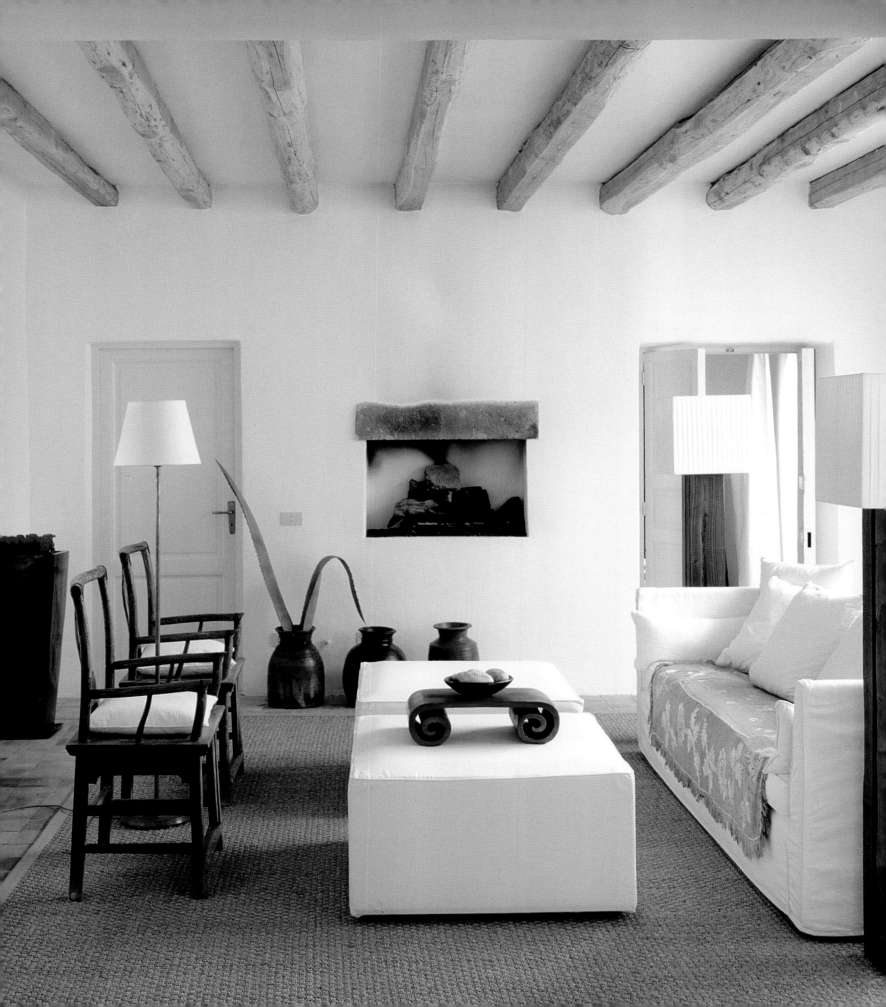

PURITY

The first step: an internal purification, a design detox—stripping your mind of any preset notions of what your home "should" look like. The next is integrating who you are with the physical realities of your home. "We must listen to the deep needs of our souls," says Italian architect James Cavagnari, "and attempt to make our environments obey those needs, instead of playing into standard clichés of 'beauty.'"

In 2005, Cavagnari and his American wife, interior designer Erin Quiros, renovated a three-hundred-year-old former farmhouse on the Aeolian island of Salina. "Our goal was to reclaim the original structure, to preserve its character and style, but to give the house a new life," says Cavagnari. Farmers had lived on the upper floor, while the ground floor was used for making Malvasia, the sweet wine for which Salina is famous.

Cavagnari kept the original cubic shapes and outdoor staircase and inserted *pergolas* (trellises) and terraces to heighten the views of what he calls "the biggest protagonist": the Tyrrhenian Sea. He retained or subtly added many facets that are characteristic of the local vernacular, including wall niches, which replaced pictures, and *bisuoli,* or built-in benches, which minimized the need for furniture. The chalky plaster is unique to the island: "The *calce*, or lime, in it absorbs light spectacularly." Handmade Sicilian terra-cotta tiles are used as flooring throughout the house, and hand-painted Sicilian tiles form the backsplash in the kitchen.

Cavagnari says the interior design had to be "simple but elegant," with a selection of pieces from other remote places in the world but "with the same laid-back feeling." Much of the furniture they designed in their Prima Design studio in Florence. While some of the pieces,

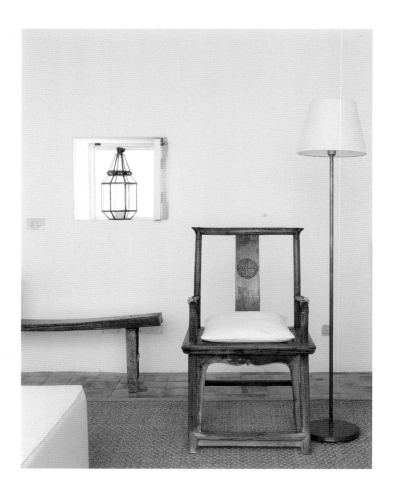

carved from solid wood, were "massive, to recall the strength of the volumes of the buildings, ornaments were reduced to a minimum, with ethnic touches in a subtle balance." Colors were also kept to a minimum, but those used are rich, deep, authentic.

"We basically created a nest—completely self-contained," says Cavagnari. "You could spend days in a row without leaving the place. . . . The first two or three days I stopped wearing my watch, and after a week I stopped wearing my shoes."

PAGE 14 In the living room, two eighteenth-century Chinese chairs face a clean-lined sofa and a pair of ottomans. A sea-grass mat lies over the terra-cotta floor.

ABOVE An eighteenth-century Chinese chair and a contemporary lamp harmonize in the living room.

RIGHT An arched window provides the backdrop for a white cotton sofa and chestnut floor lamps, all from Prima Design, in the sitting room. The brown scarf is Dries Van Noten, and the wooden tray is from Indonesia.

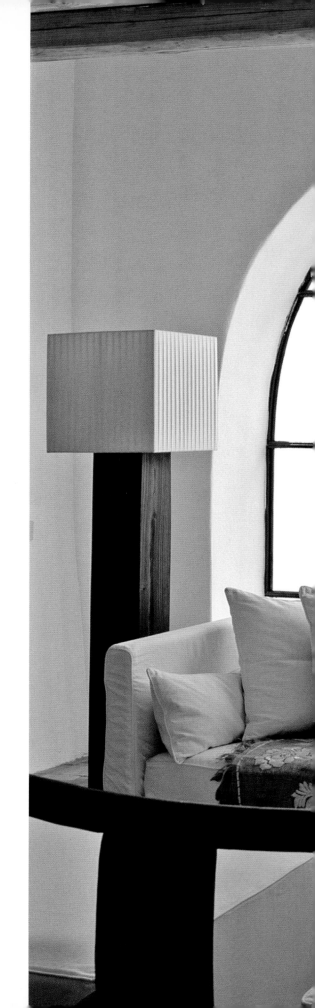

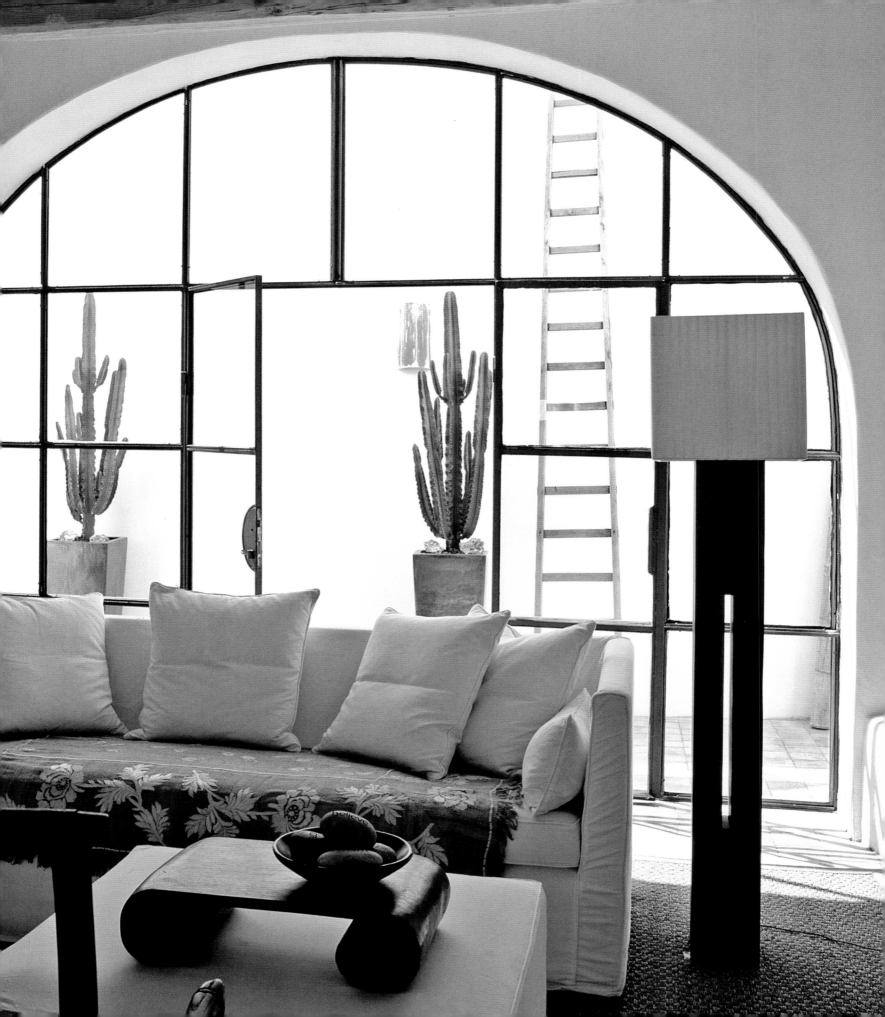

BELOW In a corner of the kitchen, a Chinese credenza from the early twentieth century and an ethnic bamboo lamp mix with musical instruments from Africa.

RIGHT Prima Design created many of the furnishings, including the chestnut table and benches in the kitchen. The same handmade Sicilian terra-cotta tiles were used throughout the house.

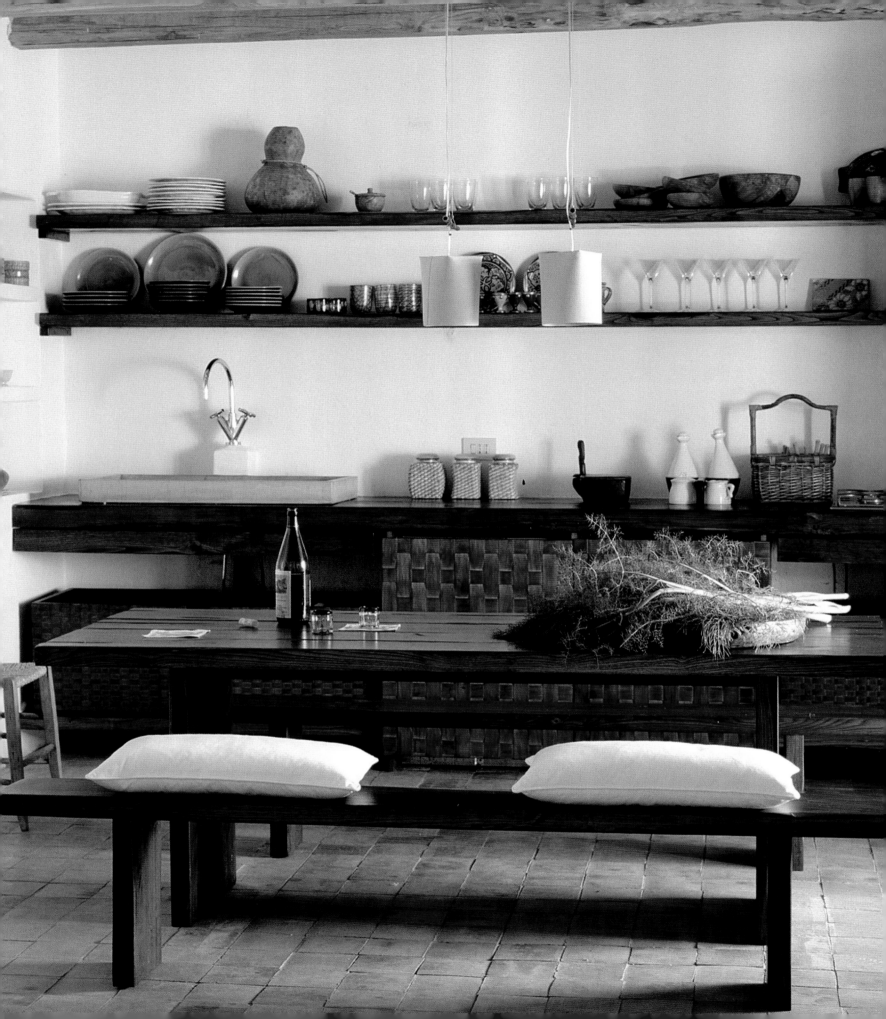

ABOVE, LEFT For the girls' room, Cavagnari designed a platform bed with a contemporary twist, and Quiros infused the space with color and pattern—a red toile fabric, a vibrant straw rug, and white lampshades trimmed in red.

ABOVE, RIGHT Cavagnari designed the four-poster bed in the "mother-in-law" suite.

RIGHT The master bedroom and bath open onto a terrace, as does each room in the house.

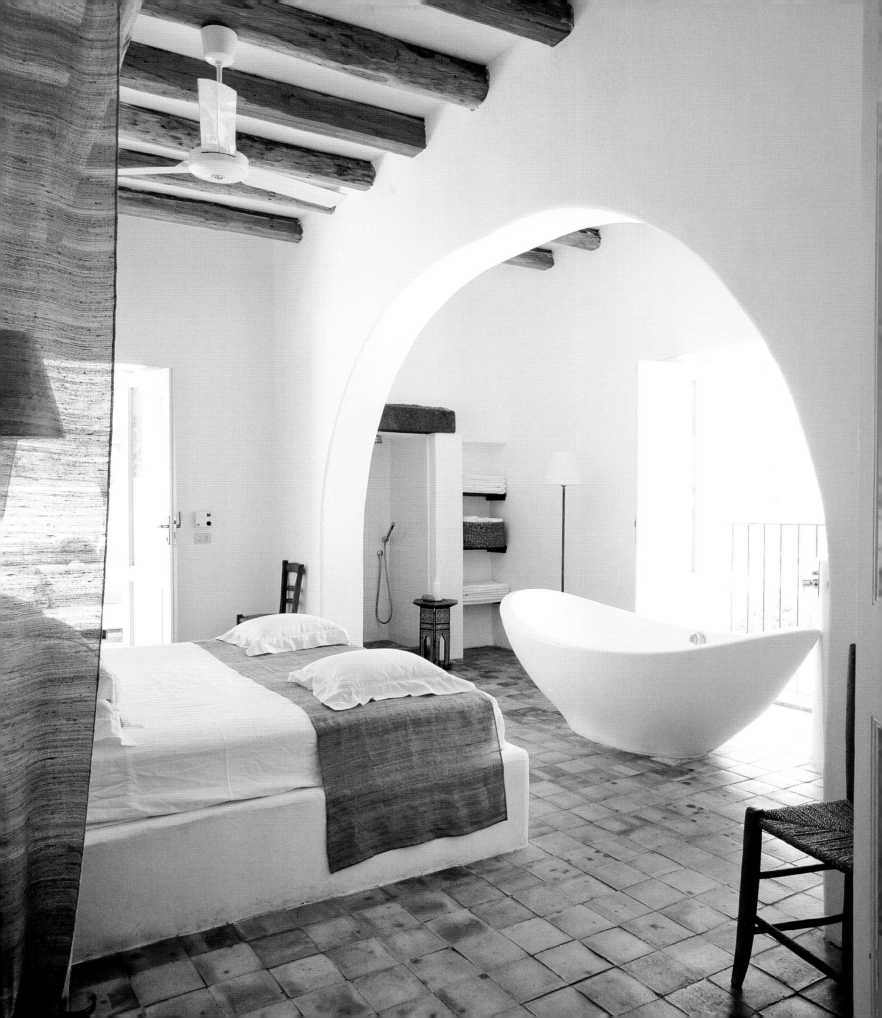

POETRY

It is not a coincidence that some of the most authentic interiors have the look and feel of artists' studios. A truly authentic environment will not just reflect your deepest self; it will distill it to its essence.

In 1993, photographer Don Freeman, having just returned from three years in Paris, was in search of a home that would give him both the emotional and physical space to experiment with his burgeoning creative talents. He came upon a 160-year-old wisteria-covered carriage house in Manhattan's Meatpacking District and was immediately enchanted. "It was rumored that Herman Melville once roamed or crashed or maybe lived there," says Freeman. "It had a spirit that one could not ignore—of rawness and artful energy."

The owner, for his part, was so respectful of the house's history that he took Freeman in, but only on a trial basis. Eventually, Freeman was not only allowed to stay but also to turn the top floor—"a jewel of raw beams, raw wood floors, and crumbling brick"—into his studio. "Everything about the top floor was rough and worn and completely original," says Freeman. With the help of stylist G. R. Waldron, he kept both floors as "raw" as he could: stripping the carpet and linoleum from the top floor's wide-plank wood floors and ripping out the old ceiling to expose raw-timbered beams; washing the bottom floor with Murphy's oil soap, and then leaving it bare.

By paring the loft down to its essence and then allowing that essence to radiate, Freeman was fine-tuning his craft. "I was hanging out with other artists whose work always started with

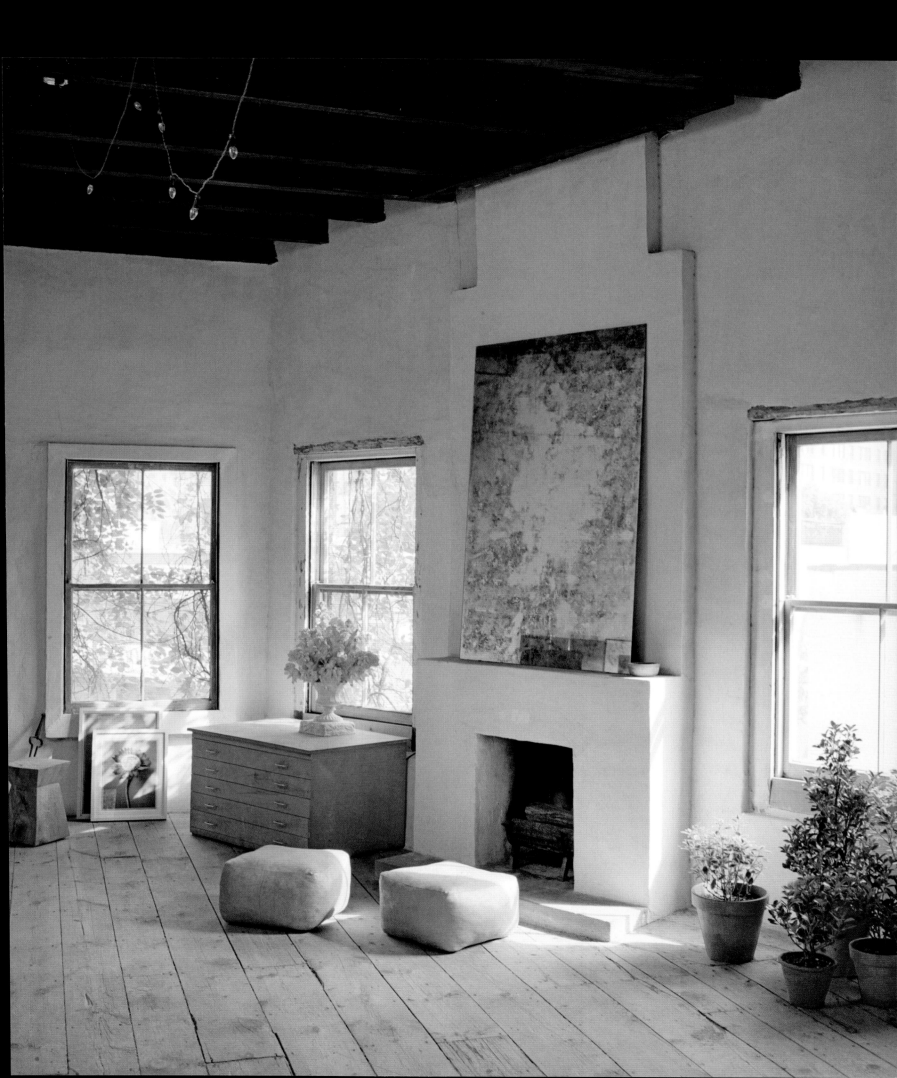

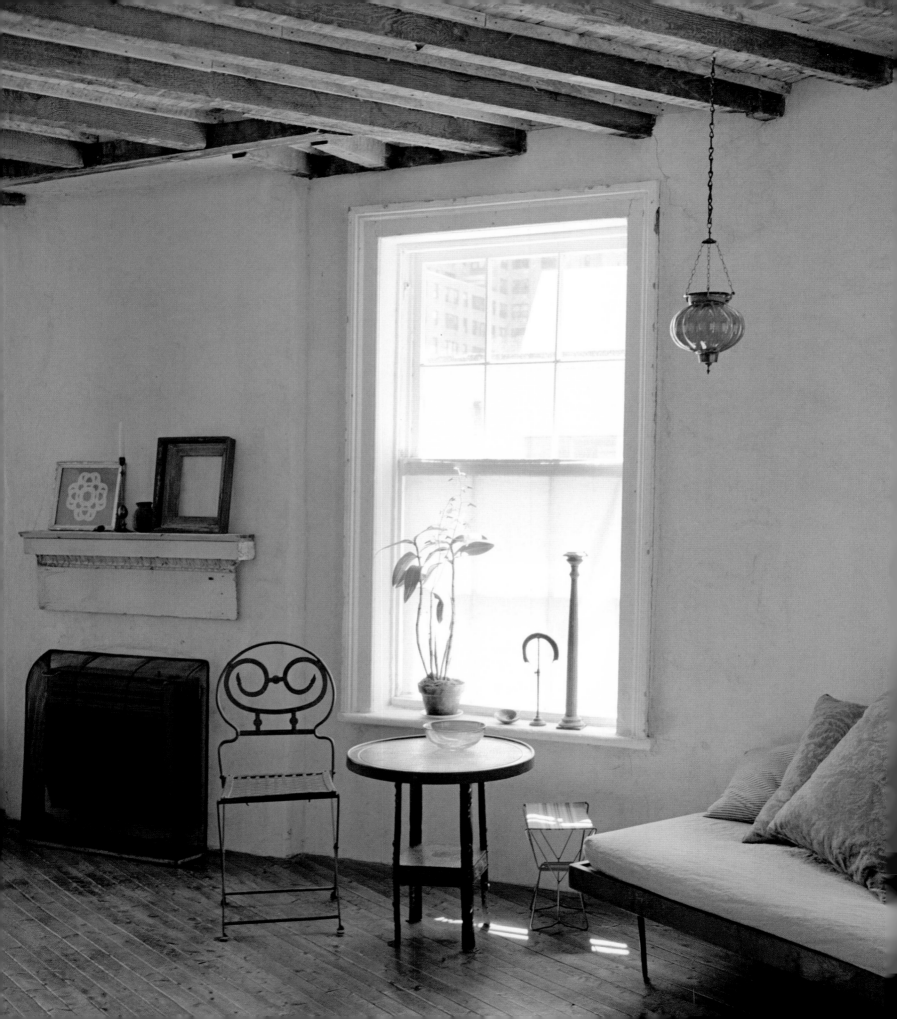

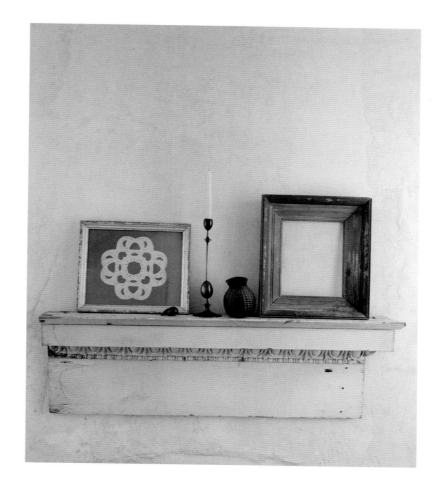

PAGE 23 The floors were stripped and the ceiling beams exposed to reawaken the history of the former carriage house. Surrounding the upstairs fireplace, a handmade distressed silver-leaf mirror by Maureen Fullam, *Flowers in a Vase* plaster sculpture by Michael Pixley, and silver and gold leather poofs by Dosa.

LEFT A delicate metal folding chair, Arts and Crafts table, daybed with Fortuny fabric pillows, and Turkish glass hanging lantern create a lyrical vignette.

RIGHT Ted Muehling prototype for his bronze candlesticks and a vintage frame on an old mantelpiece.

something inspired by nature, by craft, or by history—but always working from the heart and soul of their own personal unique style. This was something I was nurturing in myself."

His highly functional furnishings—a French wallpaperer's table in the kitchen, a brass Arts and Crafts tea table in the living room, a 1930s Italian garden chair, nineteenth-century hanging lamps from India and England—became props for his photography. "It was my studio, so I never had other art around me besides my own." At the time, he was working on a series of large blueprints of peonies, statues, and branches. "In the daytime the light was so beautiful—I was able to shoot mostly everything in natural light." The carriage house stood on a corner with three wide exposures to light, and skylights further illuminated the top floor and stairwell. But for Freeman it was the purity of the raw, aged materials that fully captured and enhanced the light. "I now feel I can represent the spirit of a place by observing how the daylight reveals its secrets."

BELOW A folding chair and a framed blueprint of Freeman's *Peonies* (1998).

RIGHT In the upstairs studio, an antique stool, a vintage Knoll rocking chair (1957), and artwork by Freeman.

PAGE 28 *Branch* blueprints (1998), vintage metal chairs, and baskets from the Dosa home.

PAGE 29 A sawhorse kitchen table and a collection of metal chairs.

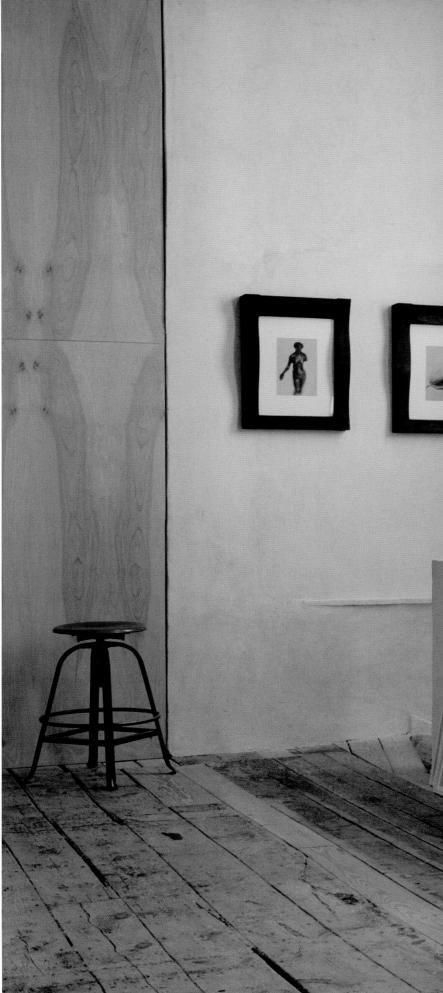

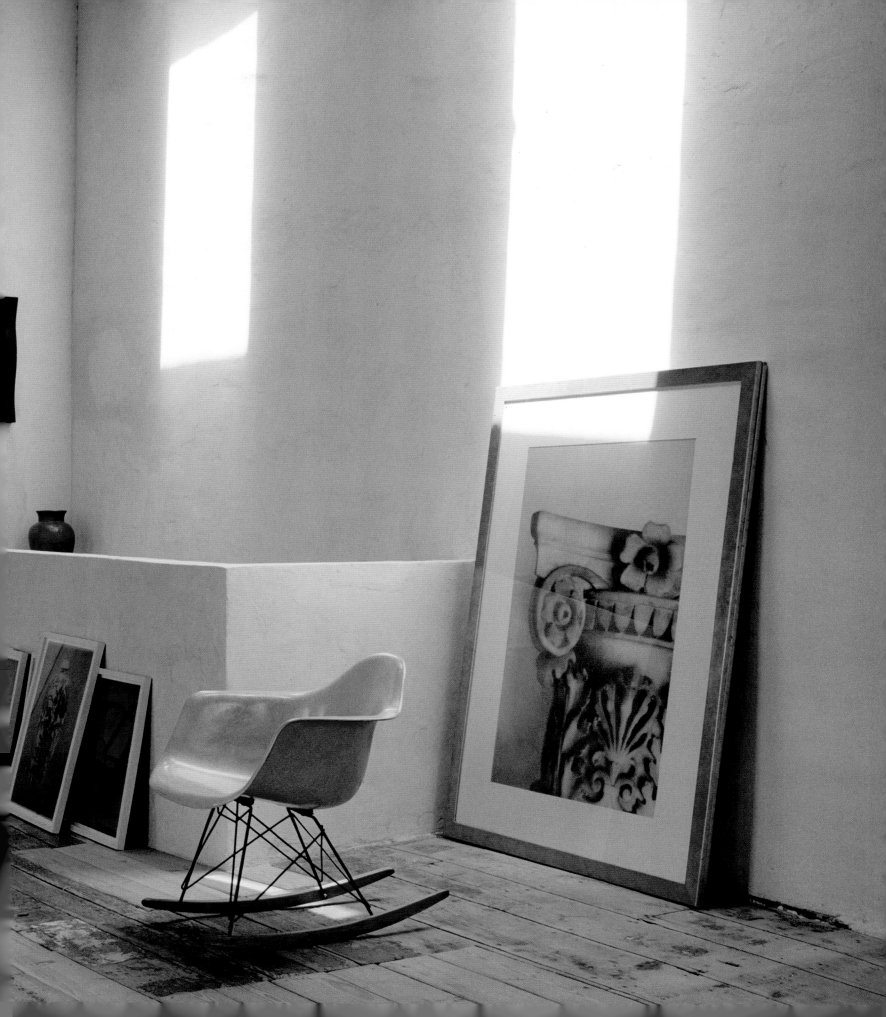

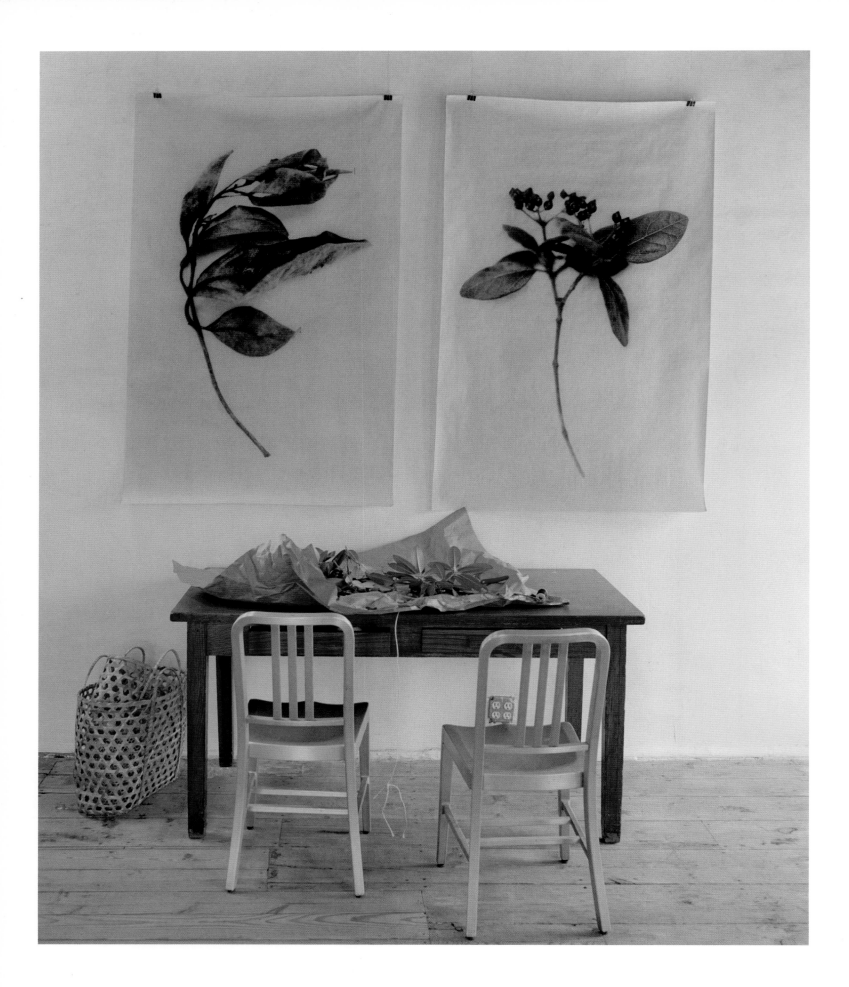

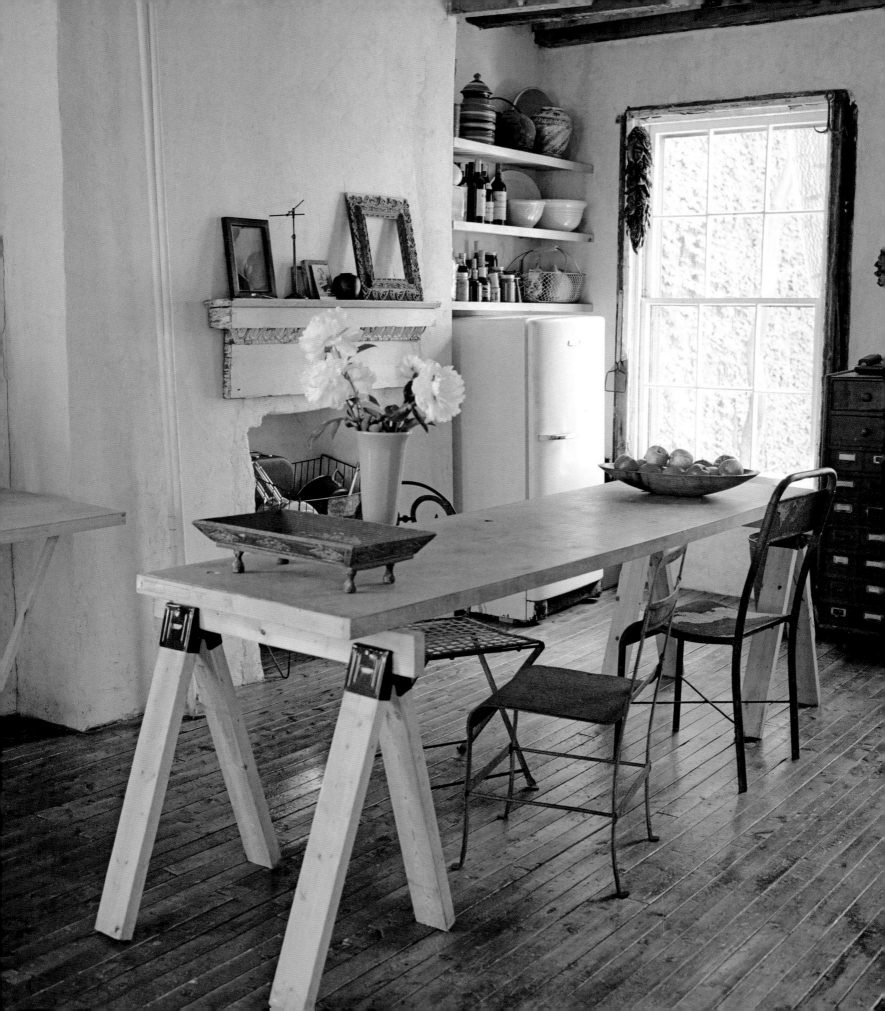

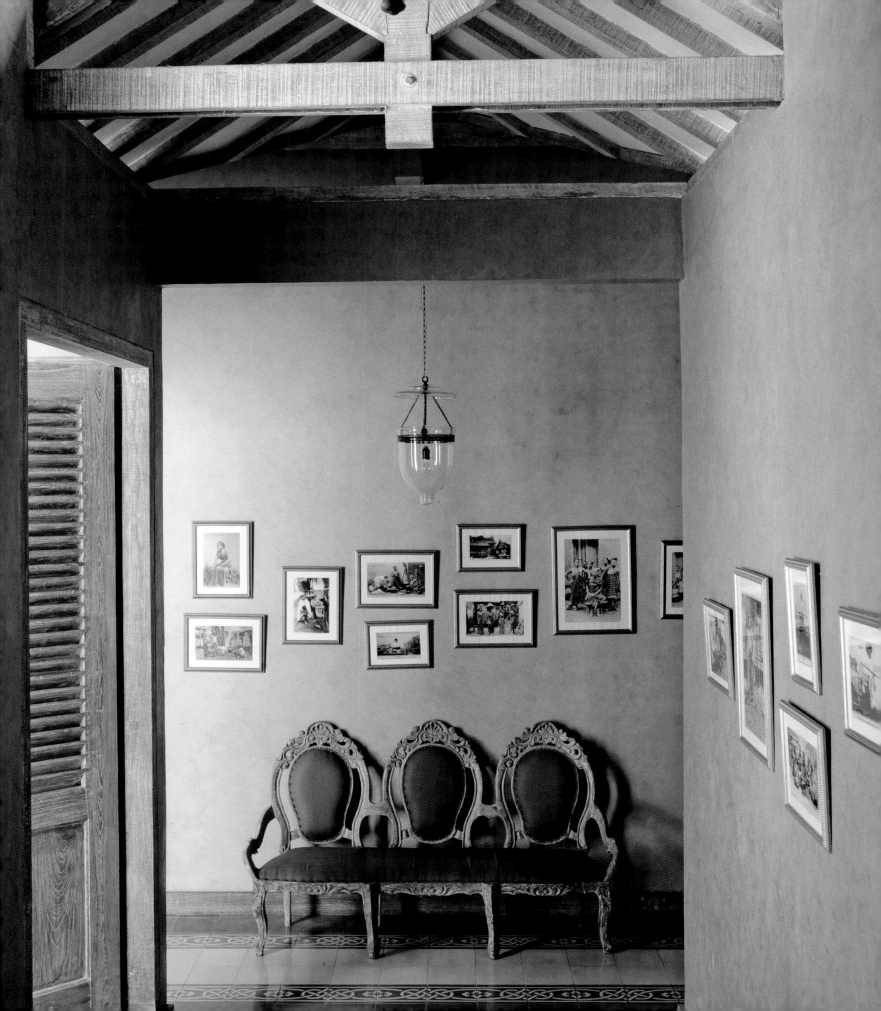

MEANING

In all things of beauty, in all pieces with soul, the spirit—the essential force of life and vitality—is quite palpable. It is the aspect that most immediately and directly speaks to us, that engages our own spirit.

This sense of vitality is certainly more apt to be found in handmade objects and textiles—in exceptional artifacts and artisanal work from around the world. But you can also connect with something that's been—gasp!—mass-produced. You're probably connecting with its design integrity—its proportions, simplicity, and composition. And you've probably been able to individualize these pieces—"mark" them—make them your own.

Personal mementos, family heirlooms, pieces created by people you know—all may have special meaning for you. Or they may not. The point is, it doesn't matter how personal, rare, eco-friendly, or (in)expensive a piece is. The important question is: Does it speak to you?

Dominique and Jean-Marc Verdellet had lived in Bali for nearly twenty years when they decided to build a traditional Indonesian house near the coast. After finding a beautiful piece of land with a coconut grove in Jimbaran, a small fishing village near the bustling town of Seminyak, they transported two seventy-year-old Joglo huts from the neighboring island of Java to create the foundation of their new home. Two and a half years later Villa Kalyana—Kalyana means "well-being" in Sanskrit—emerged, custom-made from recycled woods, antique windows and doors, and hand-painted tiles and basins.

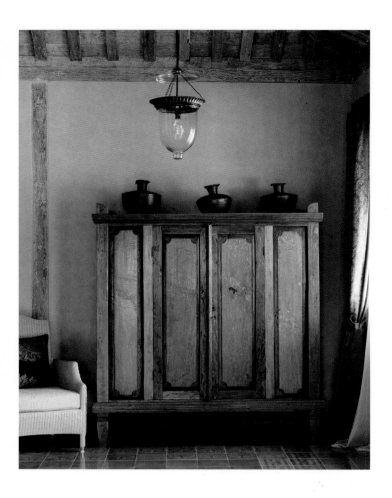

PAGE 30 The three-seat bench was bought in Java and upholstered in a linen fabric. Framed old photos from Bali and Java line the corridor.

LEFT The closet was bought in Java.

RIGHT The nearly 10-foot dining room table is teak and was found in an antique shop; the chairs are contemporary; the crystal chandelier is from Haveli.

While the exterior was assiduously constructed by local carpenters, Dominique filled the interiors with beautiful *"coup de Coeur"* artifacts that she had acquired through years of buying trips for her store, Haveli, which sells Indonesian and Asian-inspired tableware, linens, and accessories. "It took two and a half years to very precisely think about and find the right item or material for every part of the house, from switches and handles to furniture and lamps," says Dominique. "I would not buy anything if I was not one hundred percent sure that I wanted it."

Although the house is only four years old, it looks and feels as though it has been a family house passed down through the generations. Dominique attributes this to both the "long reflection" given to each aspect of the process and the variety of antiques and artifacts. "Each piece has its own particular spirit and story, and together they give a spirit to the house and they create the story of the house. I very often have the feeling that my house is actually a person, a very elegant lady that I have to take care of and respect, and in return she gives me back so much happiness."

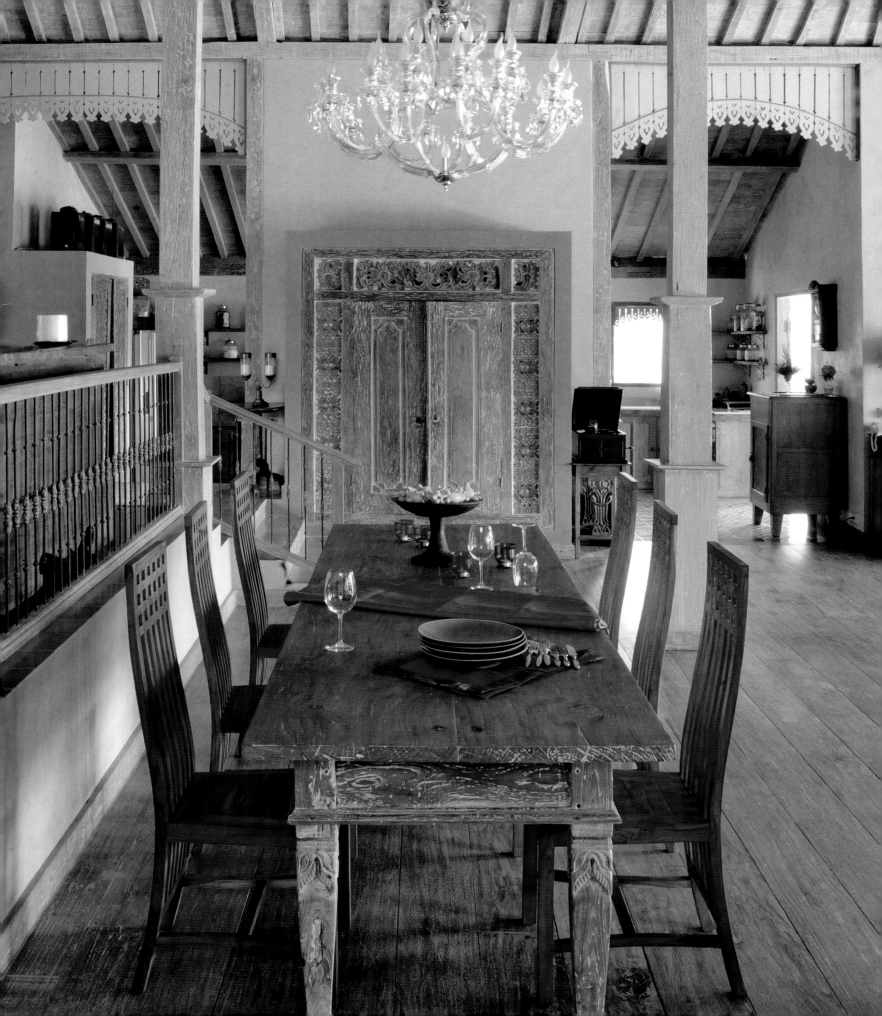

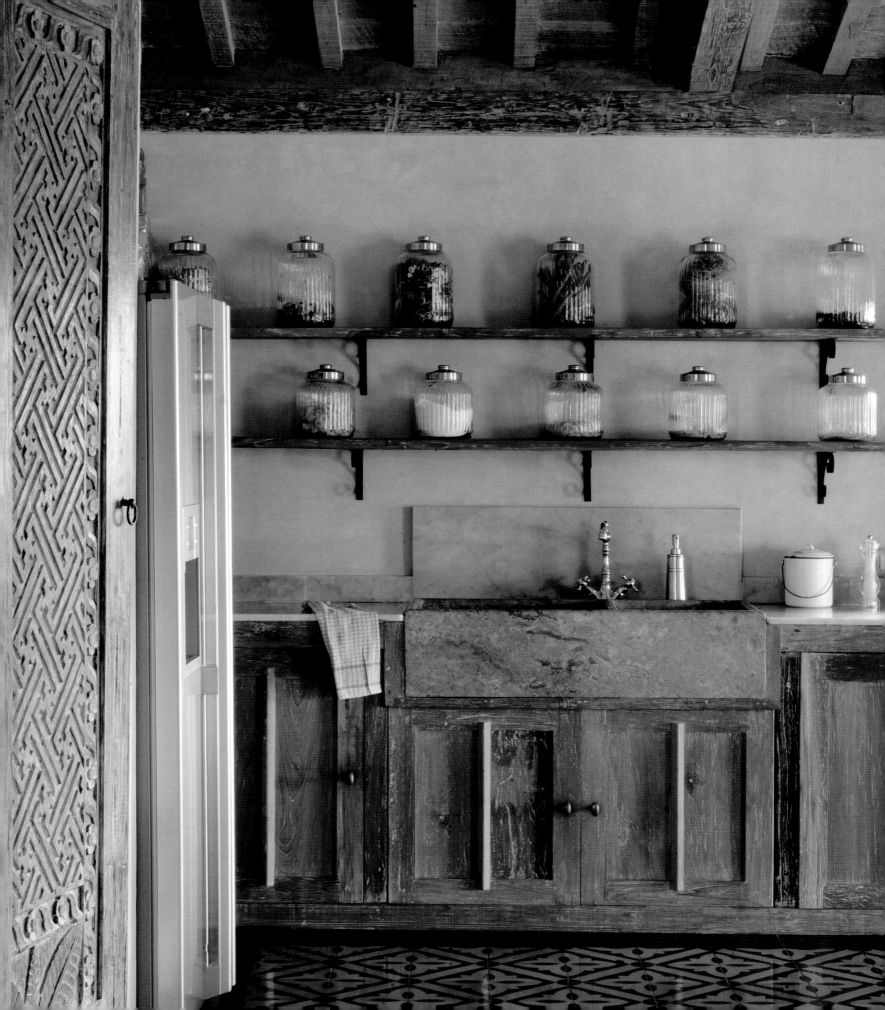

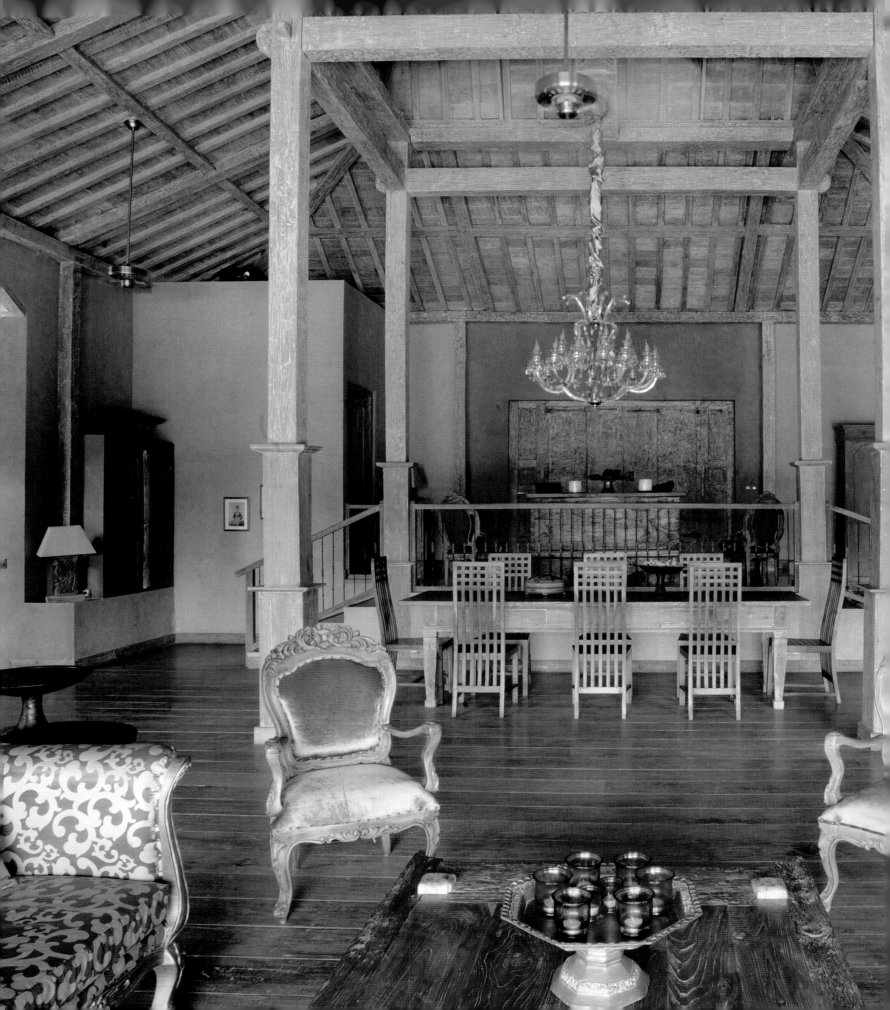

PAGES 34–35 The floor tiles come from Java, handmade following traditional Dutch colonial style. Antique patinated Joglo doors are used as cupboard doors. The table and bench are antique teak, also bought in Java. The pending glass lamps are antiques bought in Java.

LEFT All of the furniture in the living room is made of antique teak from Java. The floor is patinated Bongkirai, a local hardwood.

PAGE 38 Beams that frame the master bed are teak and come from an old Joglo house. All fabrics are from the Shahinaz Collection.

PAGE 39 Fabrics, bed linen, and curtains are from the Shahinaz Collection. An iron-and-crystal chandelier hangs from an old carved beam.

PAGE 40 In the master bathroom, two china basins, bought in Bangkok, were mounted on a vintage dresser.

PAGE 41 The bathtub is in terrazzo, a mix of concrete and small stones, and was made on site by a local craftsman.

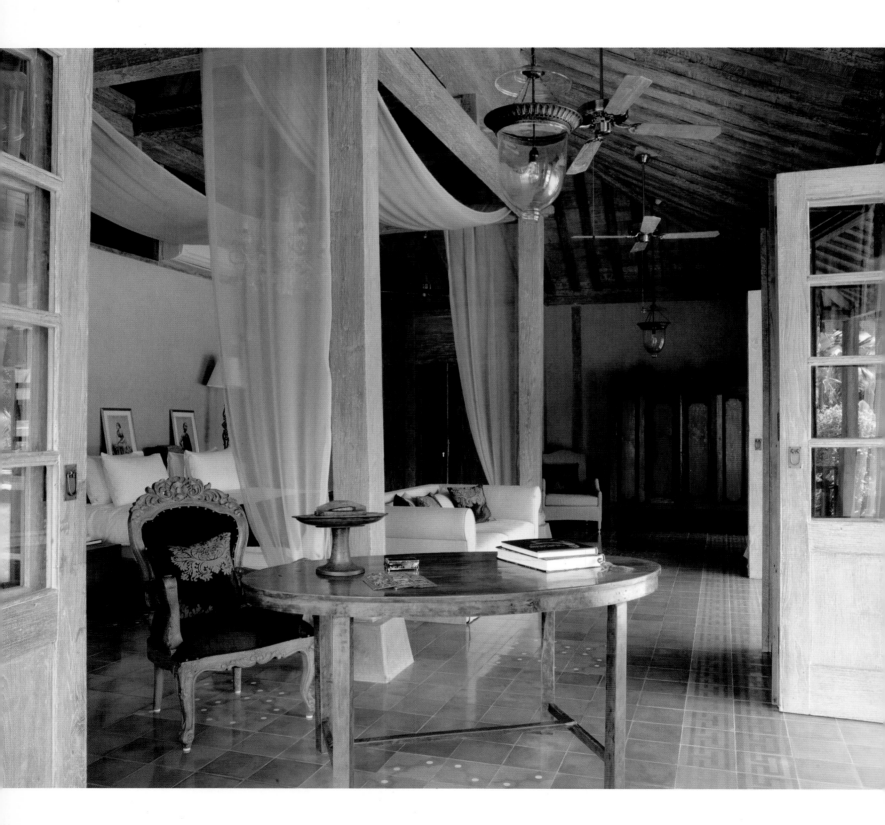

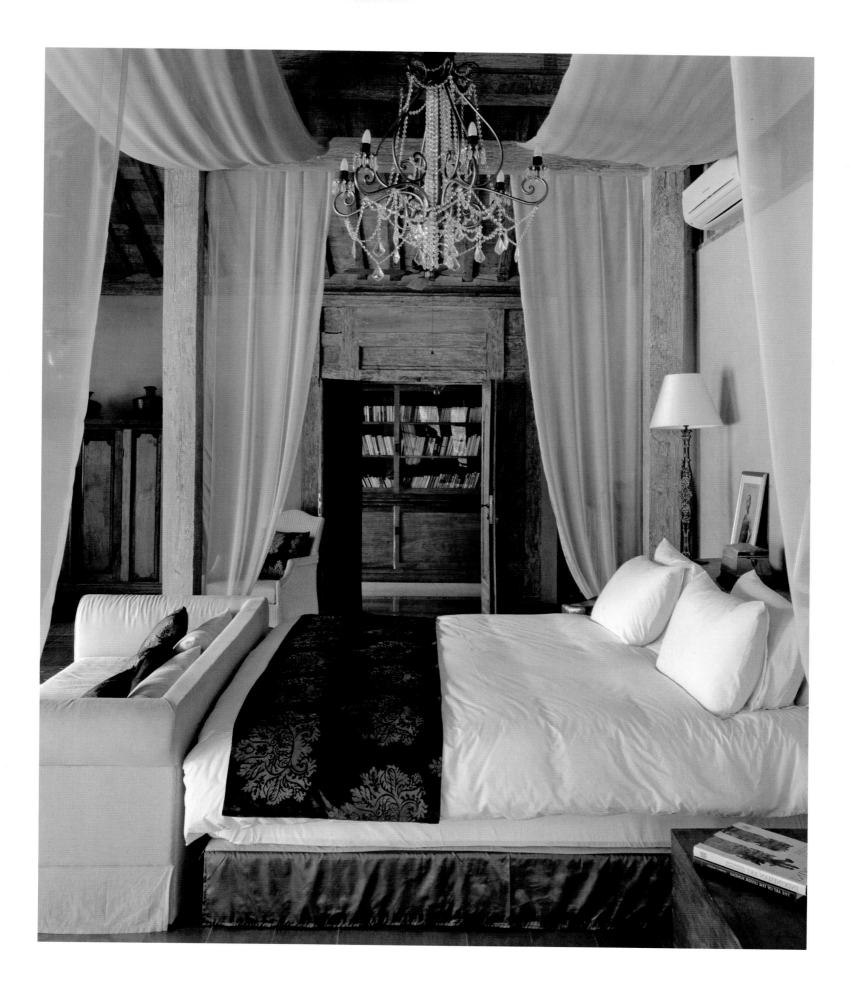

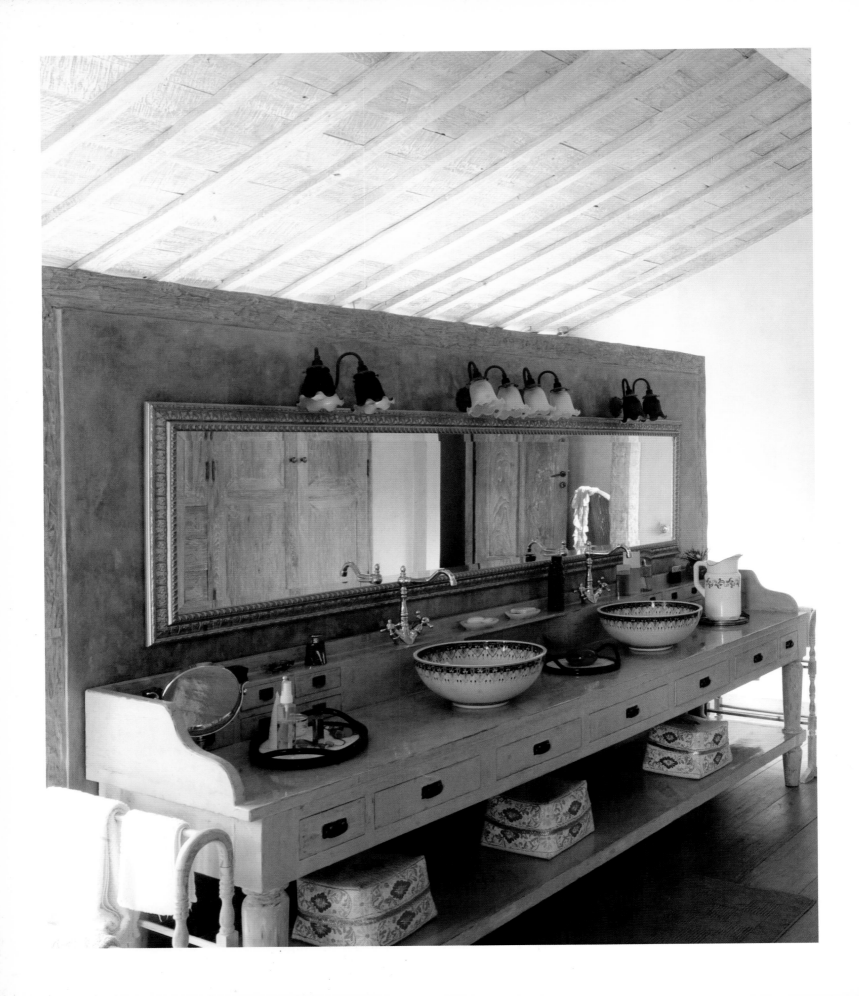

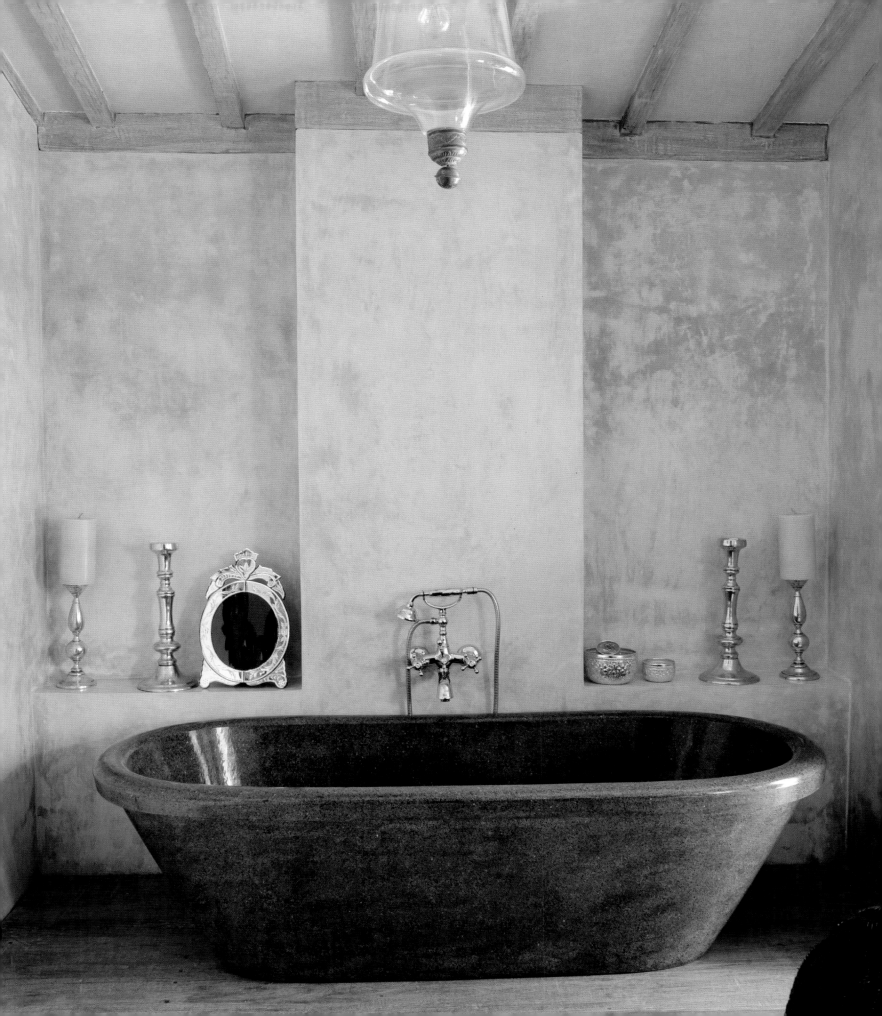

SENSUALITY

Natural materials like wood, bronze, and stone and textiles like linen, silk, and velvet are inherently sensual and can be quite grounding. Used with subtlety, they can also feel quite luxurious.

Sensuality can also come from color. Natural colors have come to mean "neutrals." But—is nature beige? The colors of nature are simultaneously pure and vibrant: amber, ochre, poppy, olive, mahogany, saffron, coral, ivory. While some homes make great use of a neutral palette, shots of bright, complex color can add not just surprise but a sense of optimism.

For years, Catherine Weyeneth Bezençon, an interior designer and owner of the Ars Vivendi boutique in Geneva, and her husband, Pierre, had searched for a home that had both space and "a soul." One spring day in 1999, in the tiny village of Veigy-Foncenex just across the French border, Bezençon saw a barn that had been built in 1890 to store the harvest. "I did not design this building," she says. "I met it."

There was, to put it mildly, a lot to do. "One could almost feel the former presence of cattle," says Bezençon. High piles of hay still filled what would become the upper floor. "But I could see that this massive, 2,000-foot 'square' was a witness of the past and had the simple but ample proportions of a future contemporary loft."

Her objective was to "never lose the soul of the house," to integrate her own personal style with as much of the existing structure as possible: the cathedral-like wooden roof, the rough-hewn stone walls, the embrasure-like openings—remnants of the feeding troughs—which now serve as light shafts and look out onto acres of lush farmland.

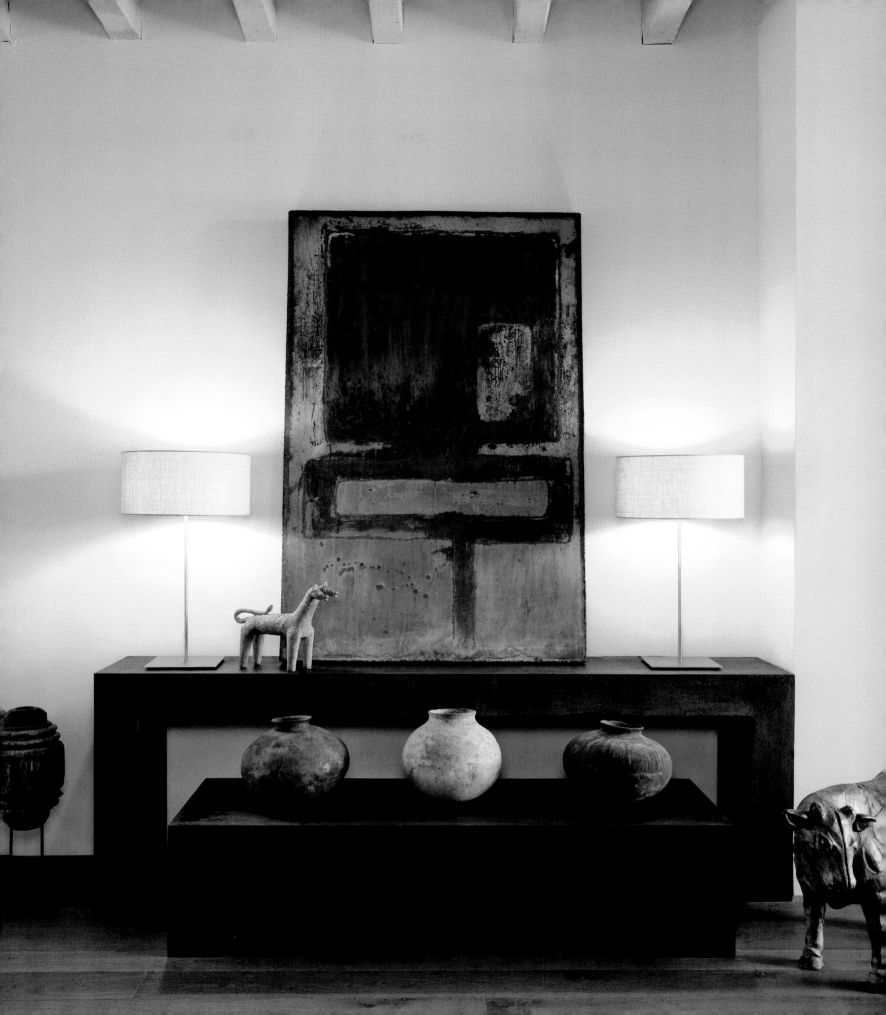

She then began to integrate glass, iron, and mid-century Modern pieces by Le Corbusier and Mies van der Rohe with natural textures like linen, wool, leathers, and skins, and a trove of artifacts that the couple had collected from their travels: Han Dynasty terracotta warriors, bronze pieces from North Vietnam, primitive African statues, a Buddha made of alabaster from Burma. The long wooden dining room table comes from a flea market in Provence. "I will always prefer the sensuality of a table that has 'lived' to the practical side of a fake Louis XVI," she says.

PAGE 43 Han Dynasty terra-cotta pieces in one of the living rooms; the small horse is a nineteenth-century bronze piece from Mali.

RIGHT Two chaise longues by Le Corbusier and calligraphic works on wood warm up the library, which is dominated by Jean-Baptiste Huynh photographs.

PAGE 46 In the spacious living room, modern linen sofas and a painting by Jeff Bertoncino are balanced by ethnic art pieces and the original wood of the barn.

PAGE 47 A view of one of the three living rooms under the original wooden structure built more than a century ago.

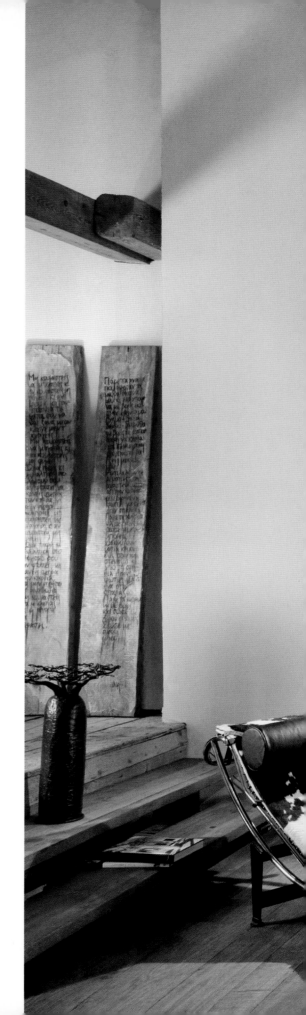

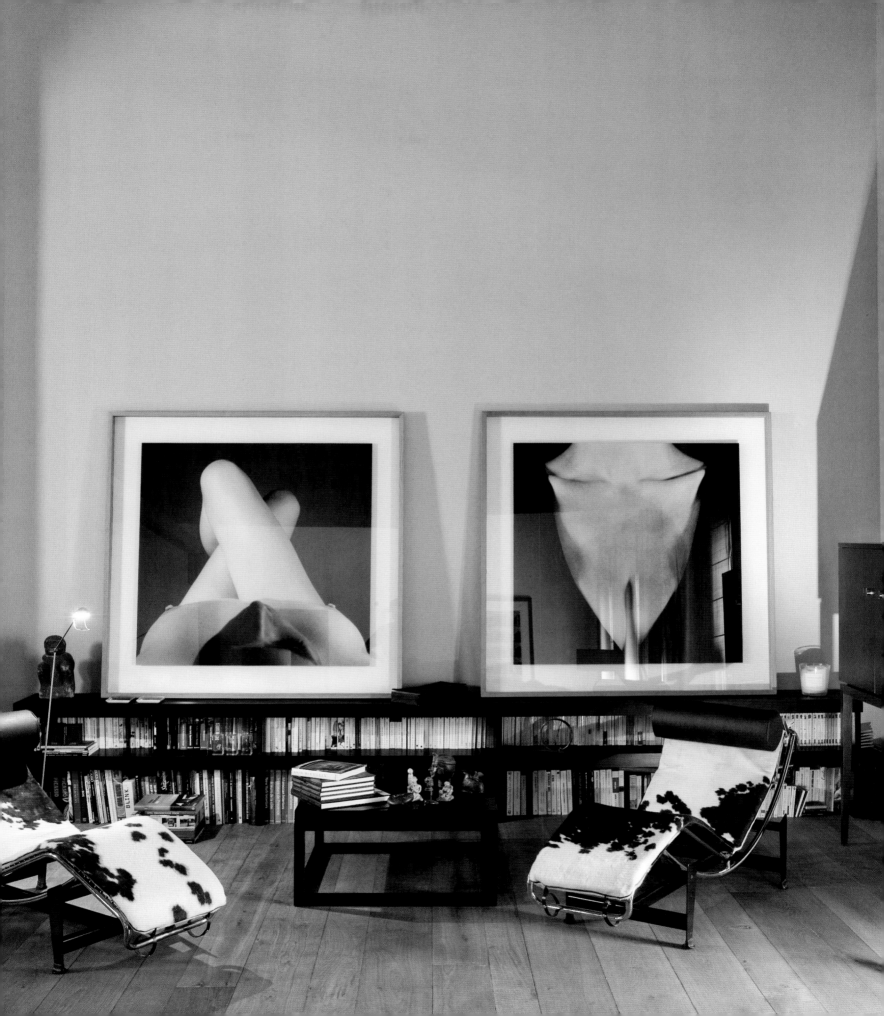

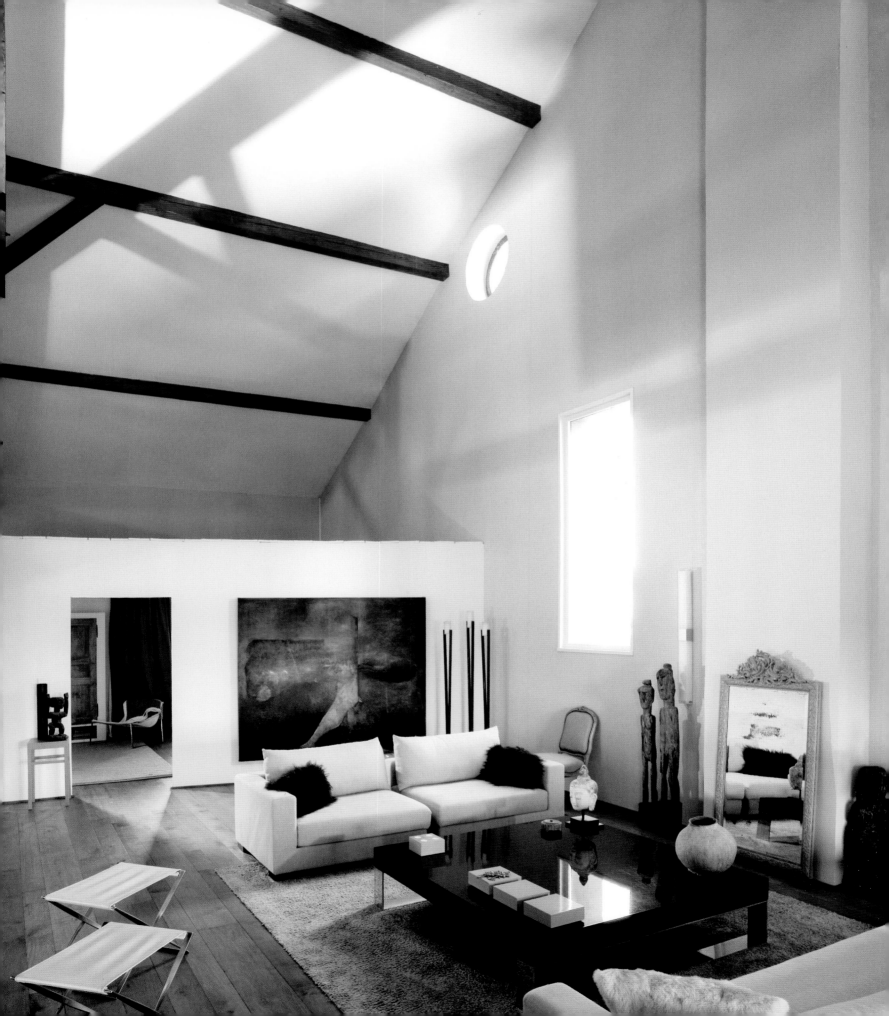

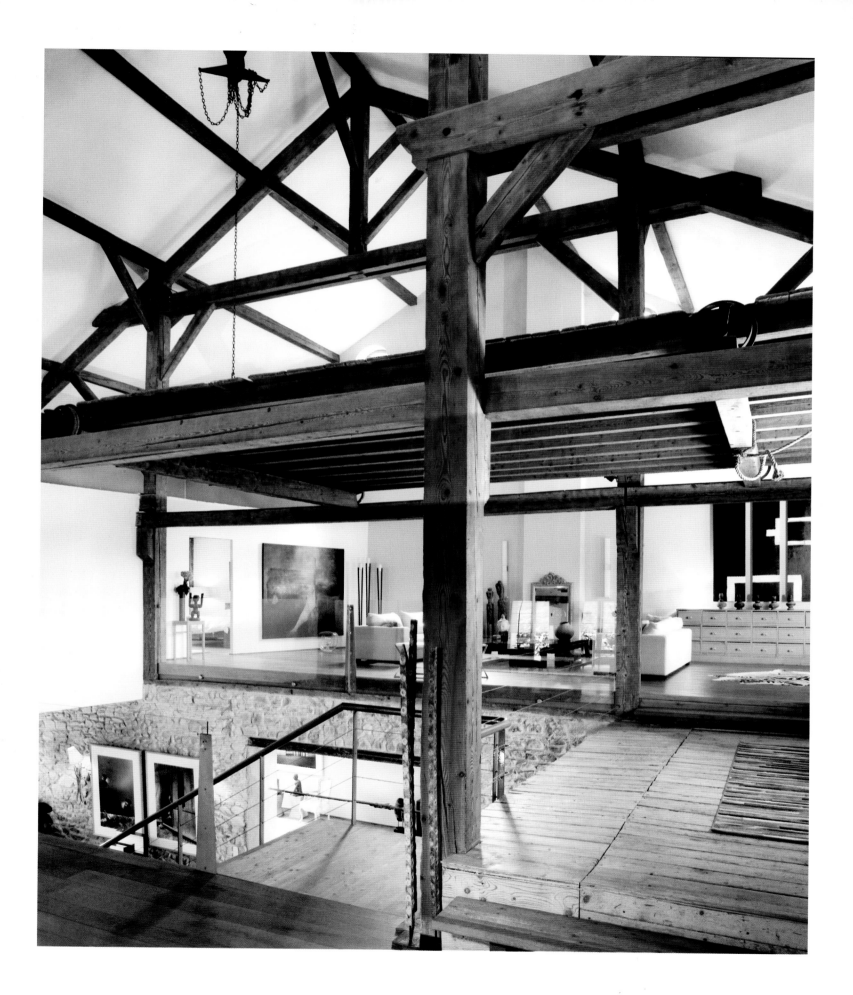

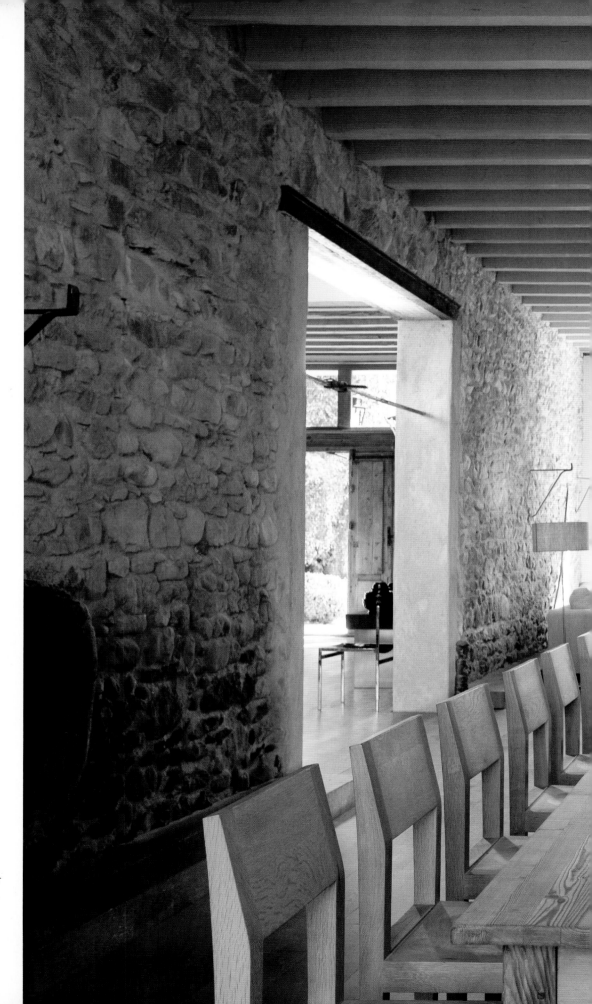

RIGHT In the dining room, an untreated wood table, retrieved from a courtyard near Avignon, blends with the exposed stone and beams.

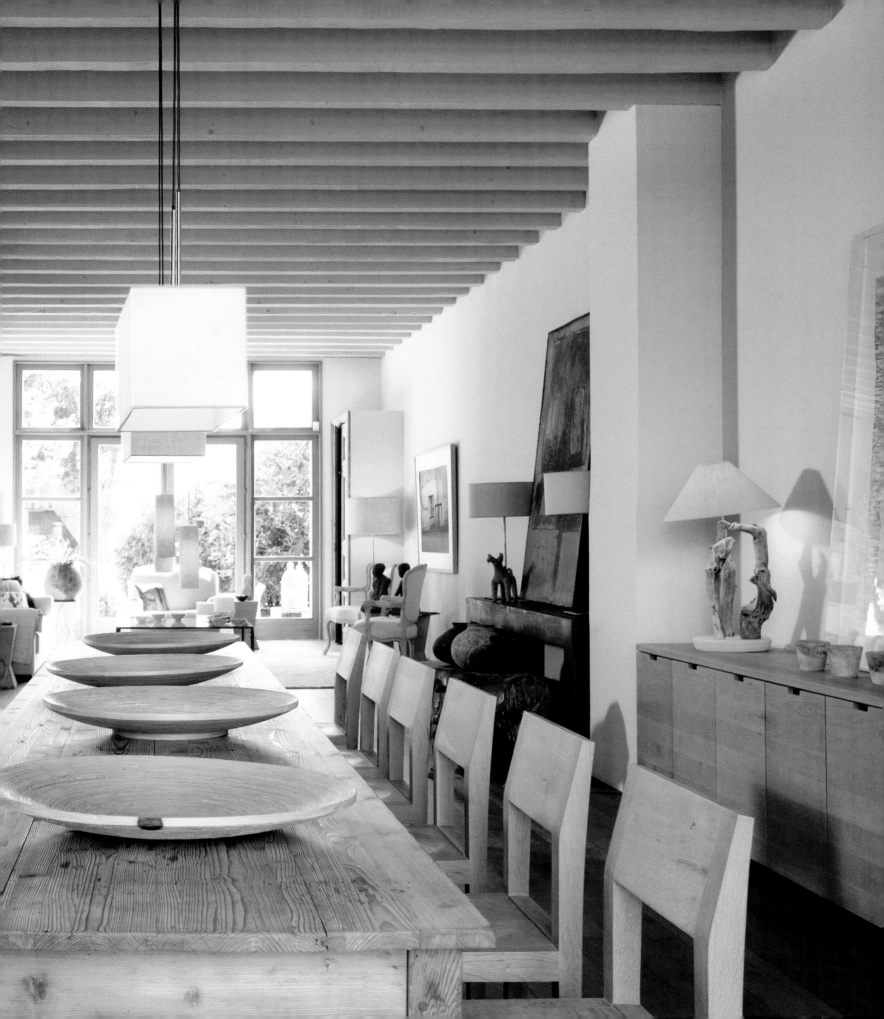

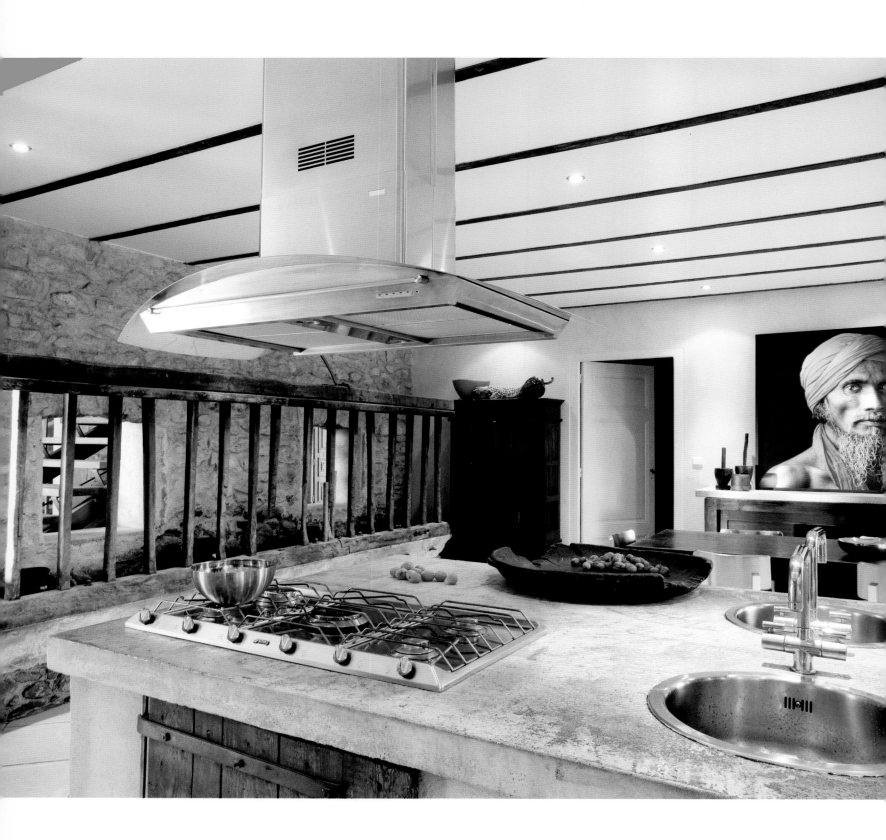

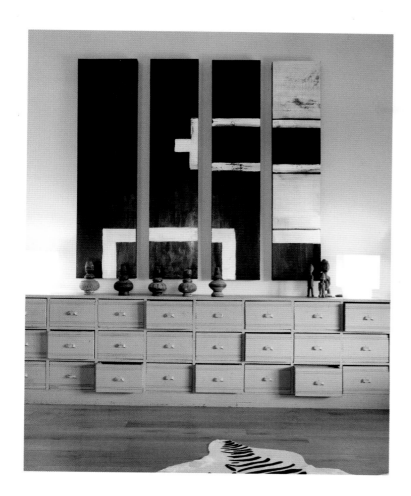

LEFT The wood-and-stone kitchen is almost monochromatic; a large piece of art by Jean-Baptiste Huynh adds riveting color.

ABOVE, LEFT In the sitting room, a "quadriptych" painting by Dominic Taylor and zebra-skin rug sensualize a refurbished cabinet and a collection of old water pots from Laos.

ABOVE, RIGHT In the dressing room, period hairbrushes sit on an eighteenth-century golden console from France; the lithograph is a Marc Chagall.

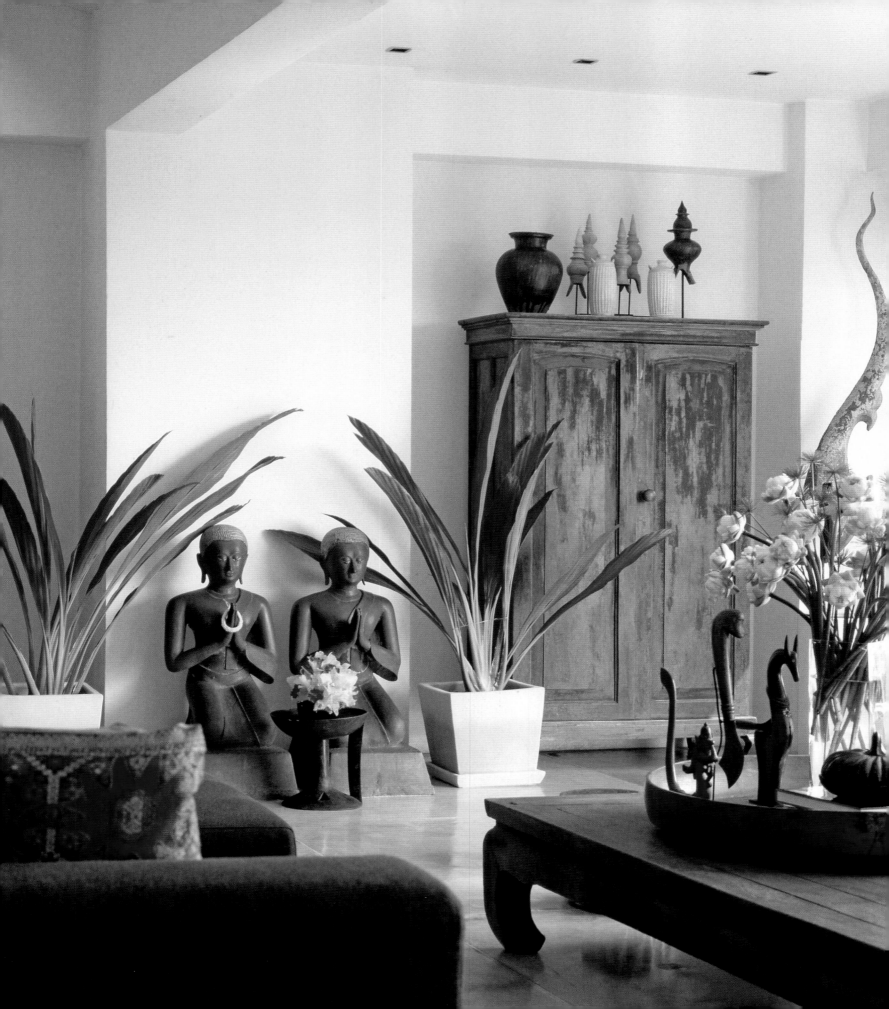

LAYERING

Nature is mysterious, complex: it does not reveal itself all at once. You have to start a relationship with it to begin to understand what it is about—and you will never know it fully. The same is true for art and interiors. The more time you spend in authentically beautiful interiors, the more you discover.

The key to mirroring the mystery of nature—to creating deep beauty in your home—is "layering": integrating different cultures and periods and diverse shapes, textures, and colors to create highly individualized, multidimensional compositions. It's not about finding the "right" chair/coffee table/painting to "match" the sofa. It's about learning how to assimilate disparate pieces of timeless beauty with the understanding that while these pieces can— and should—stand on their own, they are often enhanced by sitting on top of, next to, or underneath other pieces of timeless beauty.

Sometimes, there is hesitation in pairing contemporary pieces with antiques. The challenge is to find antiques that are truly timeless (not just old), and contemporary work that is not just innovative but that actually moves the trajectory of beauty forward. In the end, though, the same test applies to a contemporary piece as it does to an antique: Does it move you?

"I'm always looking for meaningful markers of the past—those that express a kind of sincerity by the people who made them," says collector and shop owner Cathy Vandewalle. "But when it comes to bringing an object home, it has to offer a more particular feeling, whether in the history behind it or in the emotion it evokes."

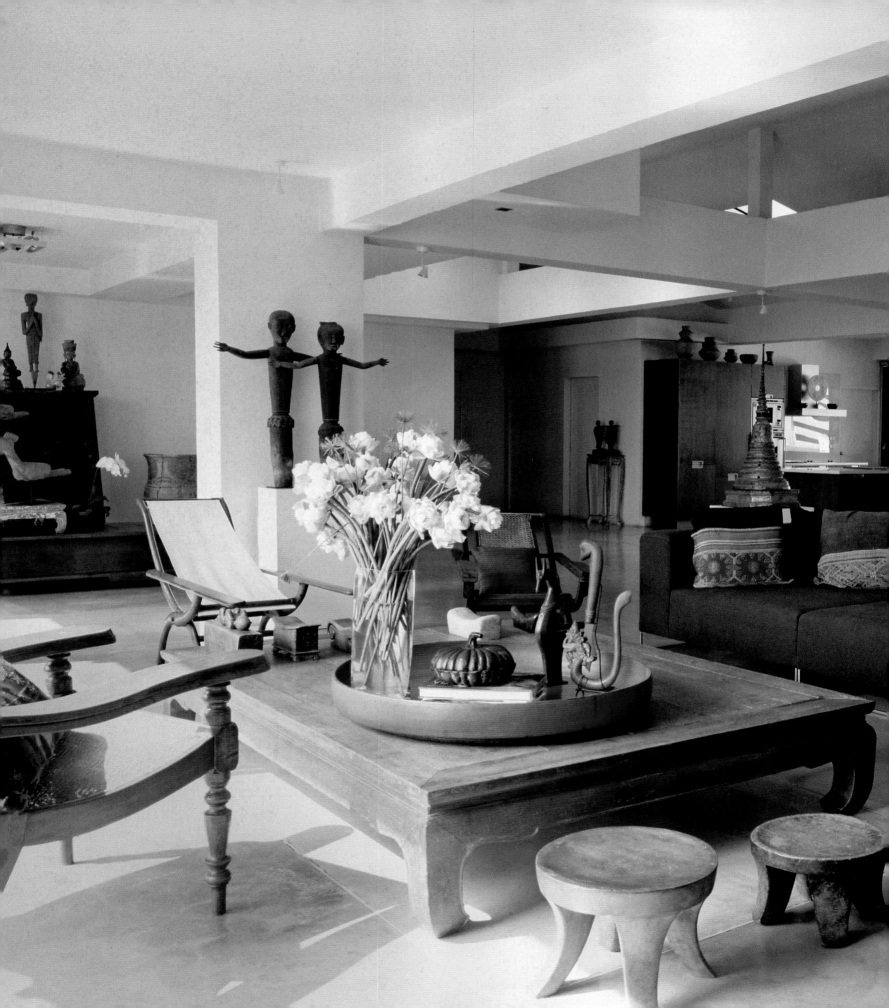

Roughly a quarter-century ago, the Belgium-born Vandewalle came to northeast Thailand to work in a camp for disabled refugees. She's now the co-owner of five stores in Bangkok, selling antiques and primitive pieces from throughout Southeast Asia. After years of collecting art and artifacts from Thailand, Burma, Indonesia, and Nepal for herself, Vandewalle finally bought a space suitable to "stage" them: a white-walled penthouse in a seven-story building in central Bangkok.

Vandewalle wanted the 3,500-square-foot industrial space to feel very open, enhanced by a lot of natural light. She elevated the inner ceiling, punctuated the roof with skylights, and replaced the original windows with large, almost floor-to-ceiling windows. "I'm lucky to have as a neighbor a huge and beautiful tree—the top reaches the level of my apartment—that blossoms with pink flowers and is home to a variety of birds."

Little by little, the art objects found their place. "I was never in a hurry to finish," says Vandewalle.

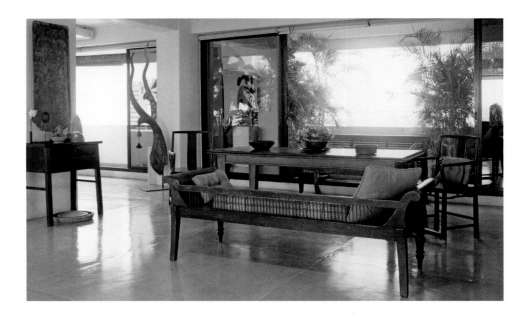

In the living area, a Thai teak bed serves as a cocktail table, topped by a red lacquer tray from Burma and surrounded by Asian tribal stools and primitive guardian statues from Indonesia. Against the wall, an eighteenth-century Chinese medicine chest and an antique Burmese teak cabinet flank bronze monk statues from Thailand.

This type of layering can be seen throughout the penthouse—and is offset by the contemporary furnishings (some designed by Vandewalle), the stark white walls and cement flooring, and the sense of space that surrounds each object and vignette.

"Living in Bangkok is really tiring; it demands a lot of energy," she says. "So for me it's a luxury to have this wide space as a 'barrier' to the outside world. It's a decompression space—it allows me to cool down, be at peace, to reconnect with true values through the beauty of art and the surrounding nature."

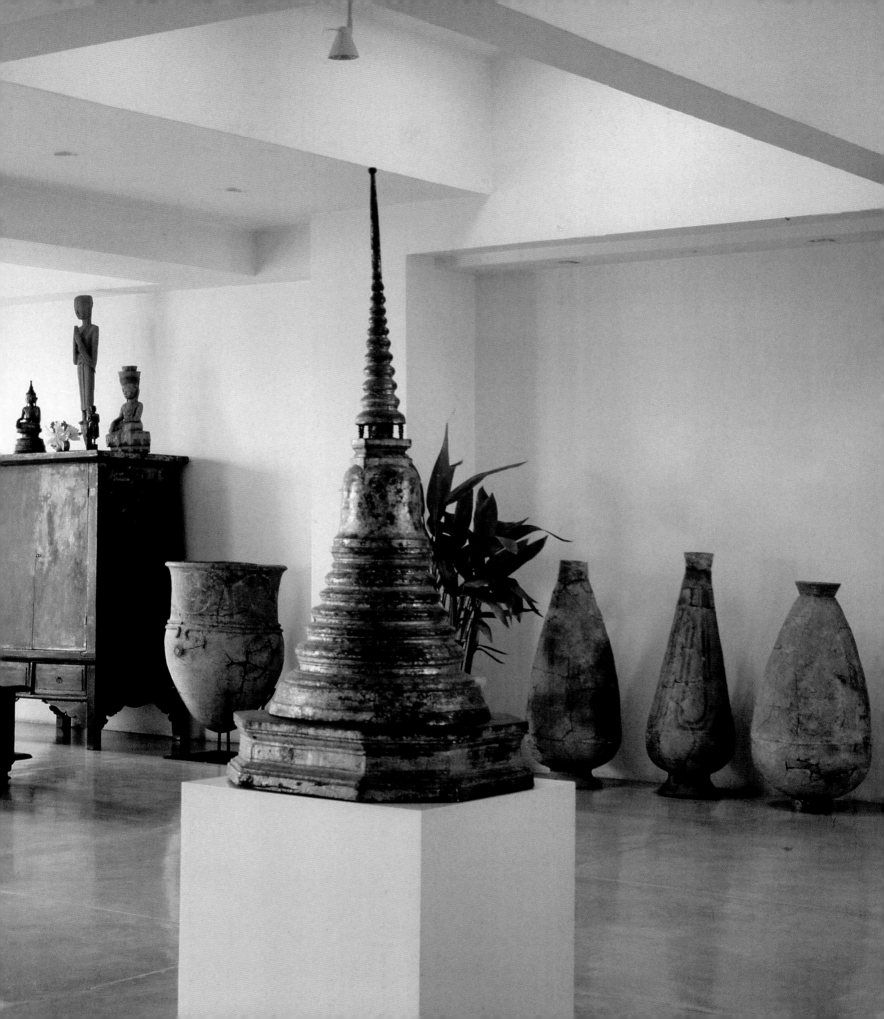

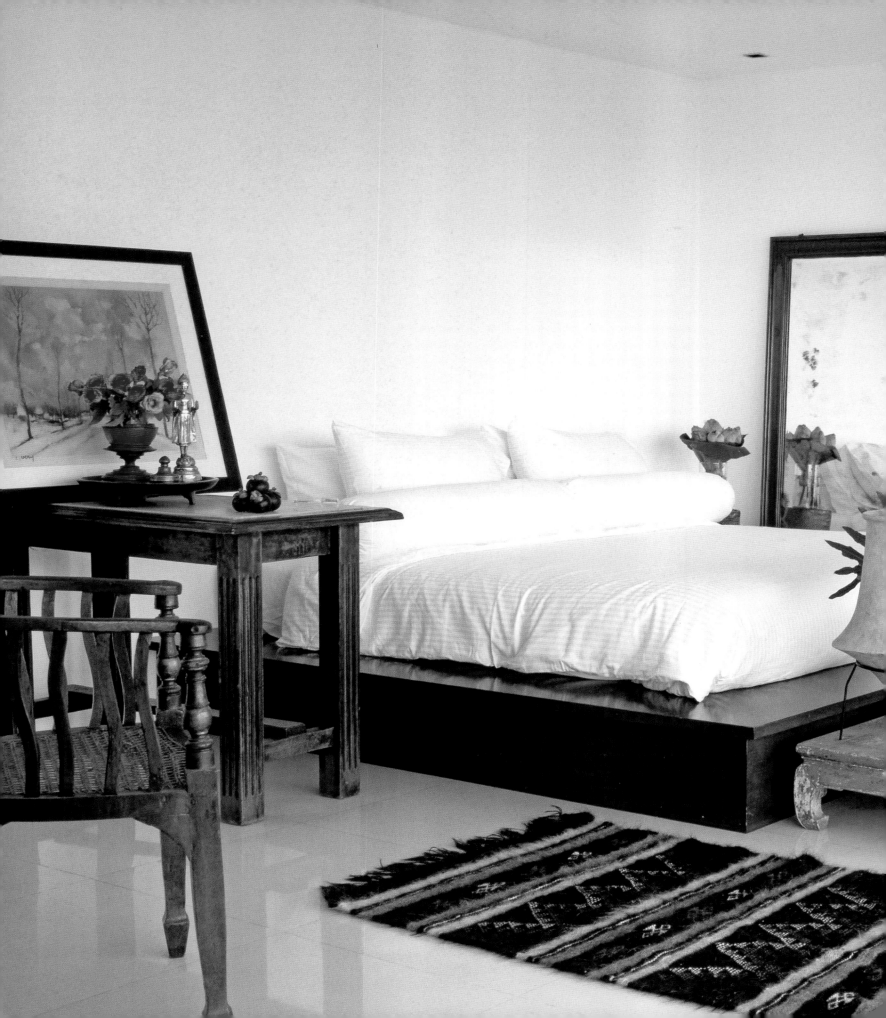

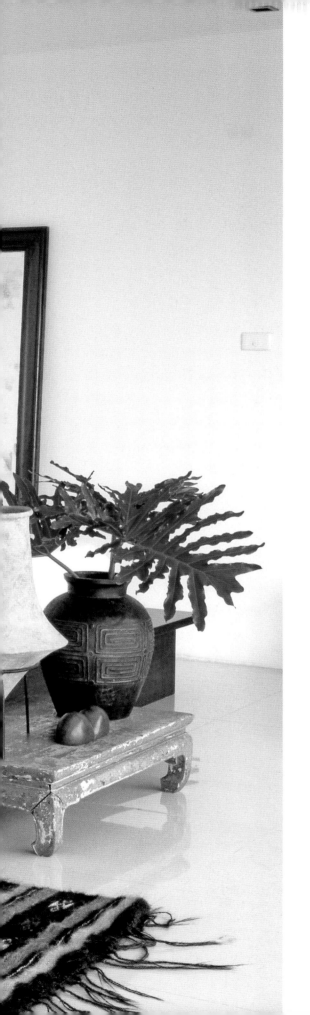

PAGE 56 A Burmese teak settee from the Colonial period faces the backyard. Against the wall is a bronze Thai Buddha footprint.

PAGE 57 On the far side of the living area, a bronze gilded stupa and a wooden "fertility" sculpture watch over a couple of wooden birds; architectural elements from a Thai temple on a low Burmese teakwood bed serve as another table.

LEFT In the bedroom, an ancient Thai vessel and a nineteenth-century bronze Japanese jar are displayed at the foot of a bed designed by Vandewalle.

BELOW In the master bedroom, a Burmese colonial teakwood "planteur" chair elegantly offsets an eighteenth-century Chinese Shaanxi chest with prehistoric Thai pottery, an ancient Tibetan rug, and a lithograph from French artist Sebastien Pignon.

PAGE 60 The master bath features hand-finished cement walls.

PAGE 61 In a walk-in closet, an antique Burmese chair, made of teakwood and rattan, is dramatically posed next to a large cabinet holding shoes. A collection of antique Burmese offering vessels rests on top of the sliding door.

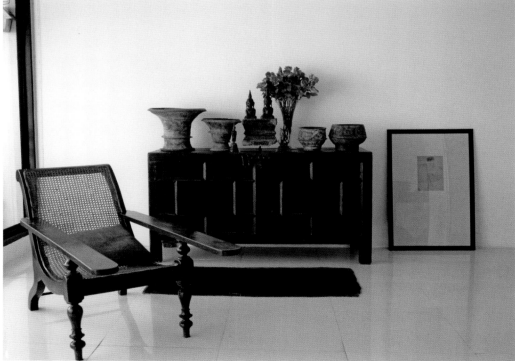

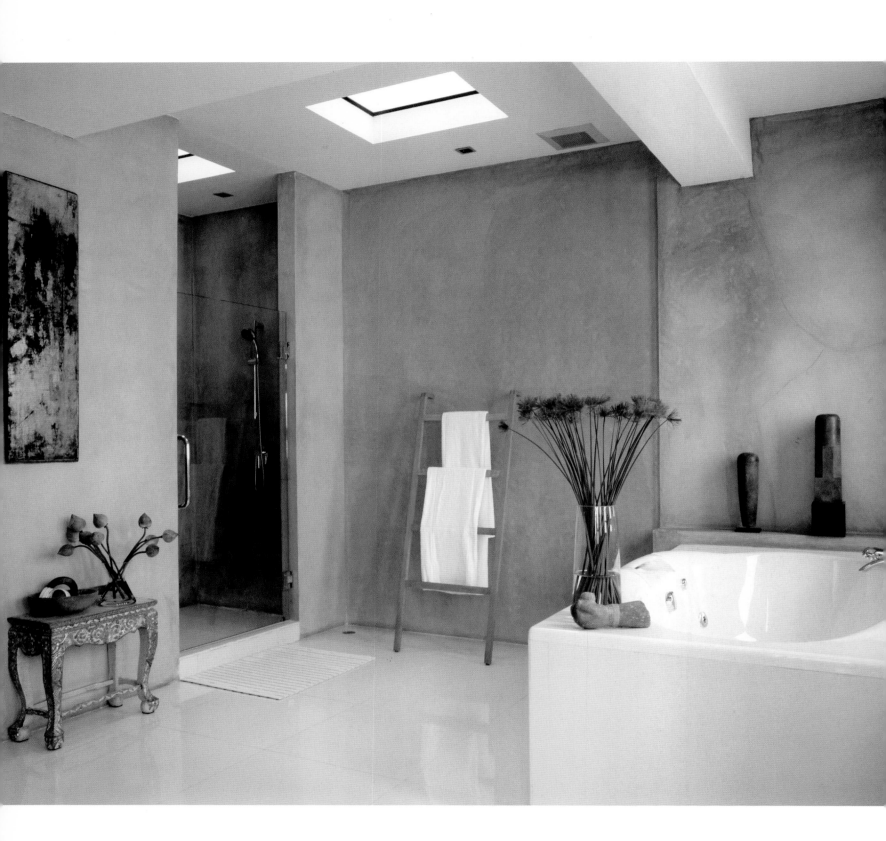

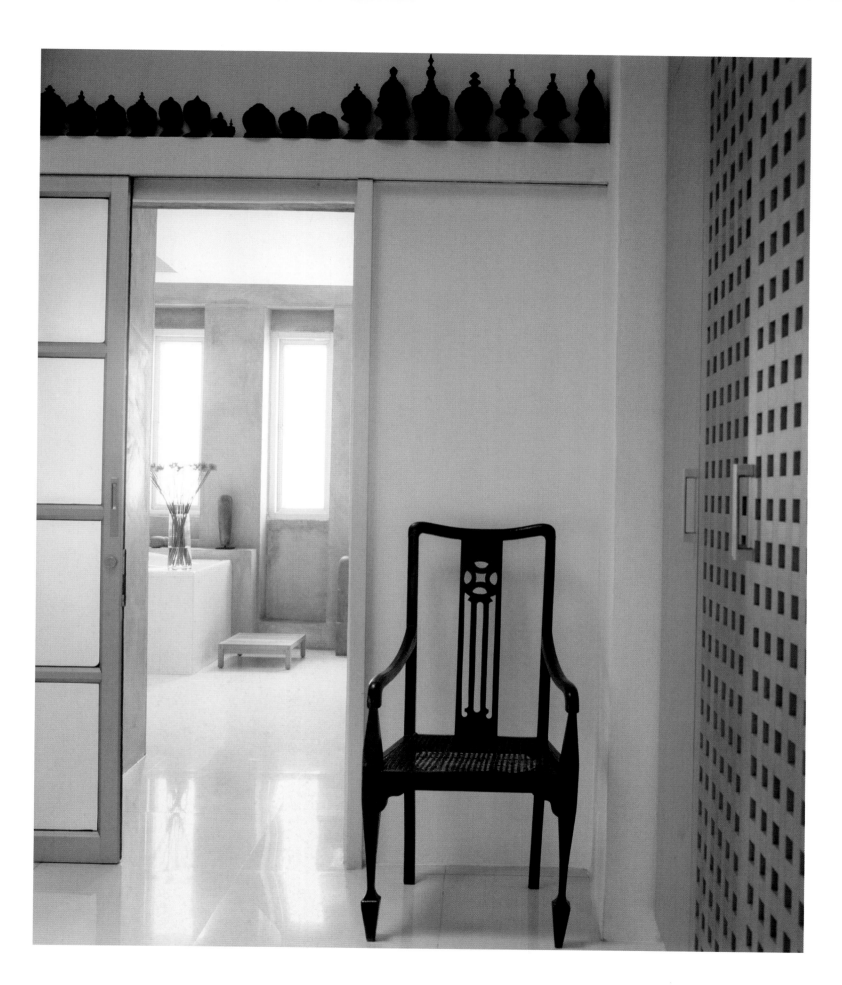

NON-DECORATION

Of course, a room can have all of these elements—pure colors, sensual materials, a layering of cultures and centuries—yet still feel too polished, too "decorated." Though deeply beautiful, nature does not feel or look decorated: it feels unified yet unstudied. As a result, the more decorated a home looks the less authentic it feels.

This is not to say that your furnishings should feel random. What you want is a home that looks and feels as though you've always lived there—a home that looks "collected" rather than decorated. How to do this? Hand-select pieces that speak to you—but do so slowly. "A rich tableau develops over time," says designer Juan Montoya. "Don't fill your house with stuff. 'This space is empty—let's fill it in.' No, you need to wait until you find the right piece. Use a pillow instead of a chair until you find the right chair."

Authentic design isn't done in six months and never touched again: it's an ongoing process. And the journey should never be over. Nature is constantly evolving, adapting, growing—so should your home. If you have things that don't have meaning for you or don't make sense, you are not bound to keep them. "Get rid of them!" advises Montoya.

Colombian-born Montoya has homes in Manhattan, upstate New York, South Beach, and Paris. A jet-setter's dream, in other words. Yet his homes are anything but high-glam and superficial. Even in South Beach, Montoya managed to create a flat that has all of the warmth and authenticity of him and his partner, Urban Karlsson.

In the 1990s Montoya discovered a seven-story apartment building in South Beach's Art Deco District—the Helen Mar—that stood out for its "modesty, subtlety, and charm." (In the

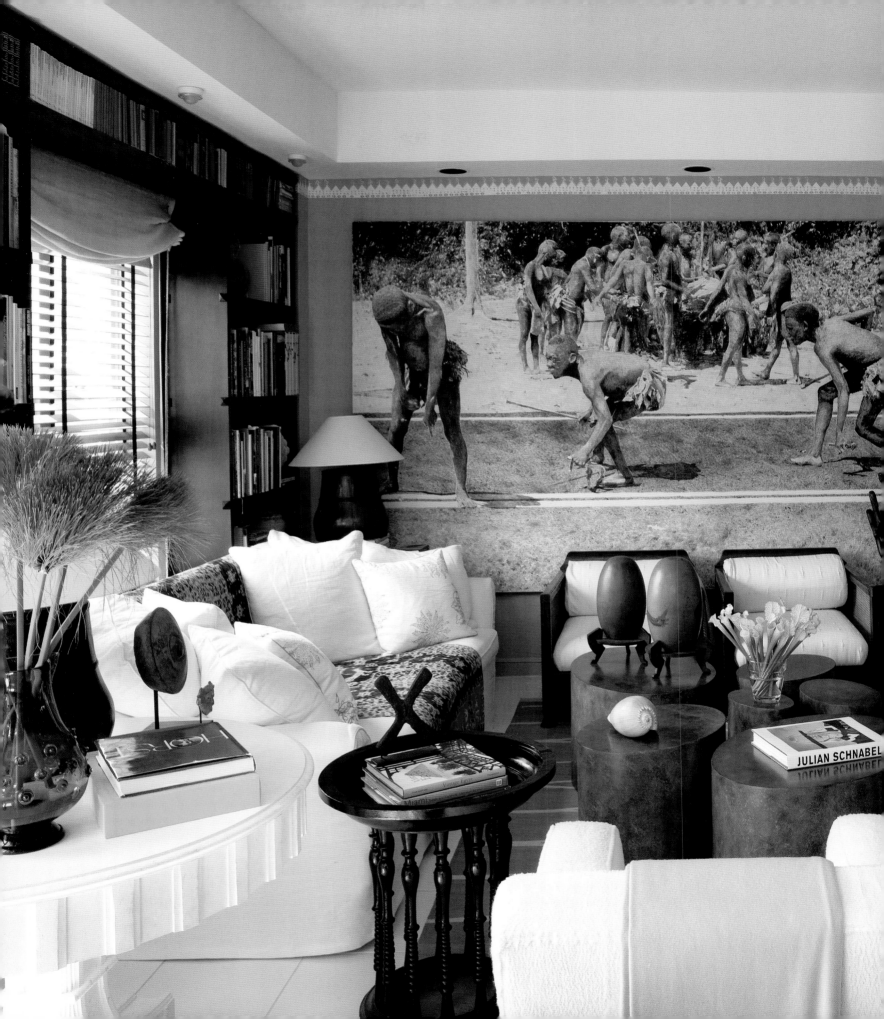

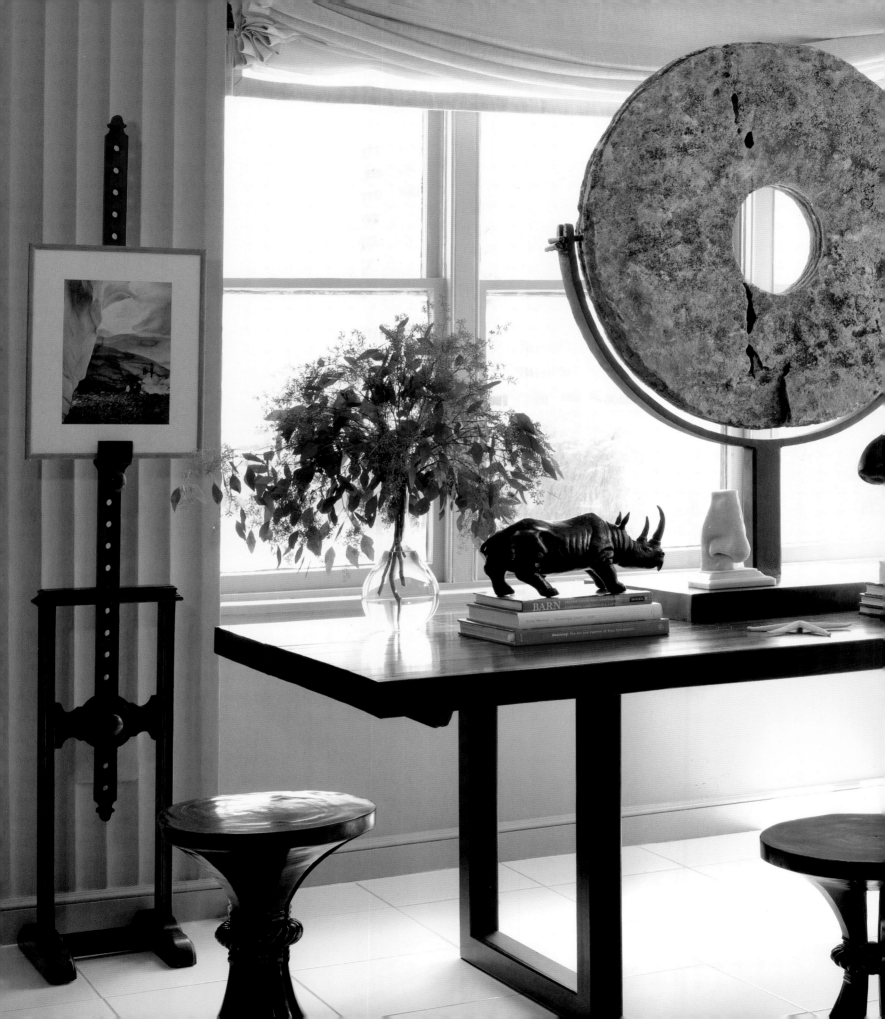

PAGE 63 In the living room, nineteenth-century cane chairs from Cambodia mix with a large oil painting from Hugo Bastidas (1999) and "egg" tables of Montoya's design.

LEFT The dining table is solid teak, made from an old floor from an Indonesian bowling alley. The Nias tribal stools are also from Indonesia and carved from solid teak.

BELOW In the entrance alcove, a 1930s concrete garden urn stands in front of Montoya's 1975 painting *Volume in Space II*.

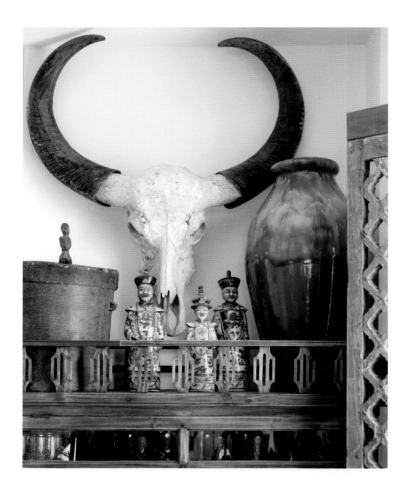

LEFT In the kitchen, an antique Indonesian pharmacy cabinet displays delicate Mandarin figurines, a cylinder box from the Philippines, and a tall Japanese vase.

RIGHT Montoya broke up the living room and kitchen with ebonized lattice panels.

PAGES 68–69 In the bedroom, neutrals set off Montoya's collection of artwork and an early Deco chair in rosewood with ivory inlays.

1930s Esther Williams had occupied the top floor.) Montoya combined two studio apartments and decorated very colorfully—very Miami. "But I soon tired of it," he says. After he met Urban in 2000, they decided to redo the flat to "make it their own." What they wanted was something more subdued, "a neutral zone" to retreat to and recharge.

Over the course of nearly a year, they combined African artwork, rustic materials, and Asian artifacts to create what might be called a sophisticated primitivism. The home looks and feels lived in—but it in no way looks disheveled. You couldn't possibly achieve this level of authenticity, this sense of beauty, overnight.

"Start with a blank canvas," says Montoya. "Then add one thing, then another, then another. Don't rush it—a space has to unfold over time."

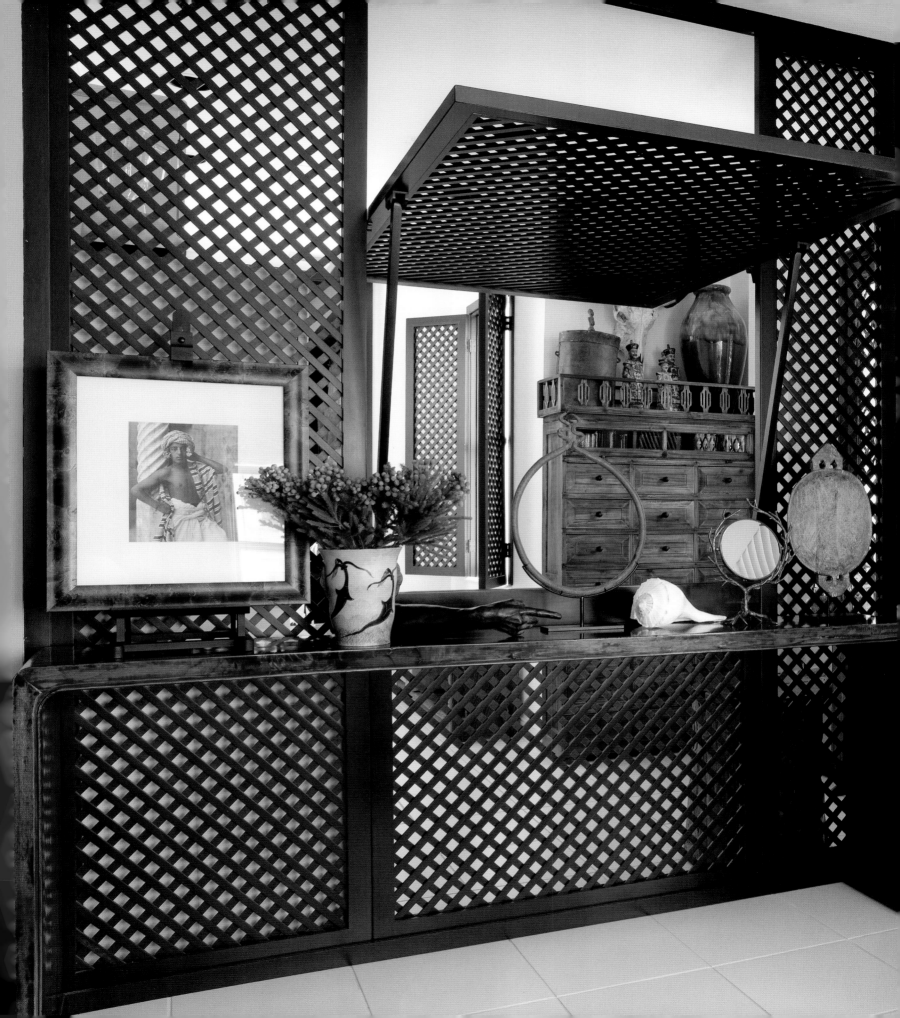

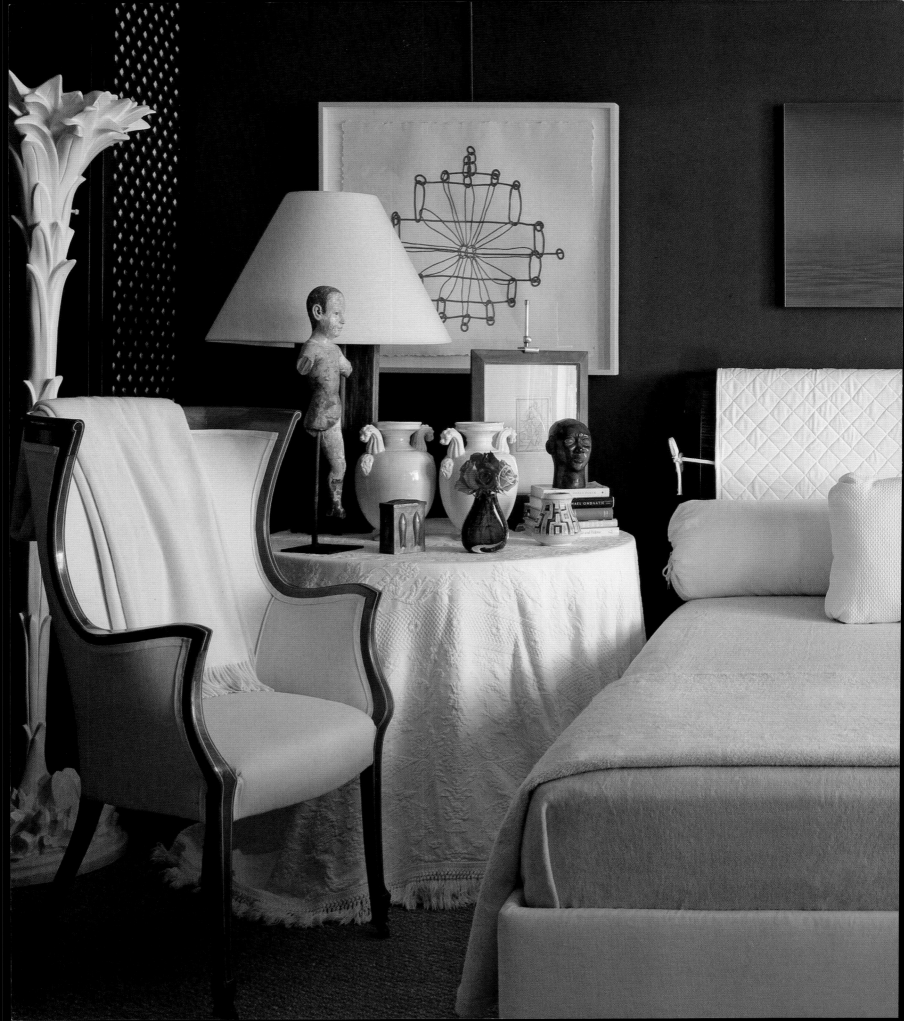

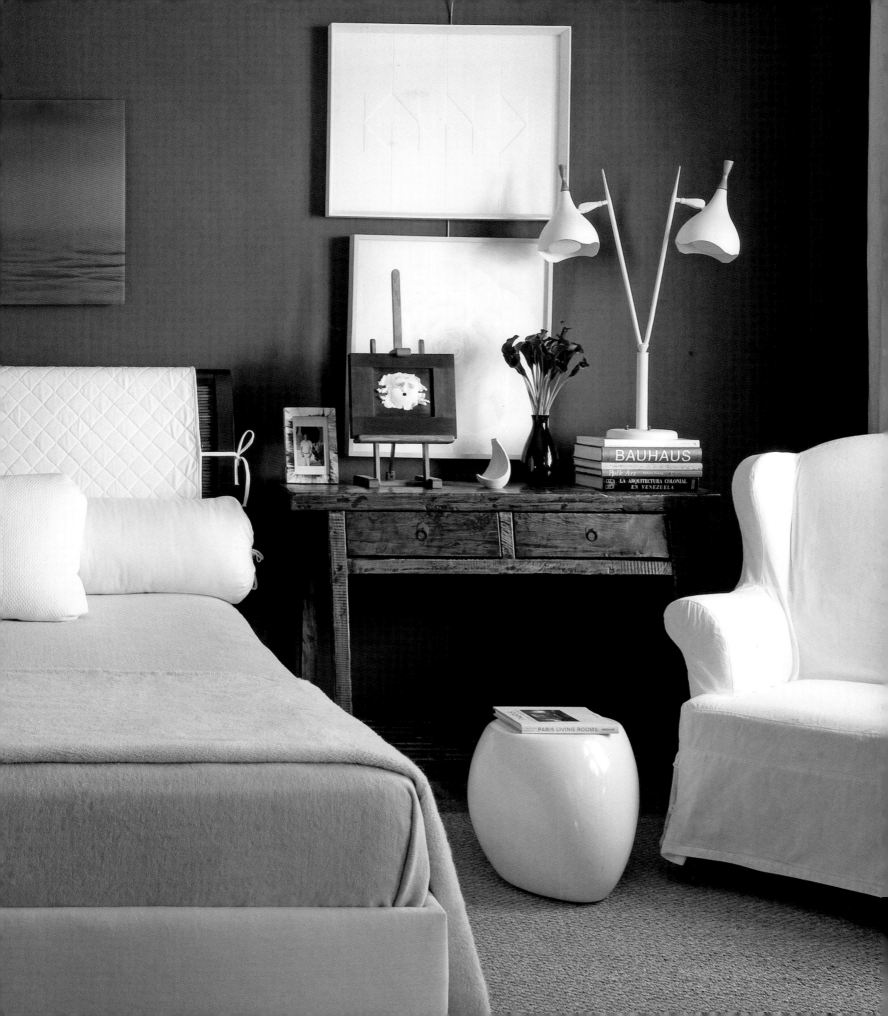

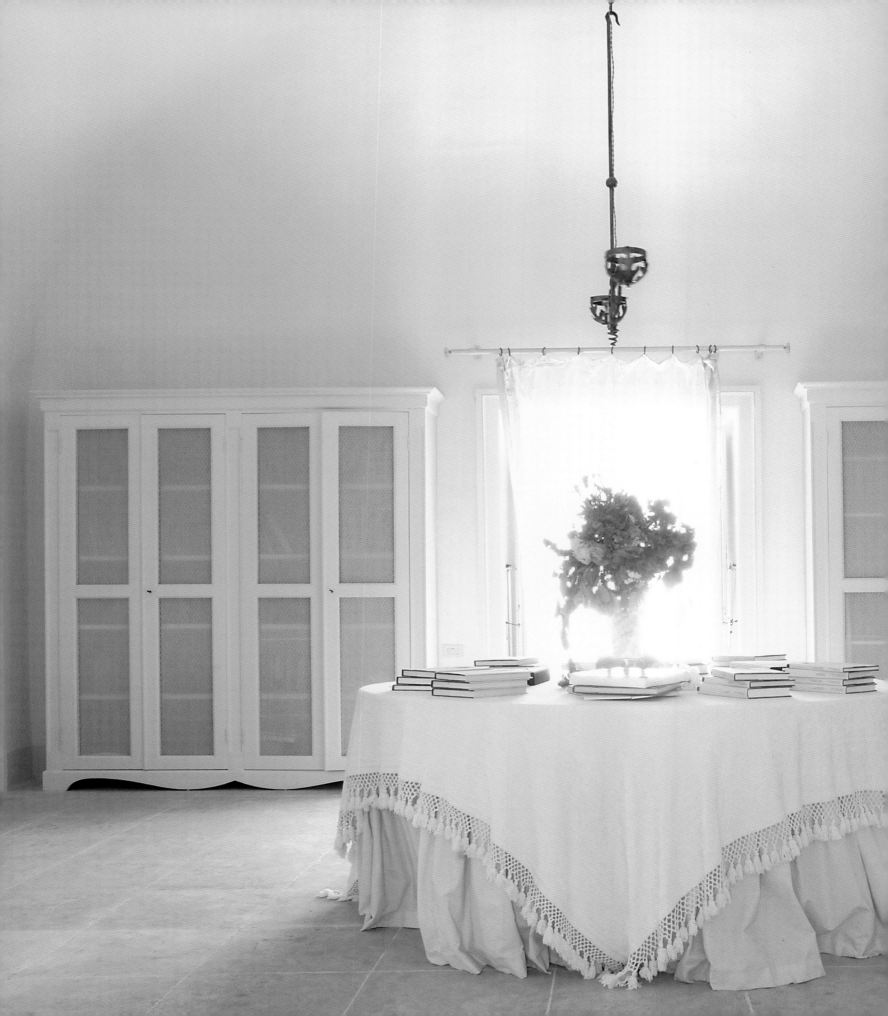

TWO

SIMPLICITY

If you want to create the simple,
master complexity.

—TAOIST SAYING

So much interior design—across the style spectrum—is packed to the hilt. It often looks as if someone asked: How many pieces of furniture can be squished into this room? How much foam can be stuffed into this chair? How many contrasting colors and patterns can we get away with? More is more!

But if you're trying to create a restorative home, more is not more. For all of its complexity, richness, and depth, nature is well edited, restrained. Indeed, evolution necessitates simplicity; gratuitous fussiness is counterproductive. While we have been taught to think that over-design and glitz (a) are beautiful, and (b) will make us look glamorous, the truth is that simplicity is at the root of elegance and elegance is the foundation for deep beauty. Moreover, too much busyness—whether in the form of traditional patterns or bohemian eclecticism—can feel as chaotic as it looks.

At the same time, a minimalist aesthetic doesn't have to feel austere, sterile, and, most especially, soulless. The goal is to create a serene, layered, sensual simplicity—mirroring the simplicity of the natural world.

The elegance of simplicity transcends culture; it makes antiques look modern and modern pieces timeless. Simple pieces mix well together. And a limited

number of pieces deepens the relationships—both among pieces and between you and your home.

The first thing we need to feel comfortable with is the concept of "negative space," what Axel Vervoordt more poetically calls "the fullness of emptiness." We've been taught to feel nervous around too much emptiness, but the truth is that our brains actually prefer it that way. The natural settings that we find most relaxing are those that resemble a savannah: low, open grassland, quiet water, scattered trees. These settings make us feel calm and comfortable today because a healthy savannah-type landscape represented safety and security for our hunter-gatherer ancestors.

Negative space also allows plenty of room for natural light to play a starring role. Much of nature needs sunlight to survive, let alone thrive. We often forget this.

It's not a coincidence that meditation is based on the concept of negative mental space: gently removing all thoughts to create a mental stillness, a calmness. We can create the same atmosphere in our homes.

PAGE 70 A very simple library in Luisa Beccaria's home.

REDUCTION

Homes that mix periods and cultures can end up feeling visually noisy. The thinking is: well, we have so many beautiful things (from our travels or our shopping expeditions), let's show them all! But pieces of timeless beauty need room to breathe.

In some respects, it's harder to edit a home than an outfit: you can always justify putting away that extra bangle/scarf/jacket by reminding yourself that you can wear it tomorrow. But the same thinking should apply to your home: if you have four beautiful sets of candlesticks, rather than put them all out at once, take one out for each season.

"Reduction has always been an aspiration," says artist Michele Oka Doner. "I admire the art of the perfumer. First, he gathers a bouquet of fragrant flowers. Then the mix, the curation, takes place. Finally, the bouquet is reduced to a few drops."

Oka Doner, who is from Miami but lives most of the year in Manhattan, bought her Miami apartment with the sole intent of achieving a sense of serenity, "a place where I could retreat from the sounds and pace of the wonderfully active world I inhabit in New York."

By leaving the walls unadorned and the furnishings minimal, Oka Doner put the emphasis on the ocean, which is framed by a band of windows that wraps around the building. A 60-foot banquette was built so that family and friends can lounge and enjoy a view of the water.

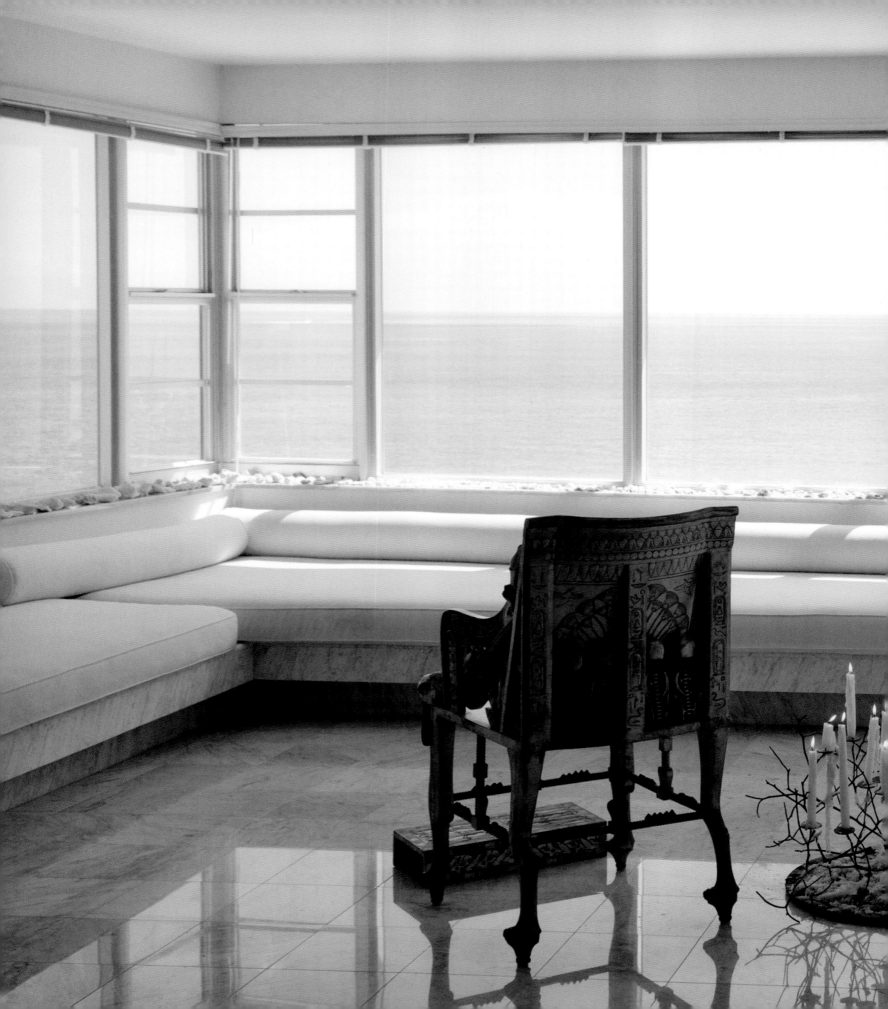

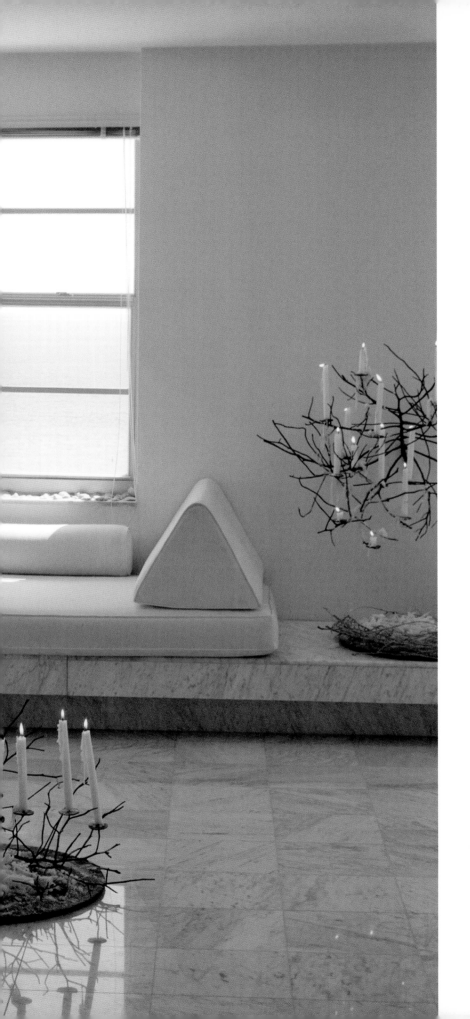

PAGE 74 The dressing table chair has a cast bronze "cosmos" seat and palm frond back.

LEFT In the living room, a 60-foot canvas banquette was created to allow guests to enjoy the birds and beach outside the window. A Roman Revival chair from St. Petersburg sits next to Oka Doner's *Burning Bush*.

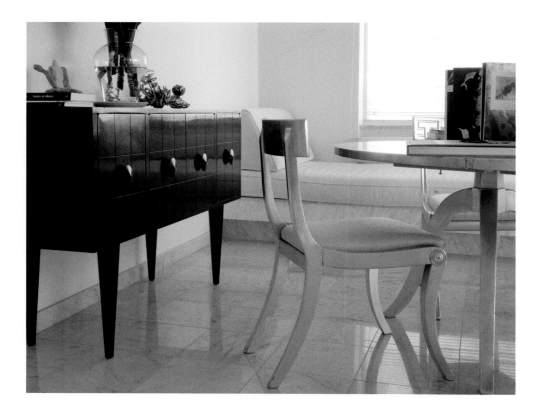

"I feel like I am in a beach house," says Oka Doner. "As the view is of the horizon, a sense of infinity permeates the experience. Finding a place to dwell that witnesses the sunrise, moonrise, and endless movement of the waves guarantees a sense of transcendence. And the lack of any floor covering allows us to sweep the sand out, and even to hear the sand underfoot!"

ABOVE A buffet circa 1951, which Oka Doner inherited from her childhood home, next to a white gold–leaf table and chairs.

RIGHT The artist designed the dining table with the same Italian marble as the floor and dressing-table top to keep visual stimulation at a minimum. The chairs are black lacquer from the artist's childhood home. A silver platter holds tropical fruits and seeds.

PAGE 80 Oka Doner's white gold–leaf table and chairs. The mahogany cart on wheels was bought by her parents in Haiti, in the early 1940s, for their first home.

PAGE 81 Shell and coral fragments laid out on a display shelf at the entrance of the apartment, with two exotic wood-framed vintage photographs of old Miami Beach.

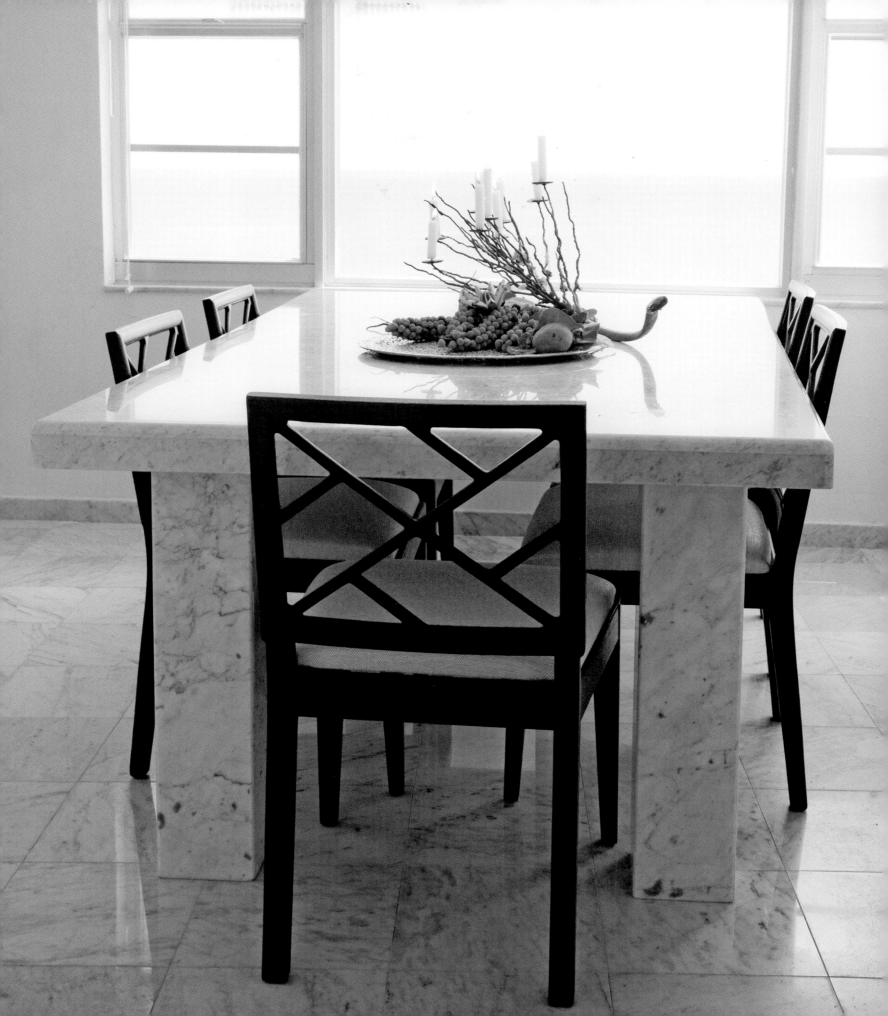

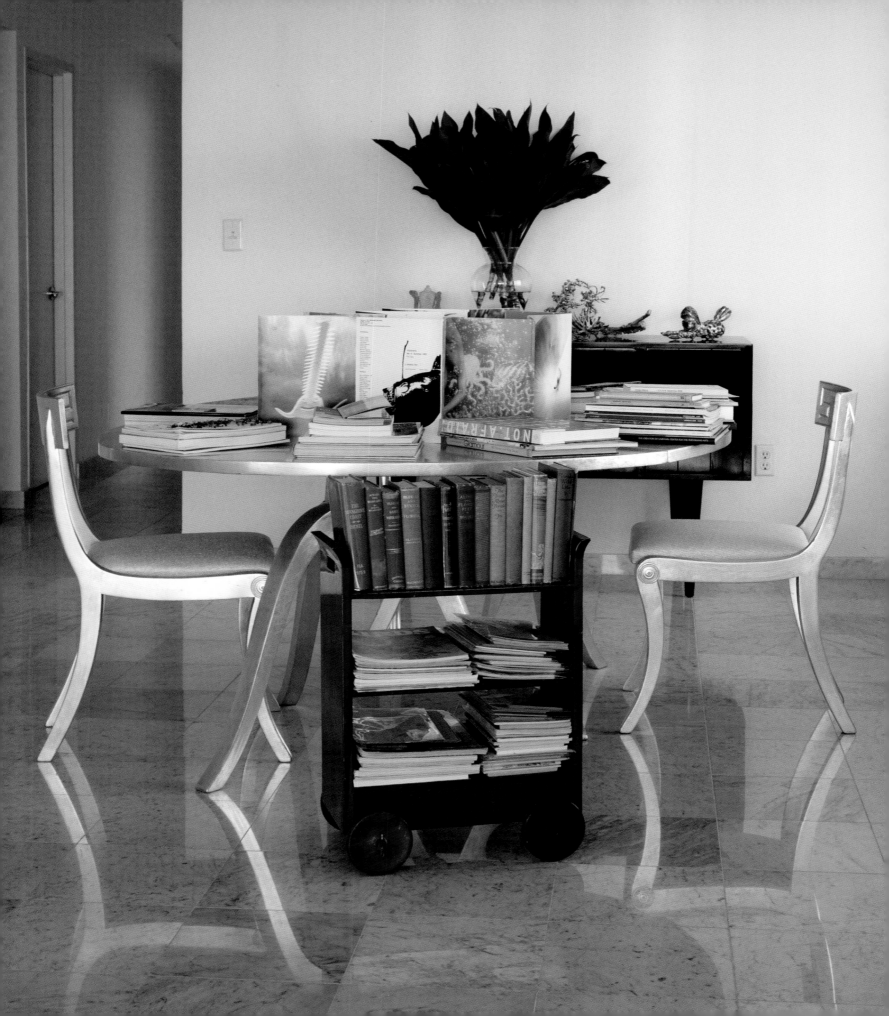

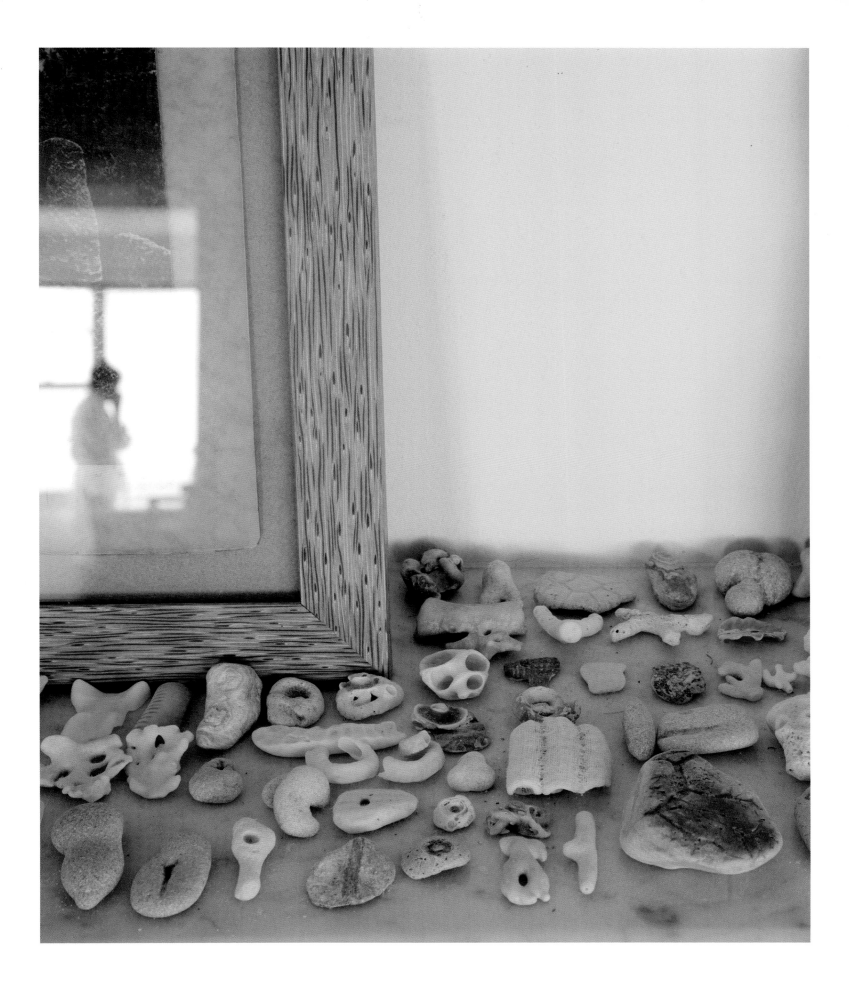

RESTRAINT

If simplicity dictates "less is more" in the number of pieces, it also dictates restraint within each piece—using patterns or ornament sparingly. Unfortunately, across the style spectrum, overdesign has been the rule: too much going on simultaneously, with every element vying for our attention.

Patterns can in fact be very calming—think of the patterns of waves or in geometric mosaics. The key is to use pattern or ornament wisely, not gratuitously. One way to think about it: use pattern and intricate ornament only on smaller pieces and accessories—as accents—keeping your larger pieces (walls, sofas, curtains, bedspreads) solid or quasi-solid. You will also be less apt to tire of a pattern that's used judiciously.

Fashion designer Luisa Beccaria understands this concept intuitively. Her fashion designs are known for their strict tailoring, accented with exuberant flourishes of color, pattern, or fabric. Season after season, Beccaria creates a romantic simplicity that's both distinctive and timeless.

The interior design equivalent of Beccaria's fashion philosophy can be found in her eighteenth-century castle, Borgo del Castelluccio, which she shares with her husband, Lucio Bonaccorsi, a Sicilian prince, and their five children. Sitting high on a Sicilian hilltop, Castelluccio had been in her husband's family for centuries (the ground floor was once a granary) when she decided to restore it in 1992 and turn it into a summer home.

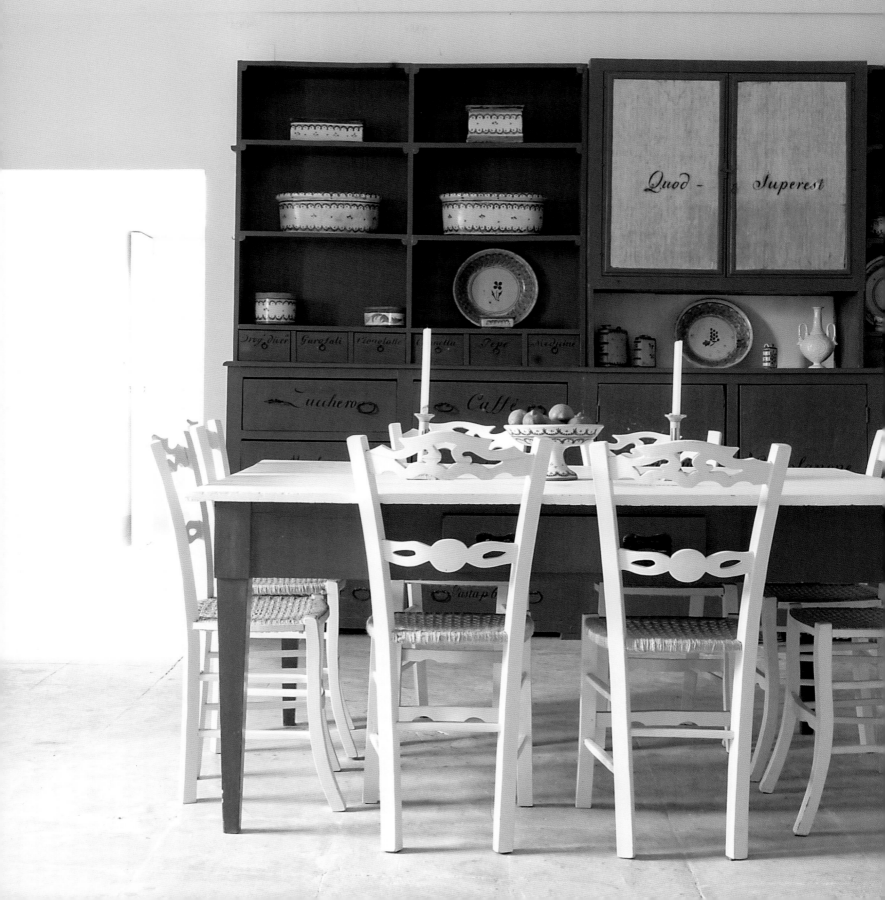

PAGE 83 The pantry features furniture with inscriptions by Lucio's grandmother.

RIGHT Beccaria's private sitting room upstairs, with *capitone* sofas in beige linen and eighteenth-century furnishings in gold and white.

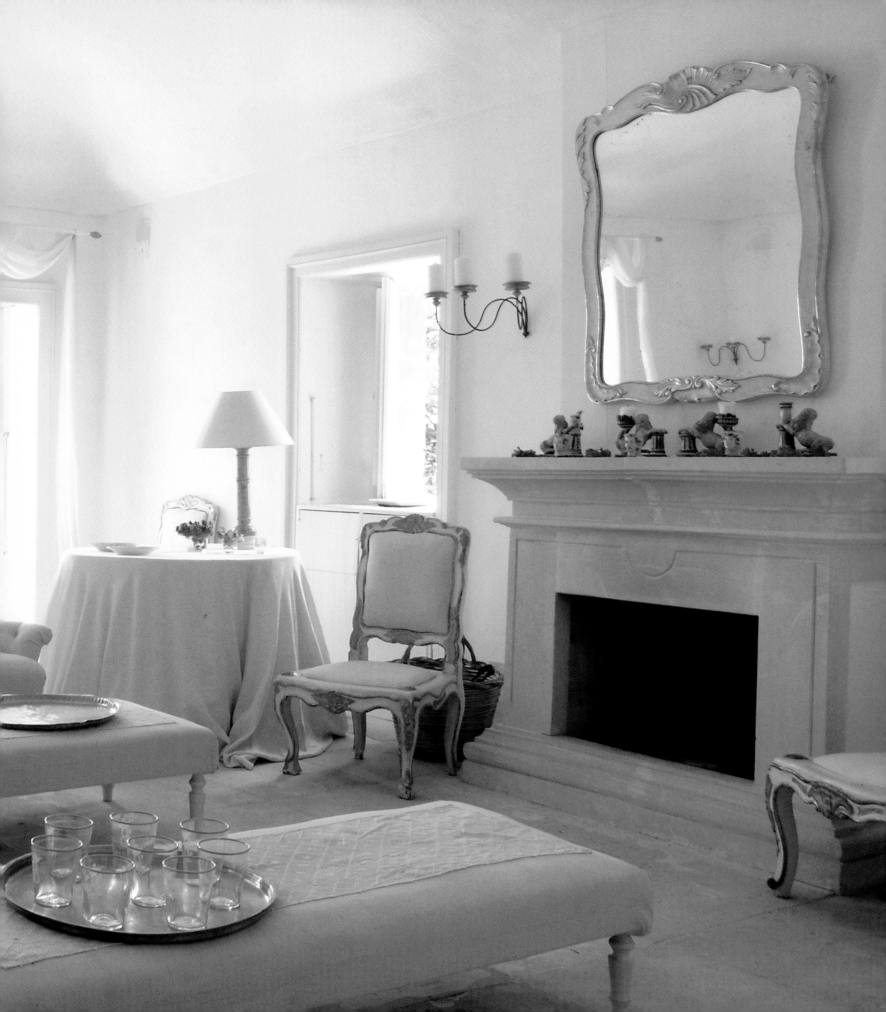

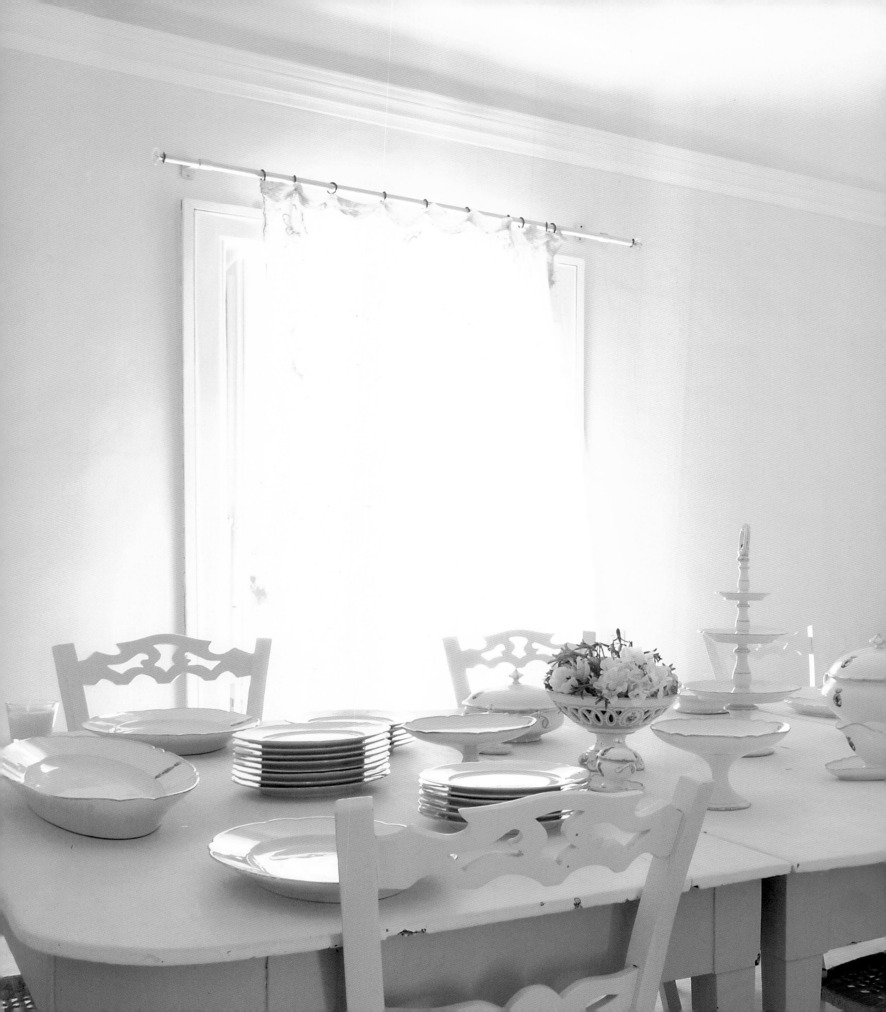

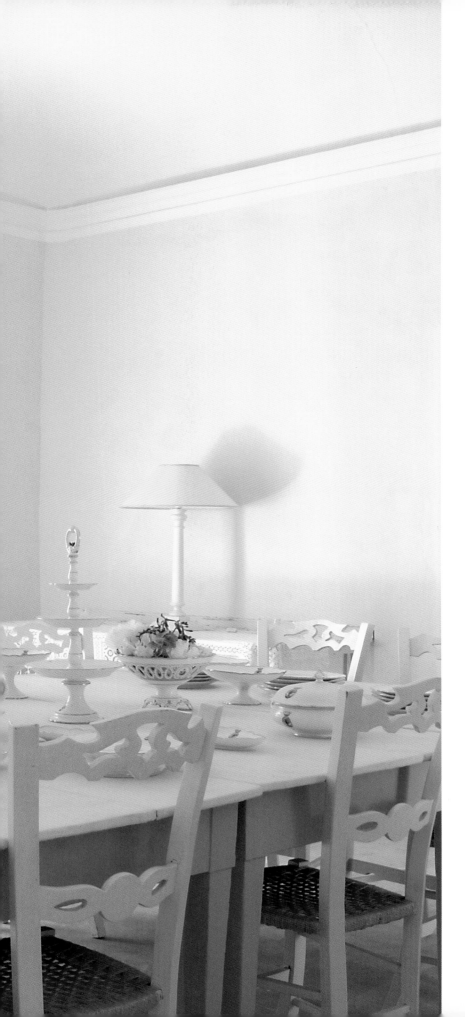

LEFT The upstairs dining room has a large wooden table painted white and soft blue.

BELOW A detail of a table with a Caltagirone round vase.

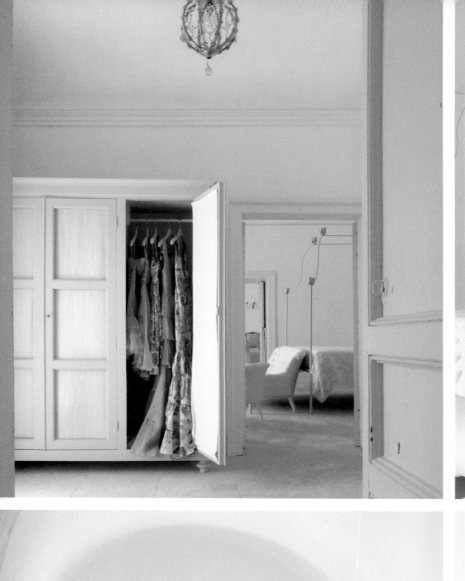
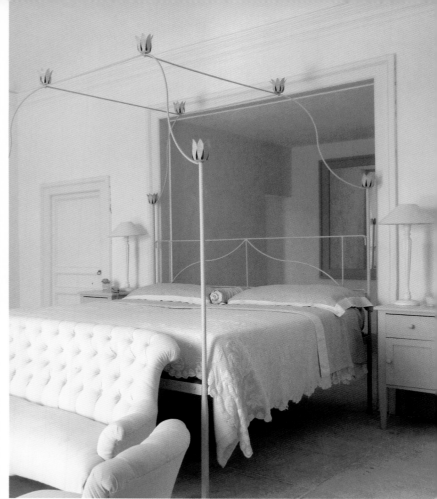
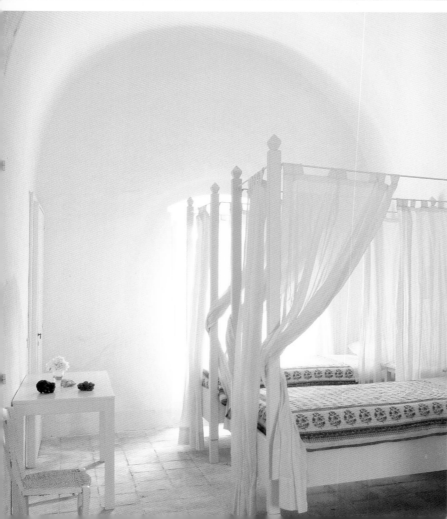

Beccaria's biggest concern was to not interfere with the natural beauty of the building, the exquisite light, and the glorious surroundings—mountains in the back, seaside in the front, and olive, almond, and lemon trees all around. "I wanted to make this feel like an airy, dreamy place, almost like it floats up here, high in the hills, instead of doing something more formal or pretentious," says Beccaria.

She accomplished this by selecting only a few furnishings, all with strong lines and minimal adornment, and then adding romantic touches: antique lace curtains and bedspreads, an over-size gilt-edged mirror, hand-painted tiles and ceramics.

Everything is set in a stage of tranquil washes of color—shell-blue, dove-gray, jasmine, lavender—reflecting the gardens and beyond. "I like using colors that reproduce nature," she says. "There are so many shades for inspiration—the flowers, the sky, the stone." The fourteen-bedroom castle has no paintings—the windows frame landscapes that no painter could capture. "The light changes throughout the day," says Beccaria. "With the sunlight, the colors become white. When the light goes, colors appear."

ABOVE, LEFT AND BELOW, RIGHT Beccaria's closet.

ABOVE, RIGHT The master bedroom with an iron *baldacchino* bed and antique sheets.

BELOW, LEFT The bedroom of her son, Ludovico, in the courtyard.

PAGES 90–91 A medley of Beccaria's bathrooms.

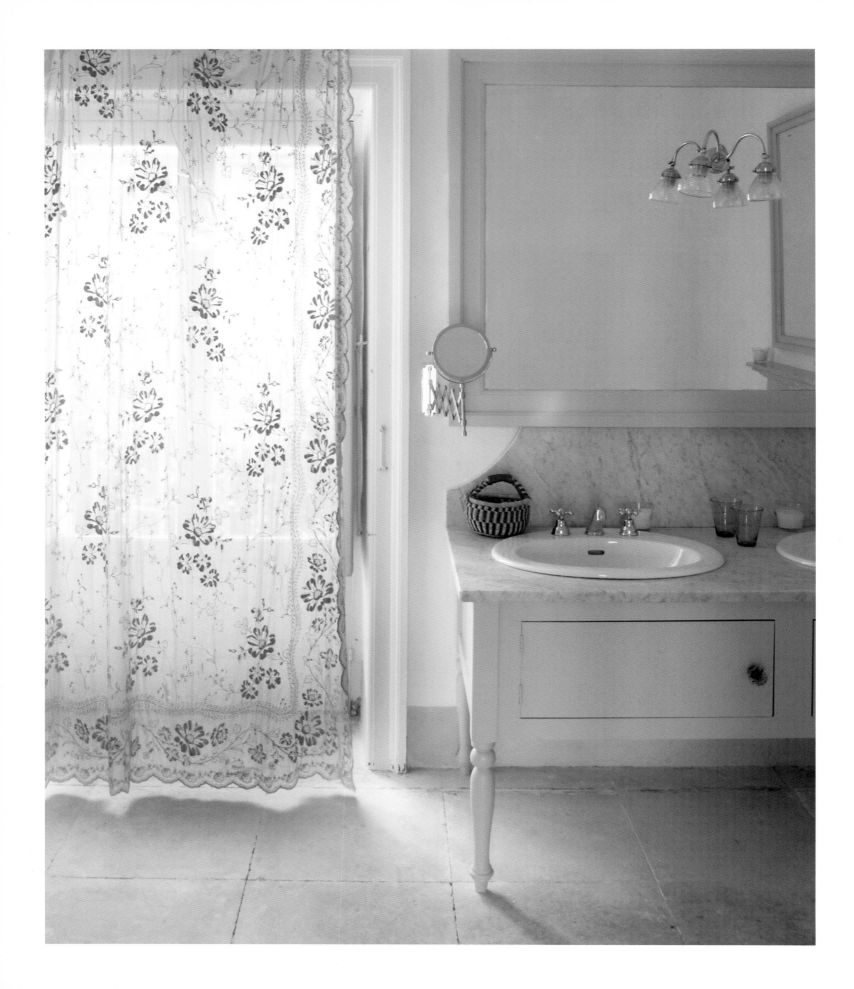

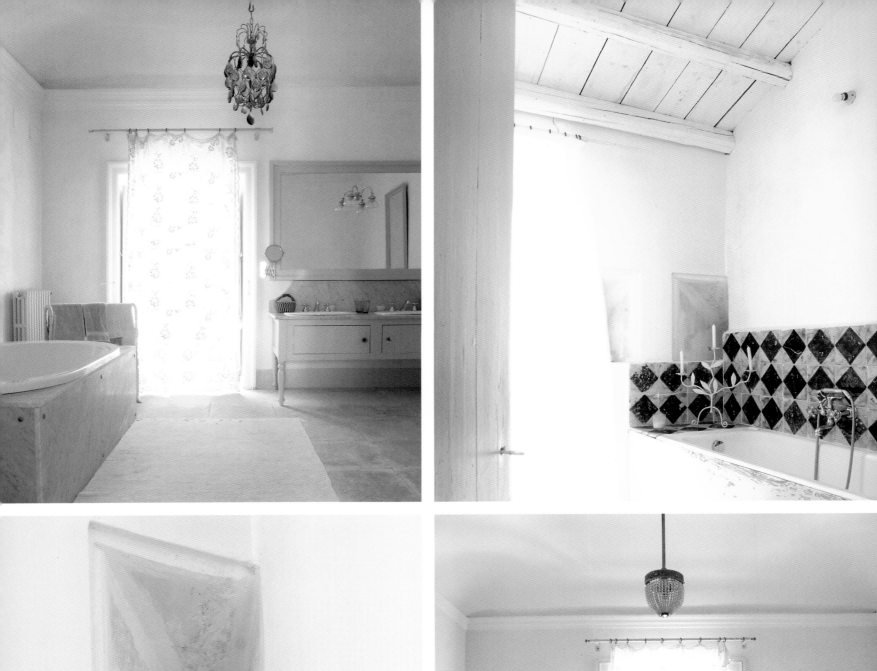

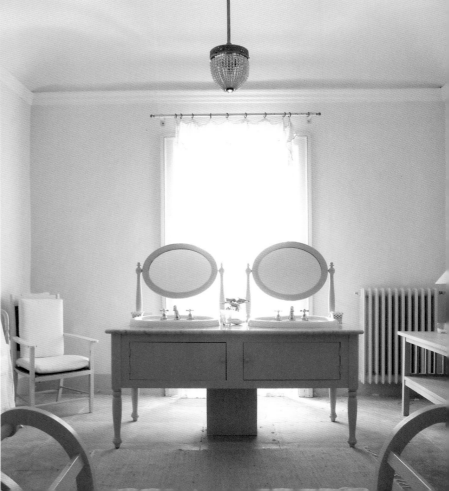

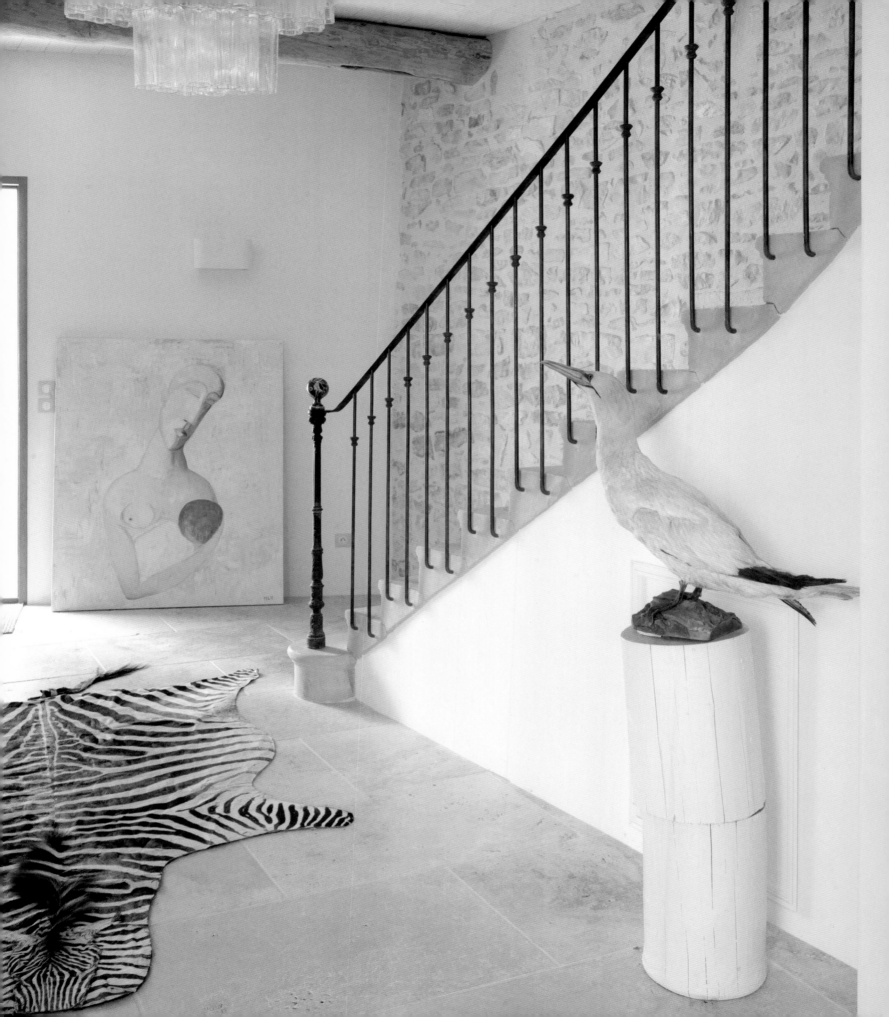

TIGHT PALETTE

One of the easiest ways to achieve simplicity is through a tight palette—a disciplined use of color. A tight palette is inherently calming; it's especially useful if you're going to mix styles, eras, and textures. It also helps to create a sense of continuity throughout a home.

After spending fourteen years in New York City, French interior designer Marie-Laure Helmkampf and her American husband decided to find a new home that would provide a more harmonious environment for the raising of their two young children. Just outside of Nîmes in the South of France, in the village where Helmkampf grew up, they happened upon an early nineteenth-century olive oil mill. Though the building was in poor condition, they immediately fell in love with its "character" and began the eighteen-month process of turning it into a home.

Everything was rebuilt by reusing the original materials—oak flooring, exposed stone, natural concrete, raw metal—as much as possible. "We tried to purify the space by retaining the rough aspects of the mill and by including contemporary as well as vintage furniture to create an offbeat spirit," she says.

The new loft-like house now features an 850-square-foot living room–kitchen, with a 26-foot ceiling. Helmkampf created huge windows in most of the rooms, including a number of skylight windows, to invite in the natural light. She mixed vintage and contemporary pieces, and then assiduously used only warm colors, such as cream, brown, and taupe, throughout. "If you want a simple, serene interior you have to remain monochrome in a warm palette so that your eye doesn't get caught in the differences of color."

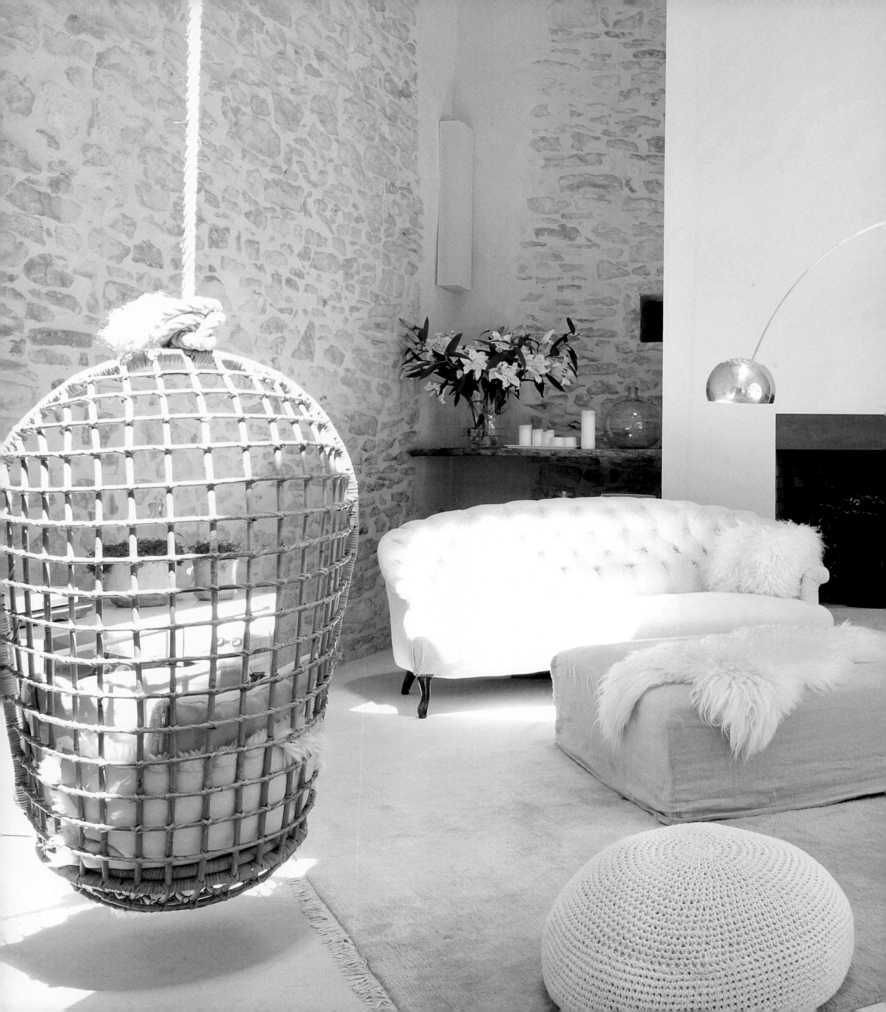

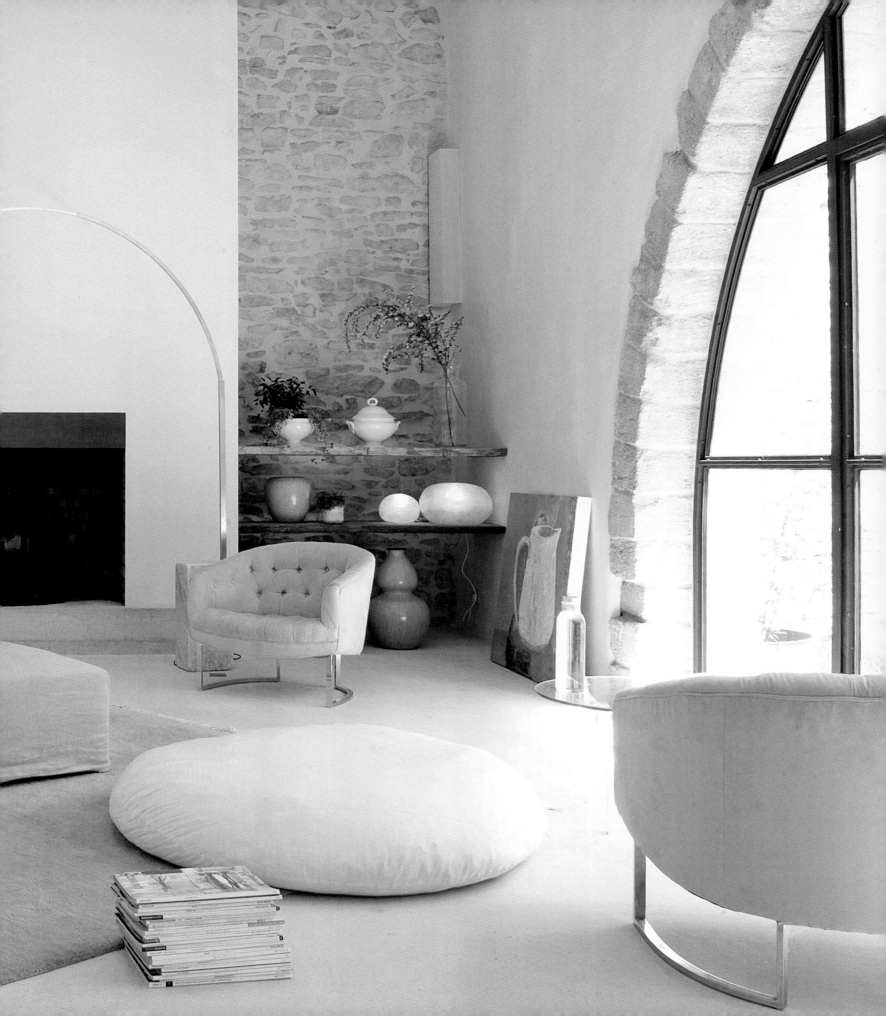

Helmkampf adds that a warm palette and texture is especially important in large rooms with high ceilings. "To keep them warm and inviting you can't use pure white or very flat uniform materials, such as contemporary glossy chrome furniture," she says. "The rooms in our home are large, yet we feel as though we are in a cocoon—a cream one."

PAGE 92 The delicate railing, designed by Helmkampf, recalls zebra-skin stripes; the chandelier is early twentieth-century Italian and the painting is by Helmkampf.

PAGES 94-95 The 26-foot-high living room features a Napoleon III sofa upholstered in antique linen, poufs of various shapes and textures, and an extraordinary arched window.

RIGHT Under a mother-of-pearl chandelier, an Eero Saarinen tulip table with an Italian Arabescato marble top takes center stage in the office–dining room; the salvaged leather-and-wood bench was found in a bar.

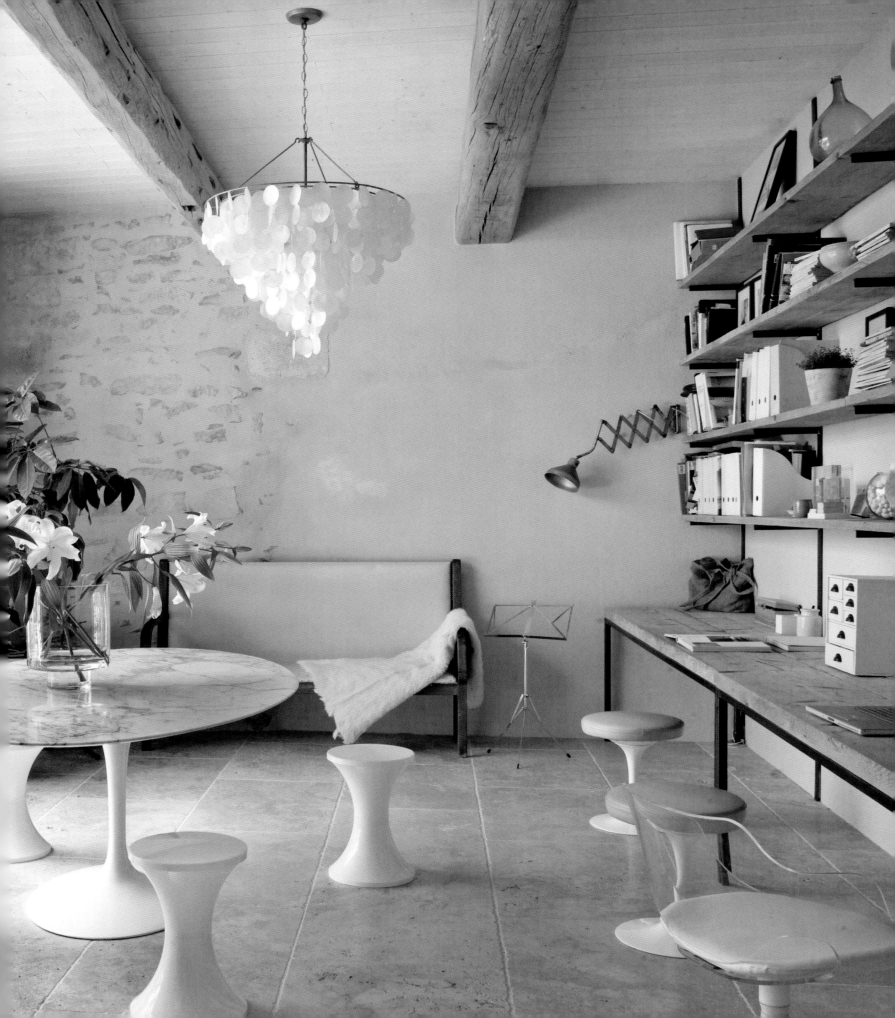

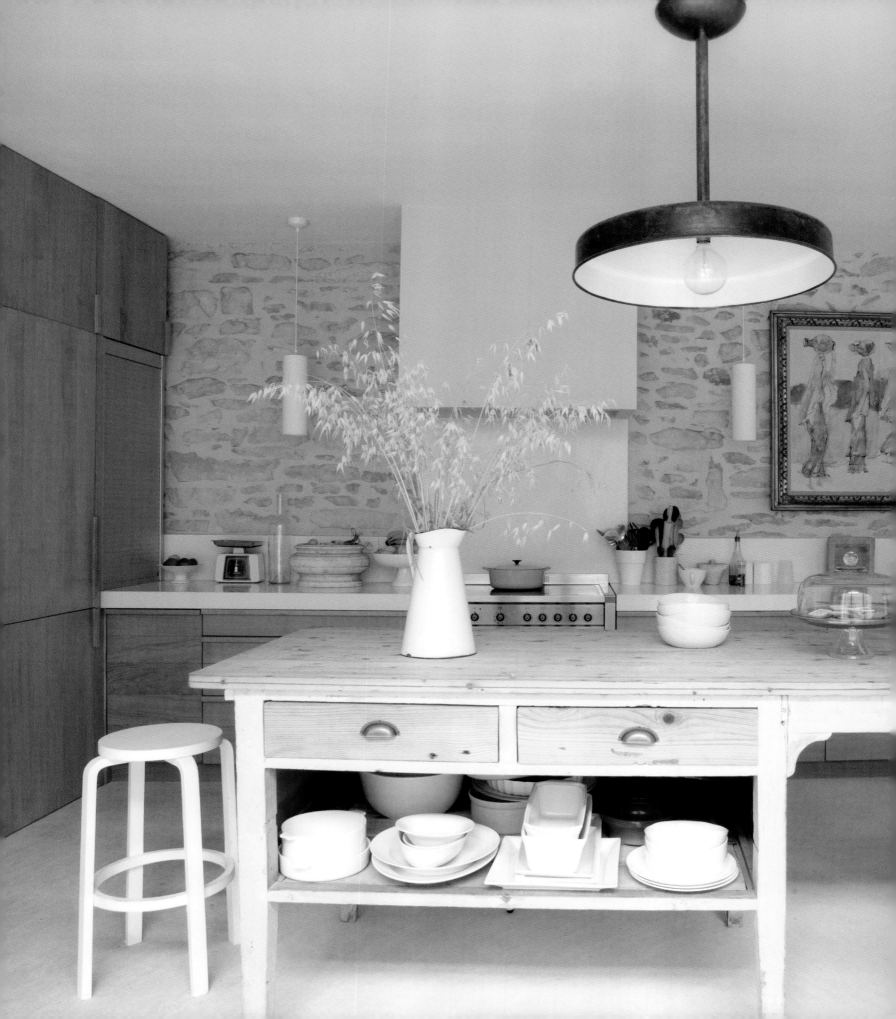

LEFT In the kitchen, an old pine workshop table serves as the central counter, joined by Navy chairs from Emeco and white flea-market stools.

BELOW A flea-market painting blends well with the exposed stone.

PAGE 100 The metal-framed doors of the kitchen open onto a terrace, allowing for easy alfresco entertaining.

PAGE 101 In the master bedroom, black and dark-gray accents are both seductive and calming. Antique doors lead to the bathroom.

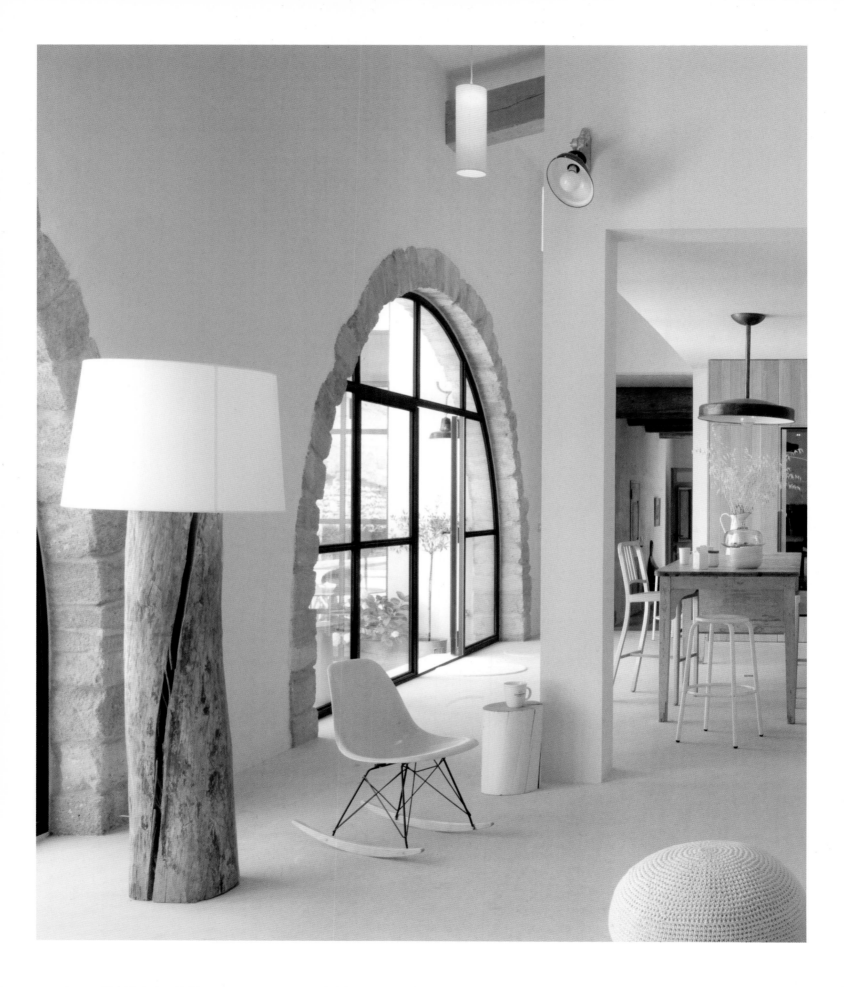

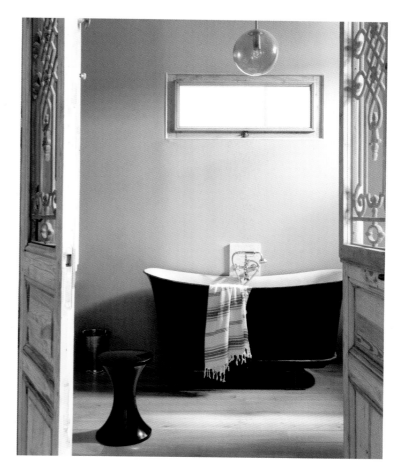

LEFT The stone wall of the master bedroom provides a sensual counterpoint to an Ikea black bedstand and a chrome lamp.

ABOVE, LEFT The three brushes are for whitewashing the walls. A white ball "garland" sits next to a Helxine plant in a terra-cotta pot.

ABOVE, RIGHT In the master bath, an antique tub and oak parquet floors.

* * *

Using a similarly tight palette, interior designer Alison Palevsky of SPI Design created a white stucco cocoon for family and friends in Cabo San Lucas. When she bought the labyrinth-style house as a vacation home in 2004, Palevsky and her SPI partner, Sarah Shetter, had two primary objectives: to create a seamless connection between the interior and the spectacular ocean views, and to create "a sense of serenity and peace."

Palevsky and Shetter began by reconfiguring the layout so that nearly every room would have a view of the sapphire sea. To enhance the blue tones of the water, they kept Casa Tortuga—called such because one of its naturally occurring rock formations looks like the head and body of a tortoise—to a cool neutral palette consisting of adobe white, sandstone beige, and deep espresso brown.

Although the furnishings are an eclectic mix of styles, from African to mid-century Modern, "the furniture all works together because there is a commonality in either materials or color," says Palevsky. Color was added through the accessories—in the patterned pillows, throws, and art.

To add interest and a bit of drama without undermining the home's serene aesthetic, Palevsky and Shetter employed a common Latin American design trope: contrasting dark and light tones. In the bathrooms, kitchen, and bedrooms, for instance, light stone is repeatedly used with dark espresso cabinetry. "You can get the same look by pairing dark wood furniture with light upholstery fabrics," says Palevsky.

The designers also used the same wood tones, stones, hardware, draperies, bedsheets, and pillows throughout the entire space. "In doing this, you will add a strong sense of continuity and flow," Shetter says, "which is very important to the sense of tranquility."

"Spending time in this house is cathartic," says Palevsky. "Every time we leave Casa Tortuga we feel rejuvenated and focused."

PAGE 105 A wide staircase leading to the master suite is punctuated by agave and cacti plants.

PAGES 106–107 In the circular living room, an African drum stool and a pair of vintage African ottomans add warmth to the built-in banquette and Warren Platner brass-and-glass coffee table.

RIGHT SPI designed the dining table, chairs, and chandelier to create a relaxed formality overlooking the ocean.

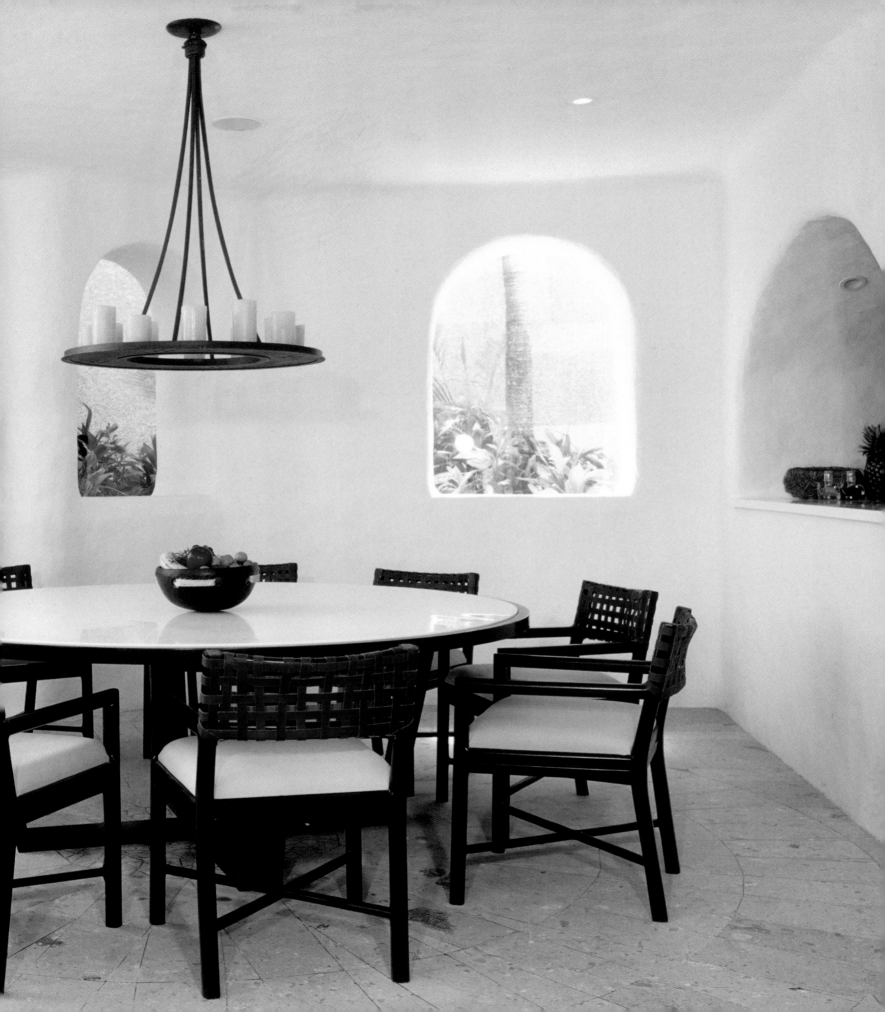

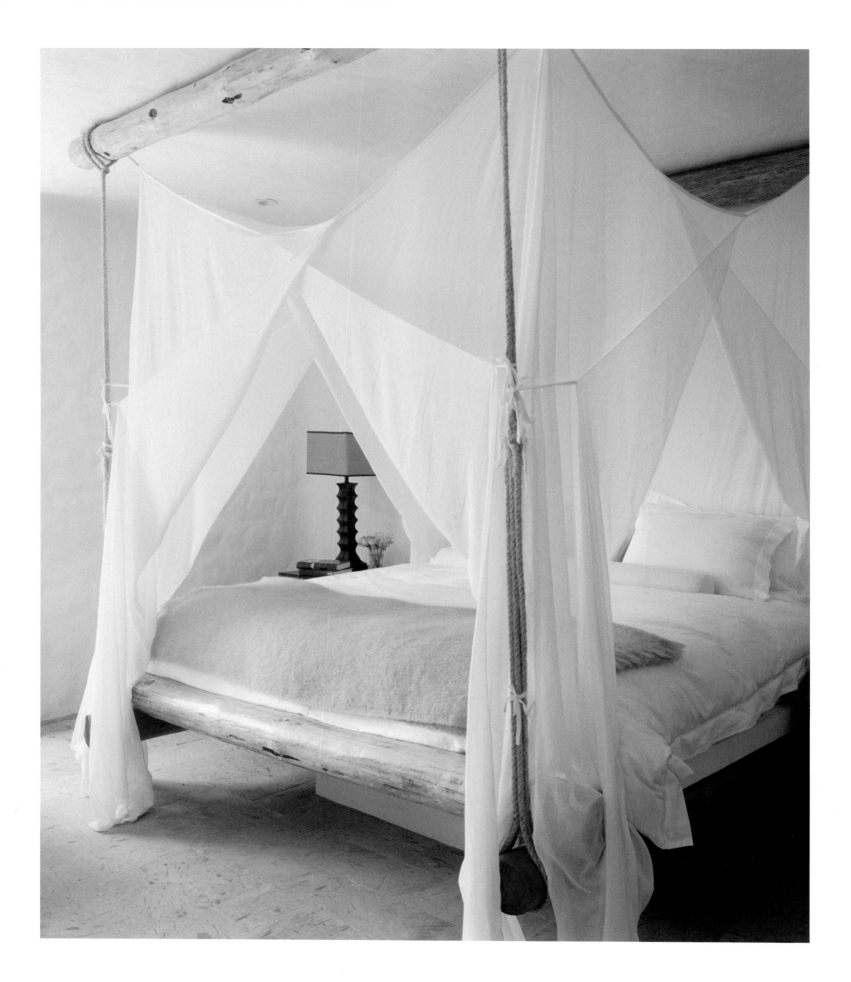

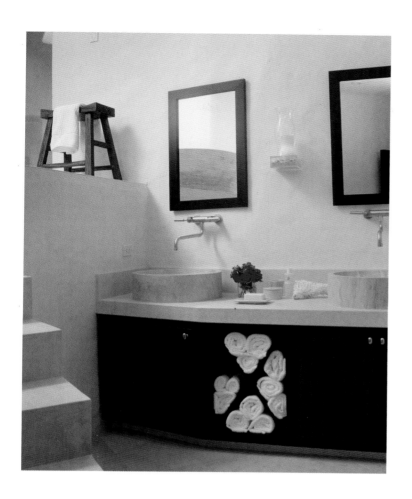

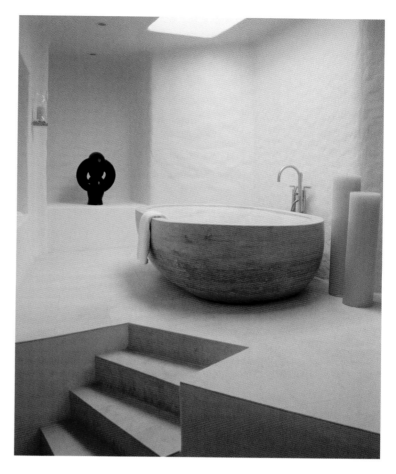

LEFT For one of the guest rooms, SPI designed a floating bed made of local wood with billowing mosquito netting. The African lamp with a linen shade is vintage.

ABOVE, LEFT In the master bath, mahogany cabinets and travertine sinks, designed by SPI, are accented by a small wooden milking stool.

ABOVE, RIGHT A travertine tub designed by SPI is the focal point of the master bath, accompanied by a Mexican wooden sculpture and a set of large candles.

S T I L L N E S S

Ultimately, you want to create a home so exquisitely simple—so sublimely still—that it replicates the extraordinary peace and quietude of nature.

"My house whispers to me; it never shouts," says South African artist/stylist Leoni Smit.

In 2002, Smit and the architect Martin Kruger designed a Moorish-style "mud house" outside of Capetown. Inspired by the landscapes of Morocco, Namibia, India, and Mexico, the house features dusty rose adobe walls, soaring ceilings and archways, and a grand staircase. Parts of the house are so achingly ethereal, it's hard not to see it as a sacred space. "I think about space as having a meaning, a resonance—a soul," says Smit.

Although the architecture is Moorish, Smit has introduced French antiques and indigenous African and North African elements, along with Afrikaner artifacts that reflect her own heritage. The vintage furnishings, found objects, and unusual trinkets in each room capture Smit's moods and eccentricities. "A home should be infused with the essence of the person," says Smit. "To create a space that has substance is a thought process, an eternal process of storytelling, the goal being to achieve an indefinable style that has a very definite signature and stands on its own."

"When you have created this type of home, you just know it," says Smit. "It can change mood, direction, inspiration, energy, thought."

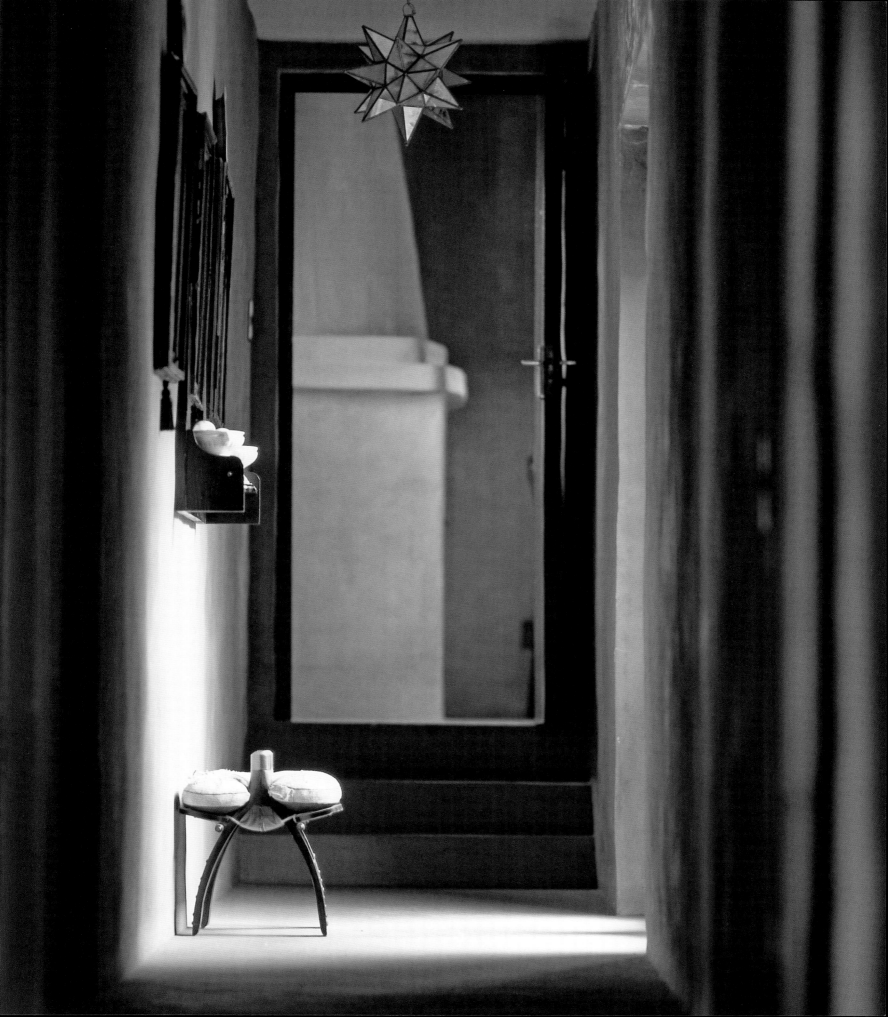

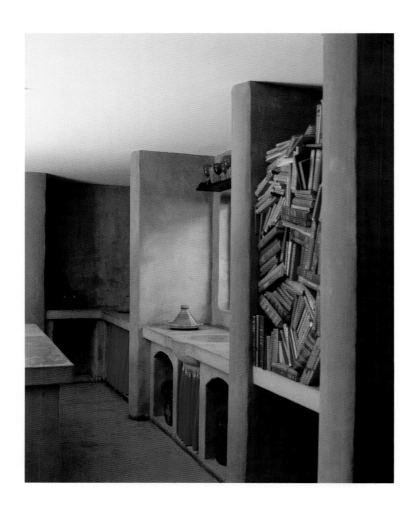

PAGE 113 The hallway, with an antique footstool and glass-and-metal lamps from Morocco, captures the mystery of the home.

LEFT Leoni's love of literature is expressed in her Moroccan kitchen with polished cement surfaces. A recessed niche is stacked with collectable classic hardbound books.

RIGHT A vintage sky-blue velvet armchair makes a striking statement set against a vivid red wall and turquoise-painted cement pavement.

PAGE 116 In the living room, white vinyl 1940s sofas face a Moroccan tin-tray table and align an assortment of artifacts.

PAGE 117 In the ethereal dining room are a white wooden table and chairs inherited from Christo's grandmother; the glass lamps hanging above the table are Indian.

While the end result may be a deep, exquisite simplicity, the process is never easy or straightforward. "Simple things are never simple," says Smit. "An athlete of note sprints effortlessly, but hours are spent in training."

Likening a house to a person, Smit believes a house must retain some mystery. "An intriguing person has a different angle on nearly everything—an intriguing dwelling embraces the same spirit. You need to get to know a person; you need to discover a space."

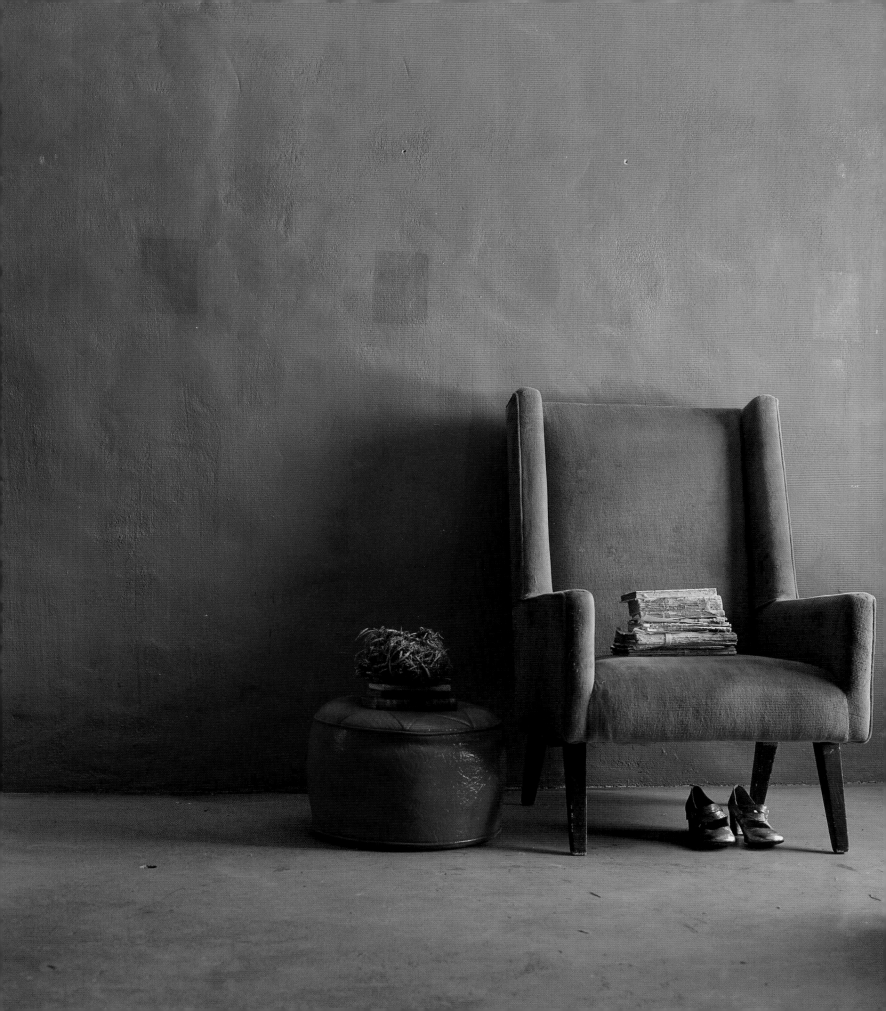

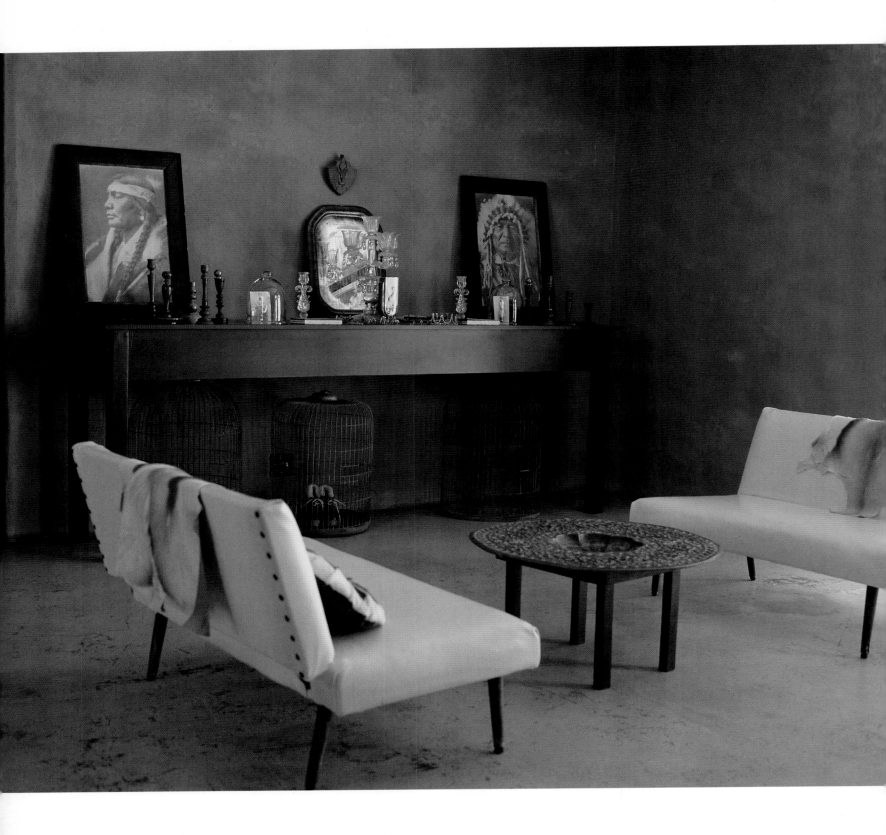

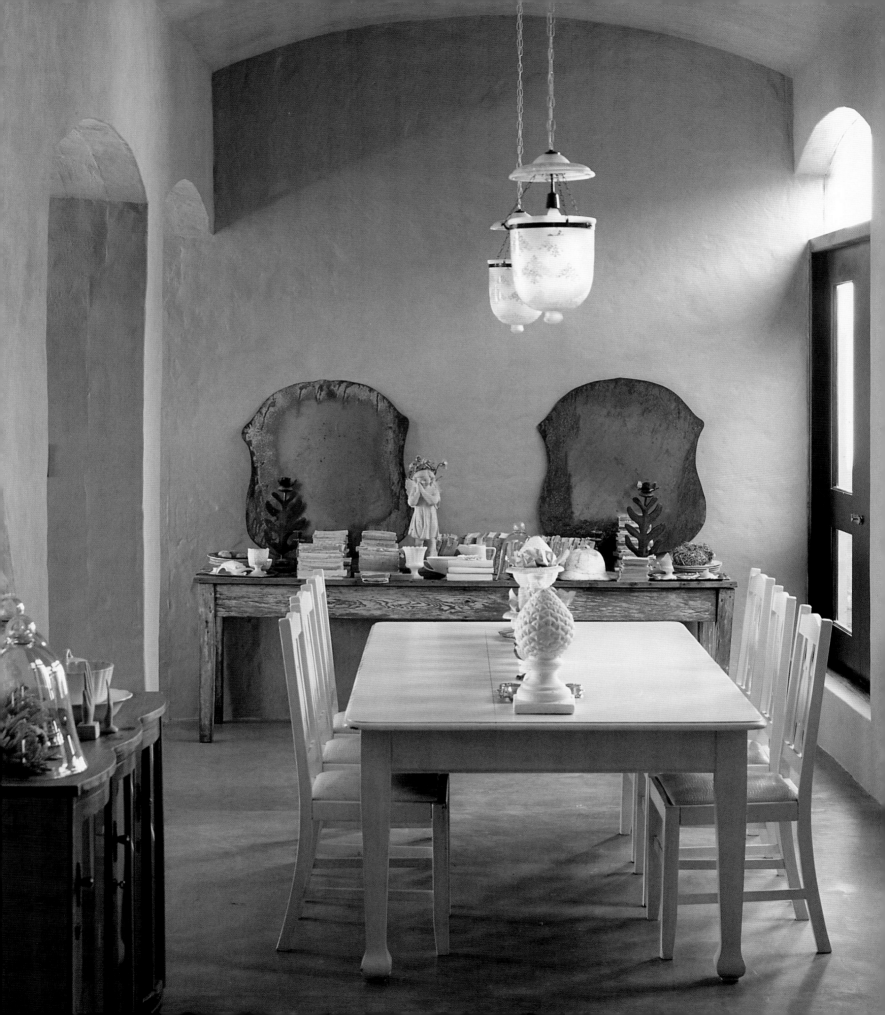

ABOVE, LEFT An arched niche looking into the bathtub of the red room.

ABOVE, RIGHT In the entry hall, a white iron patio chair from the 1950s sits under three vintage mirrors, all thrift shop finds.

RIGHT The white-on-white guest bedroom feels sacred.

PAGE 120 An earthy simplicity in the bedroom of Smit's sons.

PAGE 121 The master bathroom has a circular cement tub and three vintage mirrors.

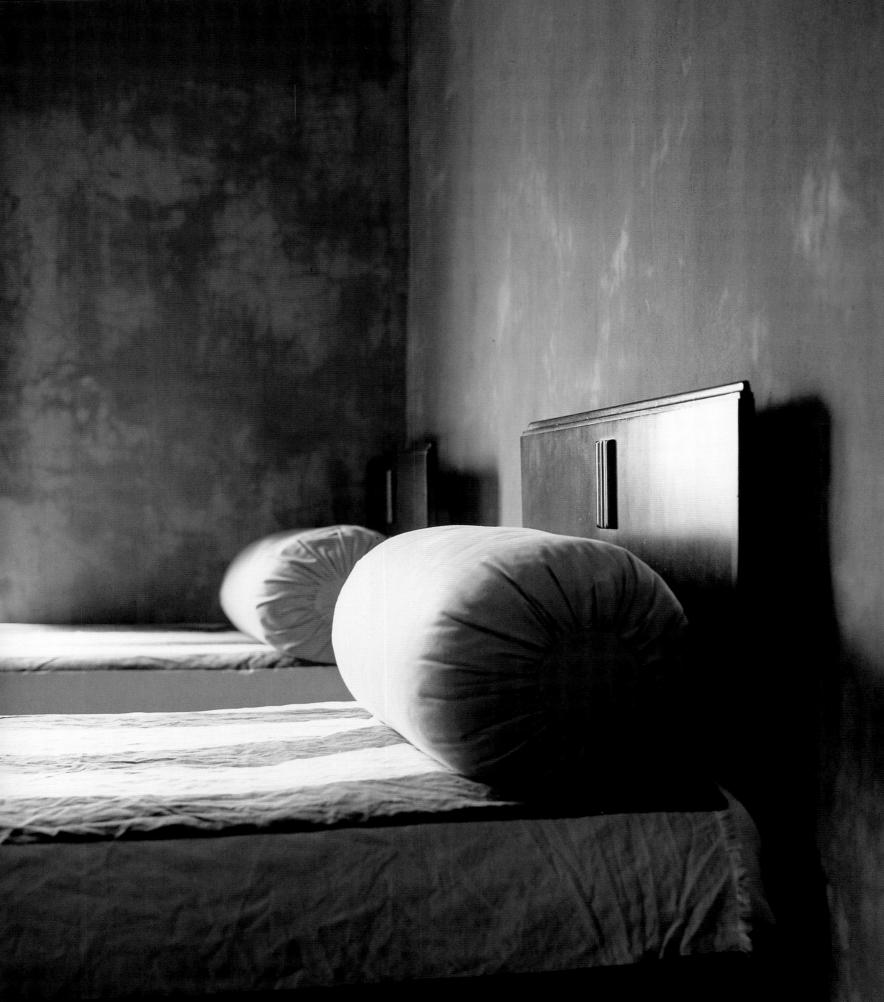

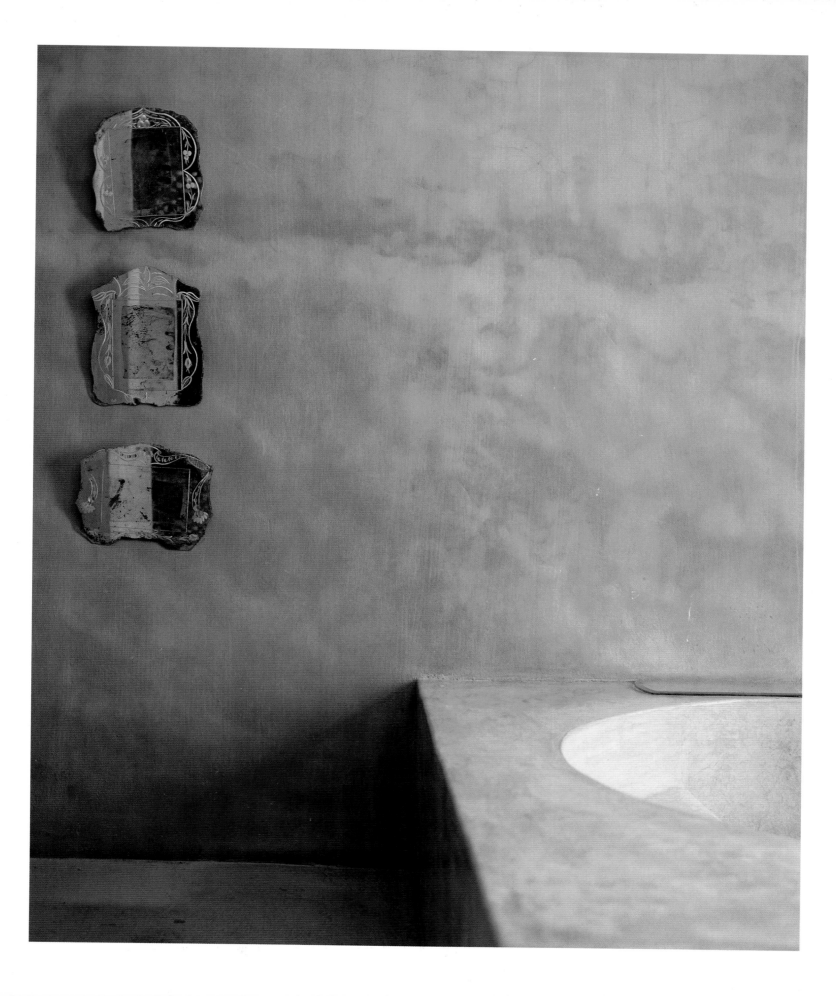

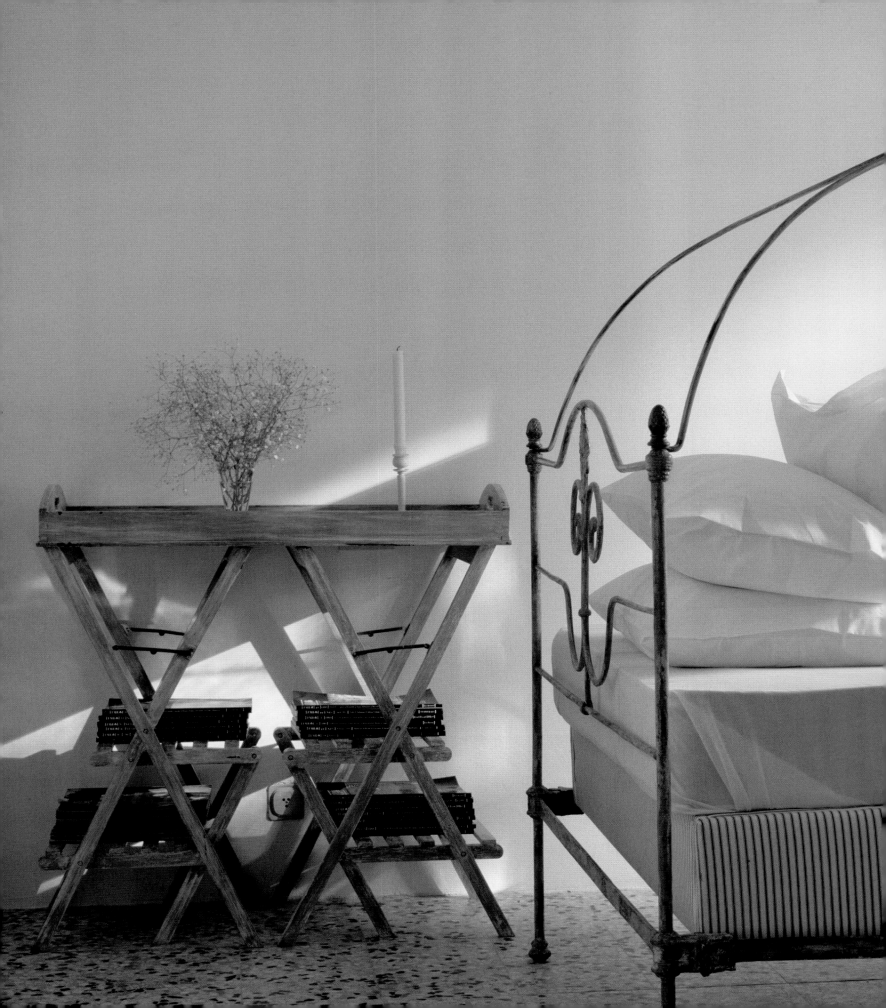

THREE

BALANCE

Happiness is not a matter of intensity
but of balance and order, rhythm and harmony.
—THOMAS MERTON

Many of us have found that a well-balanced life can help us feel strong and centered, in control. Structure induces calm; order emboldens.

This is not a coincidence. Underlying nature's splendid variety is a well-ordered framework—a network of forms and patterns developed eons ago to provide plants and animals with the best chance to grow and flourish. These subtle forms and patterns give the natural world its sense of balance and coherence. Its foundation.

Up until now, you could argue that much of interior design was in a perpetual state of imbalance—too rigid or too random, too flashy or too austere. Traditional rooms, for instance, are often bound by period and symmetry; Modernist homes proudly exhibit only Mondrian-like straight lines and asymmetrical groupings; post-Modern rooms are, well, all over the place.

There is security in uniformity, in taking an idea—whatever it is—to an extreme. But as many of us have come to realize, rigidity of any kind is counterproductive: striving for "perfection" will only make us feel less content, not more.

If we want our homes to offer the same well-grounded spirit that nature does, we need to abandon the security of extremes and create a new type of aesthetic coherence based on balance—of weight, volume, and scale; of symmetrical and asymmetrical; of straight and curved, textured and polished, modern, vintage, and artisanal.

Balance in a room is instantly grounding. A sense of order and coherence inspires our own sense of order and coherence. That said, the balance for each of us will be different—some of us may need more straight edges, more strengthening. Others may need more curves—more softening. You need to be able to "feel" your home to figure out what's right for you.

In recent years, the word *balance* has itself become trendy, with design philosophies like Feng Shui or Vastu Shastra aimed at creating equilibrium in both ourselves and our homes. The primary difference here is one of origin: an interior of deep beauty is rooted in the underlying geometry of the natural world.

PAGE 122 Shelves on a tray-topped trestle are used to store magazines in this simply furnished bedroom in Mimmi O'Connell's repurposed schoolhouse.

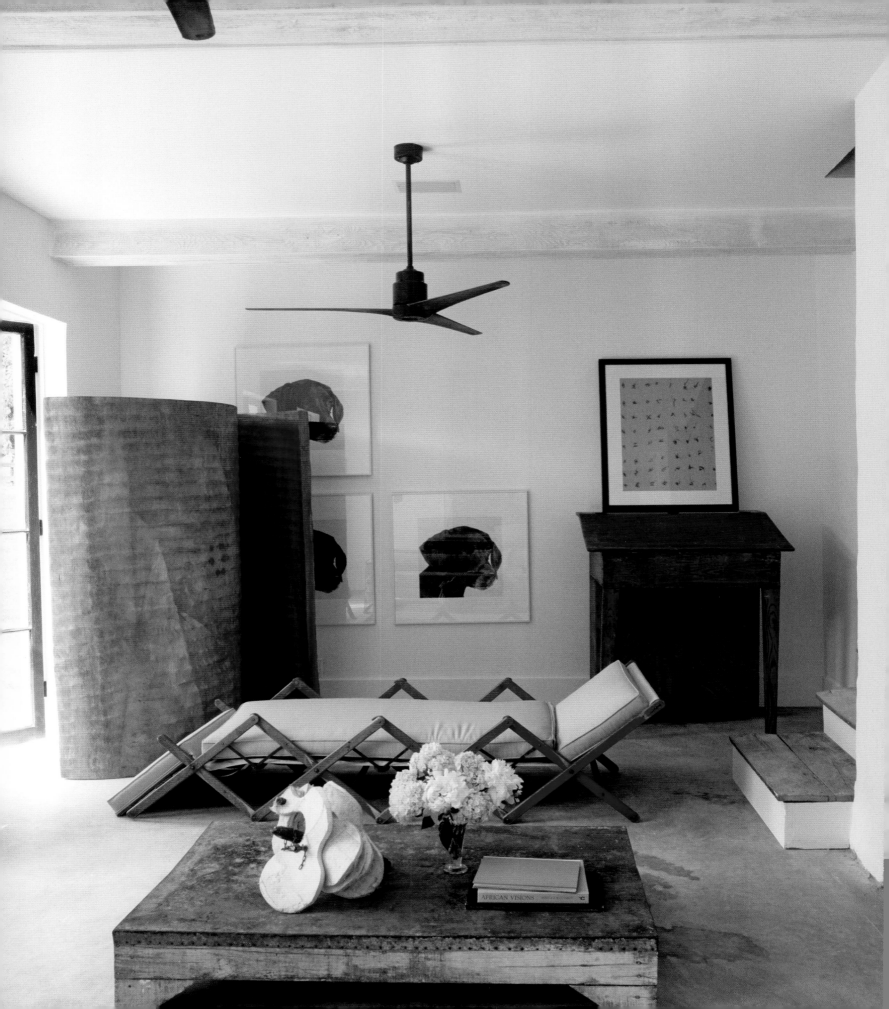

PROPORTION

If you think of your home as a blank slate—an artist's canvas—and you open yourself to the possibility of including pieces from any culture, style, or period, you could end up with a United Nations of furniture and objects. How do you achieve balance with so many disparate elements?

In a word, proportion. Underlying nature's sense of order and balance are finely calibrated proportional relationships—what those in the sciences call the golden ratio and those in art and design have come to call good lines or "good bones." Good proportion not only provides stability—a building, chair, or stiletto that is out of proportion cannot function—but also emits a natural elegance, dignity, and self-possession. Indeed, our brains are so fine-tuned to respond positively to the essential proportions of nature that design and architecture that is even slightly off will not provide us with the same depth of pleasure.

Objects and furniture with good lines are timeless—our eyes never tire of looking at them. With one caveat: good craftsmanship. A piece of furniture can have the best lines in the world, but if the materials are shoddy or the workmanship is second-rate, you're not going to want to keep it around.

A room needs to have good proportion as well—it should be visually balanced. Creating a floor plan is essential: it's the only way to fully see the relationships between all of your furnishings. Larger pieces, for instance, need to be balanced with delicate pieces, which create a sense of intimacy and warmth; they are also a reminder of the preciousness—often

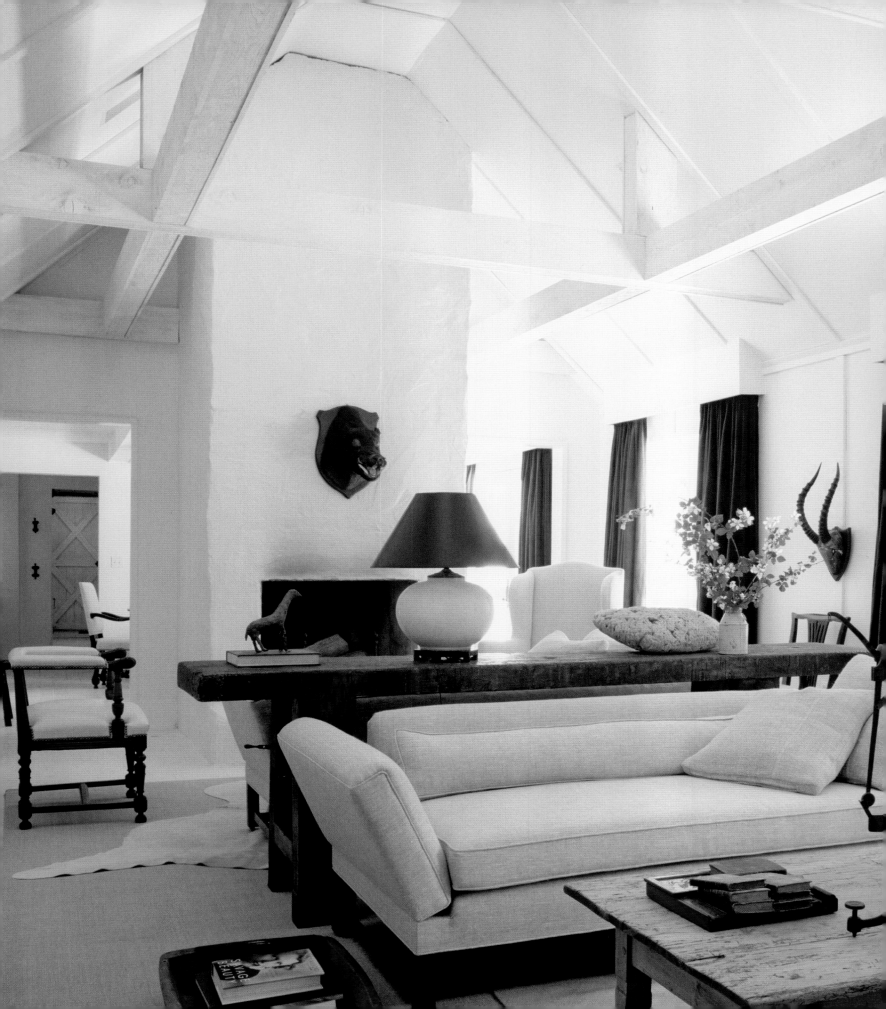

the fragility—of life. But the real test is actually living with your furnishings. They need to feel good in relation to each other—and to our bodies.

As his career was achieving critical mass (interior design, furniture lines, first book), designer Darryl Carter began looking for a weekend home in which to unwind and recharge. He had always had an affection for the Plains, a bucolic Virginia hamlet of protected horse farms about an hour outside of Washington, D.C., where he is based. Nearby he found an 1840s stucco-and-clapboard house with a 150-foot-long wisteria pergola—very much the opposite of his D.C. home, a five-story Beaux-Arts town house that was once the chancellery of Oman on Embassy Row.

"The drive to the property is transformative; likewise, the setting," says Carter. "As you step through the front gate, you are overcome by an alley of wisteria for as far as the eye can see. It is as if you have stepped into another world." Indeed: Carter's neighbor raises endangered miniature goats.

Carter first had to undo many of the renovations of the past century, and then he tried to expose as much of the rare, original

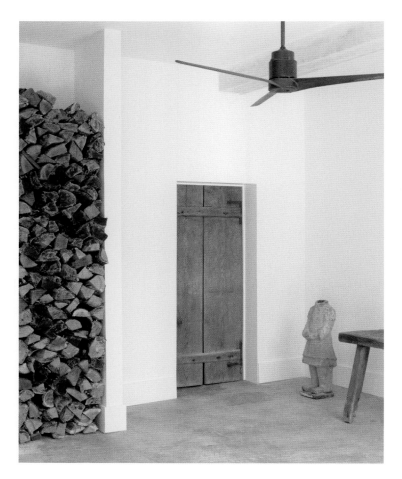

infrastructure as he could, "returning it to its primitive roots." Local materials were used wherever possible: weathered barn doors were repurposed into cabinets; a 12-foot "refectory" dining table was made from one-hundred-year-old local timber.

But for Carter, known for his restrained mix of simple, refined elements and strong silhouettes, a house in the country does not necessarily imply a "log cabin" of unfinished wood and plaid blankets. Reinventing the term "rustic," Carter balanced the unfinished with the polished and sophisticated in proportions that suited both his personal aesthetic and the space. "My work is driven by contrast: inverse/converse, masculine/feminine, precious/rough, light/dark," he says. "Authenticity is not so challenging to achieve when you populate an environment with all things *real*. The challenge is to have the confidence not to be too methodical or literal in this regard."

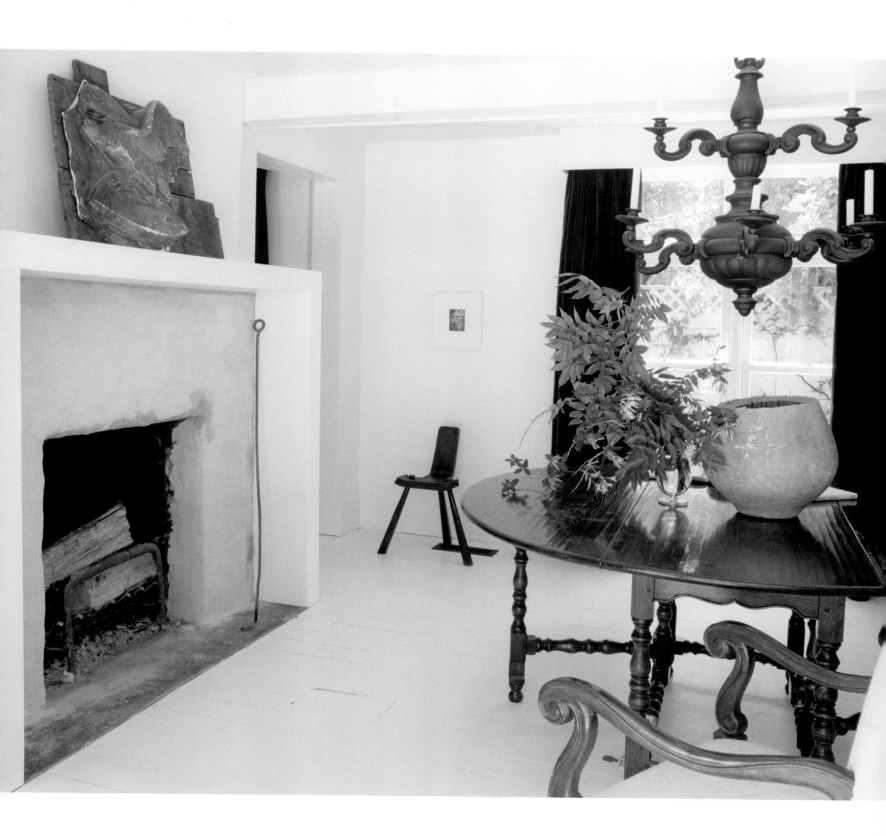

PAGE 130, LEFT Carriage lanterns flank a silversmith's table in the foyer; the boar heads are antique and the large ceramic vessel is Korean.

PAGE 130, RIGHT In the studio, a tall alcove is piled high with logs for winter.

PAGE 131 In the dining room, a Baroque-style pewter chandelier is suspended above an antique oak gate-leg wake table and armchair.

LEFT For the breakfast room, Carter designed a 12-foot dining table from one-hundred-year-old local timber.

In the breakfast room, a large, black lacquered cupboard and a graciously curved white wing chair of Carter's design accompany his rough-hewn dining table. In the living room, stucco hearths and primitive wood benches are balanced by an Italian nail-studded armchair and a sofa of Carter's design. In the studio, an antique gurney is paired with a partition made of banyan bark from Indonesia.

Part of Carter's ability to pull this off is due to his instinctive attachment to pieces indebted to the golden ratio (the cupboard, the table, the gurney) and his penchant to treat furniture and accessories as sculpture, allowing each a well-proportioned stage. In addition, many of these rooms play with vertical scale (again, the golden ratio) in a dramatic way. "I look at the experience of the house as a whole: my approach, as simply as I can articulate it, is that of geometry and topography," says Carter. "I view a certain architectural gravity, a huge mantel at one end of a room, to call for a similarly monumental piece at the opposing wall. A room is like a seesaw: it should never tip in any one direction."

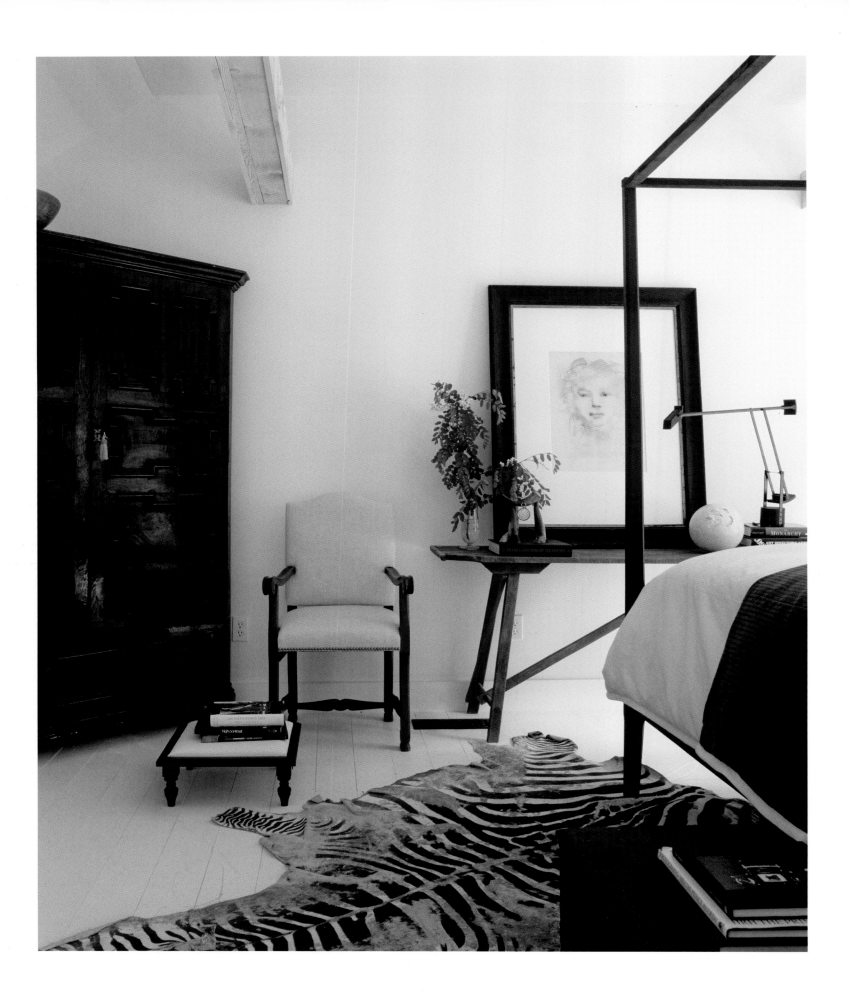

LEFT A large, antique zebra-skin rug covers the floor of the guest bedroom, harmonizing with a nineteenth-century oak cupboard that serves as a wardrobe.

BELOW, LEFT In the bathroom, the antique oak-rimmed bath is made of galvanized iron, with a large framed animal print hanging above.

BELOW, RIGHT In the master bathroom, a semicircular antique oak table has been transformed into a washstand.

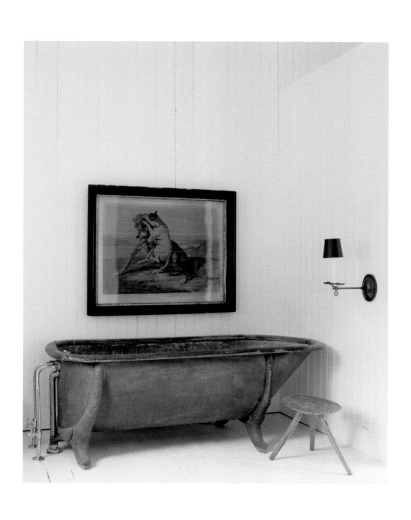

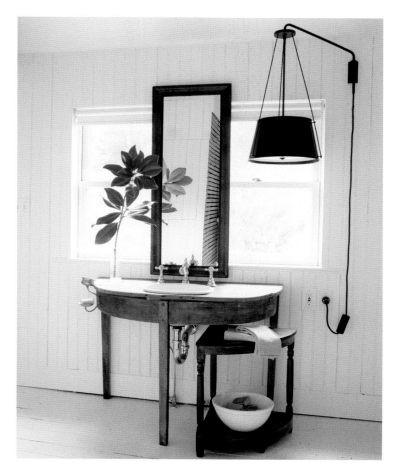

HARMONY

Think of a "room" in nature. It may consist of some trees, grass, a small lake or cliff, possibly a squirrel or two. As your eye travels from one "piece" to another, it notes the differences, may even be intrigued by them, but is never irritated or offended.

Nature harmonizes: it blends differences. We are used to thinking of harmony in music, but harmony in all of the arts stems from the essential harmony of the natural world: while each plant and animal is distinctly beautiful, together they blend to create a larger beauty, an aesthetic symphony that is neither boring nor jarring.

The most common mistake in trying to incorporate pieces from different periods, cultures, and styles is the idea that everything can go together. But everything does not go together. In fact, a lot doesn't go with a lot. Of one thing you can be certain: two pieces are more likely to harmonize with each other—even if they are from different cultures or eras—if they are clean lined, well edited, and based on nature's proportions.

At the other extreme, the most common mistake in trying to create a calm, tranquil space is the idea that everything has to be similar or "neutral"—in other words, bland—to look good together. Nature is neither neutral nor bland. Harmony is in fact a dynamic interplay of complementary opposites: it intrigues our brains while it calms our minds.

"Each piece balances the other, which creates a sense of equilibrium," says Vicente Wolf. "To create harmony, you have to learn to listen to the silent voice, the voice that most people never hear but feel, the voice that says order, calm, a sense of balance."

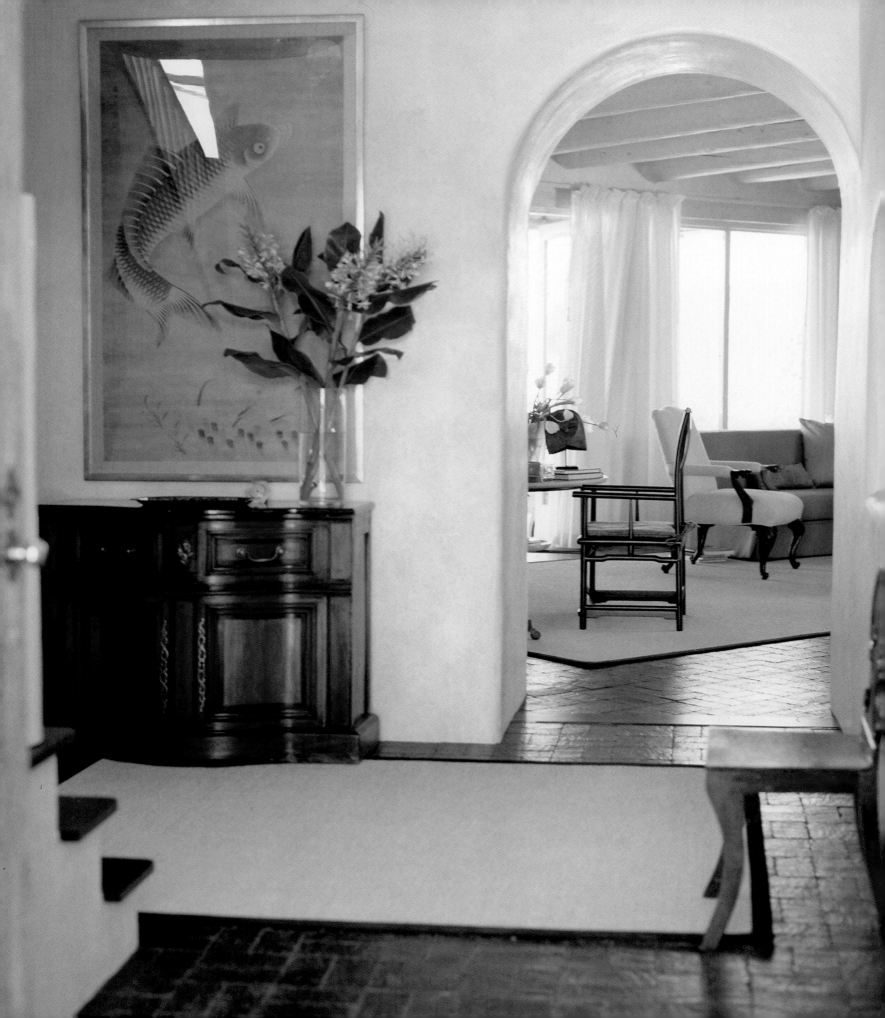

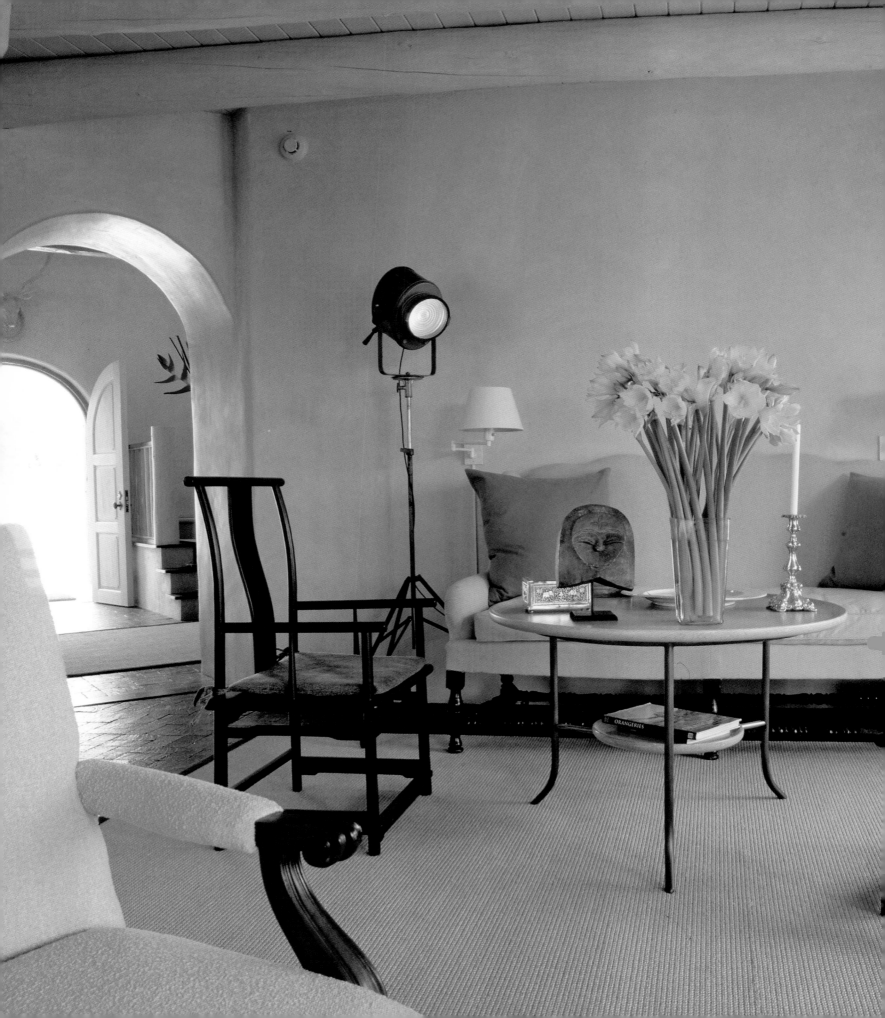

PAGE 137 A nineteenth-century English console and a nineteenth-century Japanese painting decorate the entryway.

LEFT In the living room, a nineteenth-century French sofa and Chinese chairs with Scalamandré fabric cushions face a delicate bronze-and-oak table designed by Wolf.

Wolf is a master at creating harmony within and among objects and furniture. "Always try to give the viewer the sense that while each piece stands on its own, it's also part of a tapestry of a space," advises Wolf.

One of Wolf's biggest challenges was to create harmony in a contemporary adobe house in Taos, New Mexico, with wraparound views of the desert. Wolf hates everything that's typically associated with Southwestern design. "It's the subtlety of nature that counts in Taos—all those Disneyland doodads and bright colors just detract from the peacefulness."

"My objective was to make it nothing like other homes in the Southwest—without losing what's best about an adobe house." Wolf took as his starting point the surrounding landscape: all of the colors in the space—straw, bark, sun-whitened wood— literally come from right outside the door. Wolf bleached the ceiling beams to match the pale adobe walls and stained the brick floors dark.

He then harmonized furnishings from the clients' home in London with many of his own designs to create an interior that was

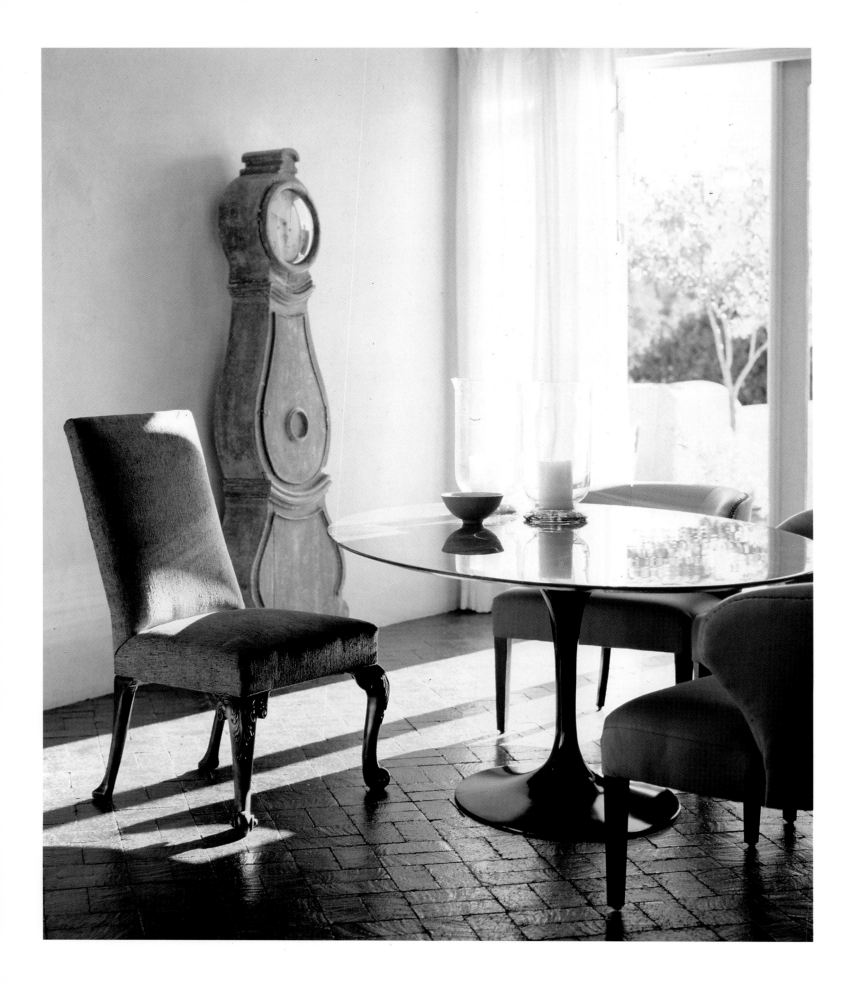

 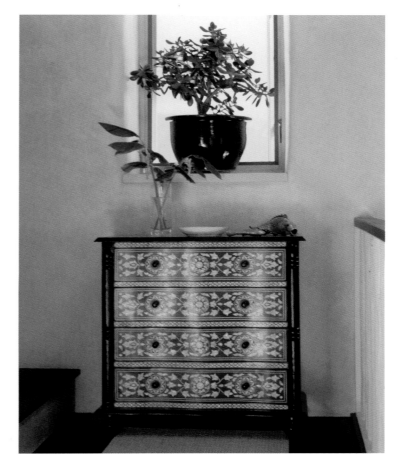

unique and personal—and comfortable in the arid, light-filled Southwest. In the living room, a nineteenth-century French sofa and two Chinese chairs blend with a delicate bronze-and-oak table designed by Wolf; in the bedroom, a vintage slipper chair synthesizes with an eighteenth-century French chest, a nineteenth-century Italian stone head, and a Moroccan trunk. "When you look at these rooms, nothing jumps out. All the different ideas are poetically woven through." Indeed, the pieces appear to be having a conversation of their own. "You try to have a dialogue without words, a visual dialogue between pieces."

Wolf believes the ability to harmonize stems from an ongoing learning process. "A traveled eye is one that through education and experience becomes familiar with all different periods and cultures," he advises. "When you've seen where something comes from—when you've seen its roots—you'll be less intimidated to play with it."

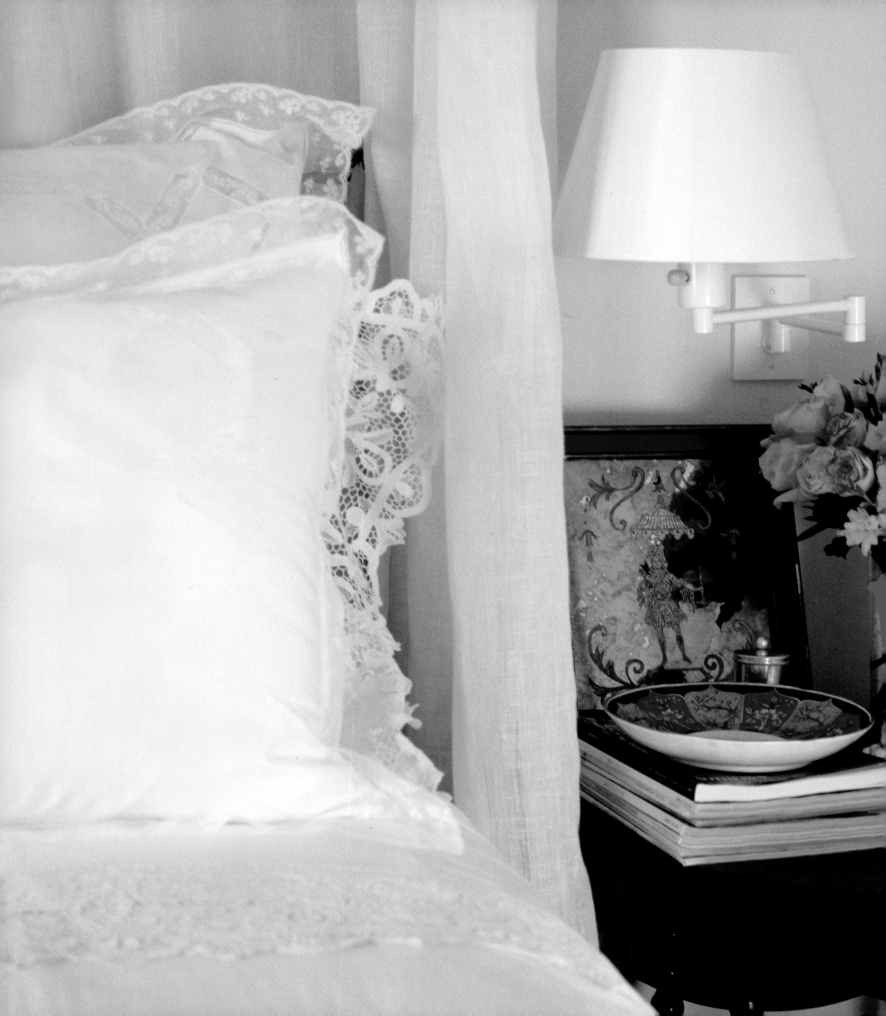

PAGE 140 In the dining room, a nineteenth-century Swedish clock harmonizes elegantly with an Eero Saarinen table.

PAGE 141, LEFT An eighteenth-century hall table from Holland holds a variety of ivory African and Indian objects.

PAGE 141, RIGHT An exquisite nineteenth-century Dutch inlaid chest blends with the adobe walls and stained terra-cotta tile.

LEFT In the master bedroom, romantic flourishes counter the austerity of adobe walls.

BELOW In the bedroom, a vintage slipper chair rests between an eighteenth-century French chest and a nineteenth-century Italian stone head.

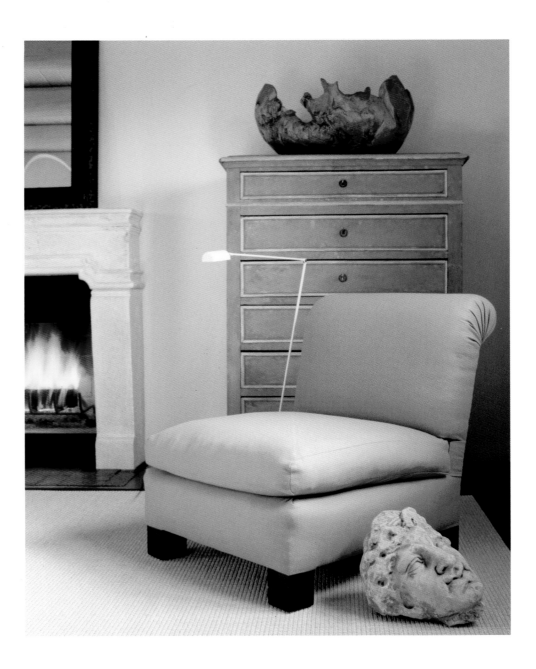

RIGHT An 1800s Filipino sugar press serves as a cocktail table in the den, balanced by a nineteenth-century Chinese mirrored window panel and a contemporary painting.

A 1950s ranch house in the Southampton hamlet of Water Mill provided Wolf with a very different canvas. The house had undergone so many additions in the sixties, seventies, and eighties that all the ceilings were of different heights and the rooms went off at odd angles. First, Wolf had to "reallocate the space"—his tactful way of saying it had to be gutted—with associate David Rogal. He then created cohesive rooms and used glass doors in the kitchen and living room so the interiors could better interact with the outdoors. The result: a clean-lined glass-and-whitewall pavilion that recalls both Richard Neutra and Mies van der Rohe.

"It's not about being in the perfect space," says Wolf. "There are not many perfect spaces. It's, How do you balance out the negatives with the positives so that the viewer sees it as a balanced space?"

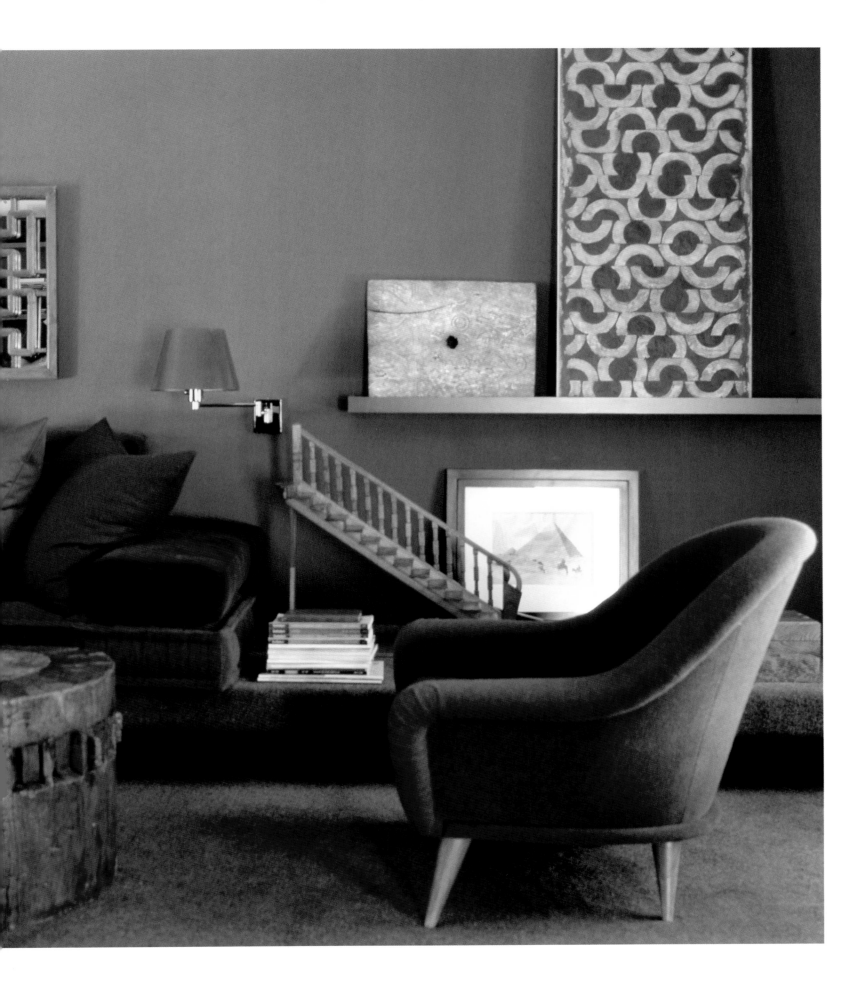

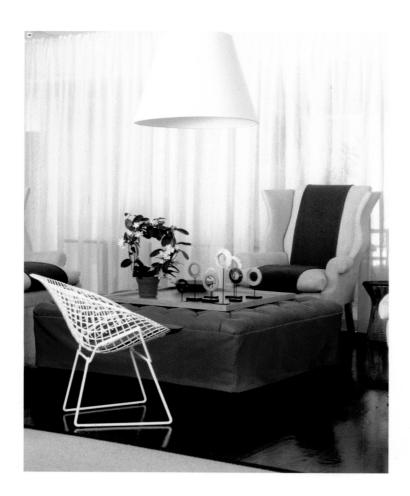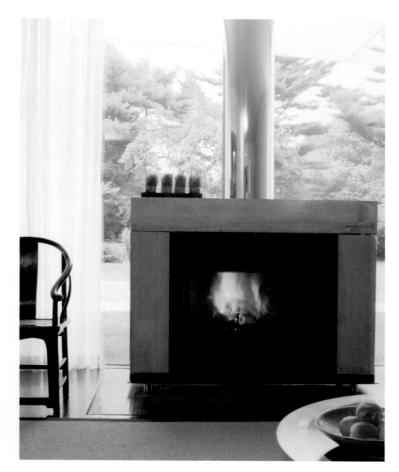

As for the furniture, Wolf allows it to "float" in the space by pairing pieces that blend seamlessly: in the living room, a Harry Bertoia chair blends with wing chairs of Wolf's design, and a Danish rococo chair mingles with South African ceremonial spears; in the den, a nineteenth-century Chinese mirrored window panel hangs above an antique Filipino sugar press.

Because of the design integrity of each piece, harmony—and thus calm—is the result. "It's a total sanctuary for me," says the homeowner.

ABOVE, LEFT In the living room, a traditional wing chair is juxtaposed with mid-century classics.

ABOVE, RIGHT A freestanding fireplace is set off by lush landscaping and a nineteenth-century Chinese chair.

RIGHT The kitchen elegantly blends brick, resin, and modern elements.

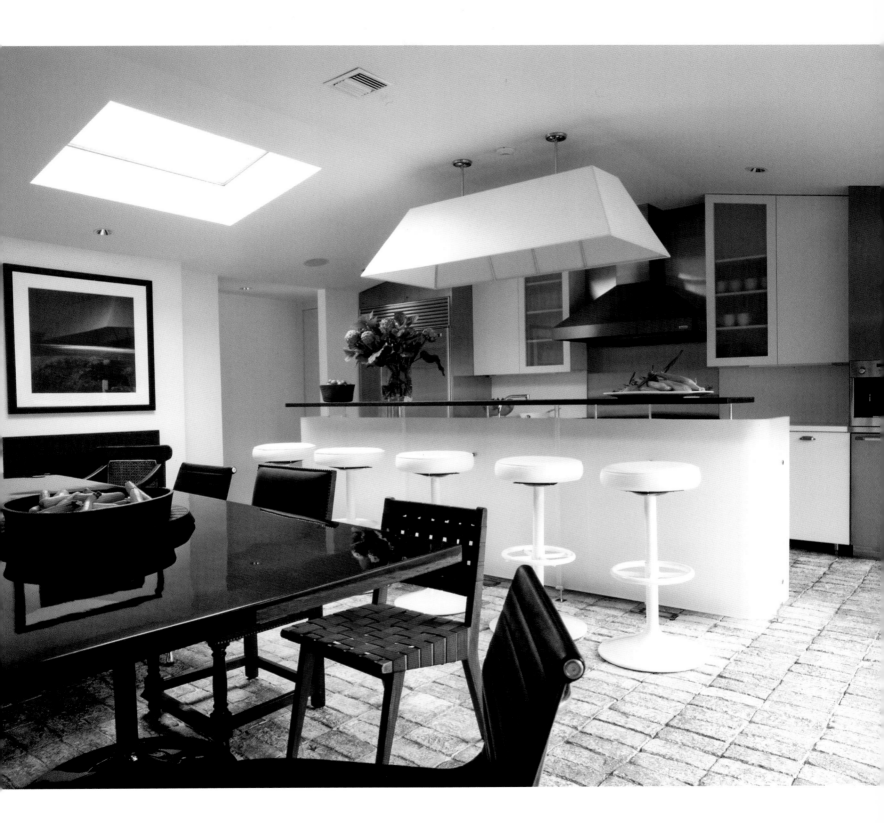

BELOW Ethiopian canes play vertically with a floor-to-ceiling contemporary mirror and a Danish rococo chair.

RIGHT An African Ladders plant accompanies a mohair-upholstered bed, designed by Wolf, in the master bedroom.

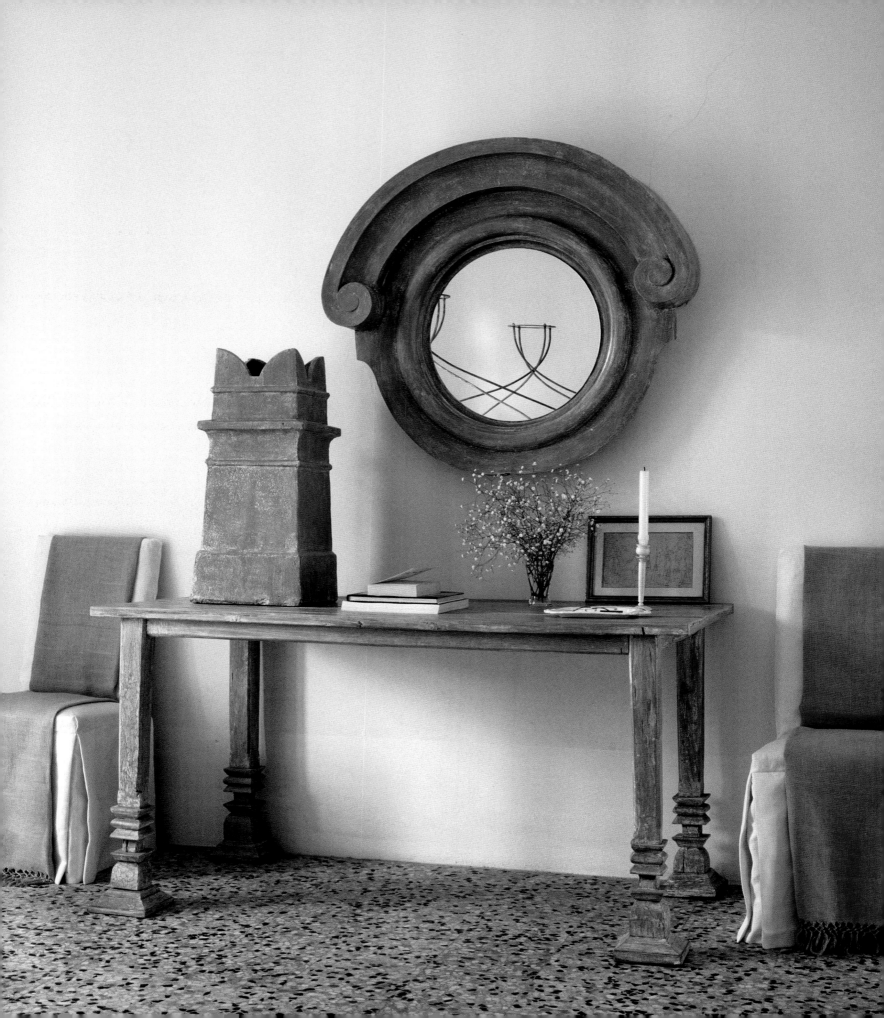

U N I T Y

Repetition is key to nature's design process. Common elements—colors, textures, patterns, shapes—provide an underlying unity that runs throughout the natural world, creating a visual continuity, a sense of visual peace.

You can do the same in your home. The challenge is to have each room relate without appearing to do so, to create a thread of colors, materials, shapes, and/or patterns that subtly connects all of the rooms.

In 2000, London-based designer Mimmi O'Connell was looking for a vacation home in her native Italy. In the small medieval village of San Casciano dei Bagni, overlooking the hills of Siena in southern Tuscany, she found something far more intriguing than she had ever imagined: an abandoned schoolhouse with triple-height ceilings, "glorious, golden light filtering throughout, and views like an old master painting."

O'Connell transformed the schoolhouse, which had been built in the 1960s, into a seven-bedroom villa. The former classrooms were turned into en suite bedrooms that open onto a scented garden. The original flooring—terrazzo tiles in white, beige, gray, and light brown—provides not only texture but a primary continuity that defines the color scheme throughout.

The bedrooms are decorated with four-poster beds, either in iron or bamboo, inspired by the ones O'Connell slept in as a child. Asian antiques and art objects—chairs, chests, benches, sculptures—can be found throughout the villa, as can O'Connell's signature striped cottons and linens.

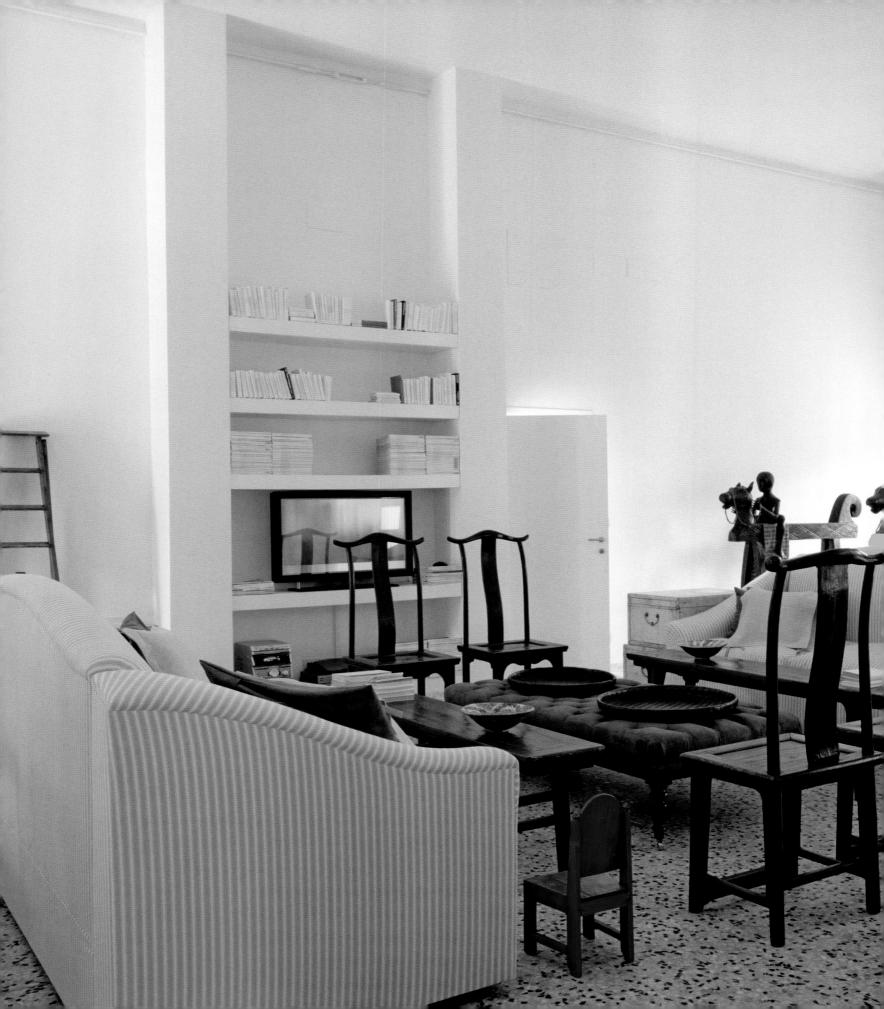

PAGE 150 A mirror, fashioned to resemble a circular window, hangs above a console table that is flanked by a pair of chairs dressed in linen.

LEFT Light pours into this living room, furnished with a selection of Chinese benches, chairs, and porcelain stools.

RIGHT A large rectangular mirror hangs above a pair of eighteenth-century Chinese benches in the hallway. The multicolored terrazzo flooring unifies the home and creates a pleasing visual contrast with the monastic white walls.

PAGE 154 These cast-iron beds were designed by O'Connell and produced by a local craftsman.

PAGE 155 A band of mirrors enhances the space and light in this bathroom; a bamboo ladder at the edge of the sunken bath is used for hanging towels.

The bare white walls in all of the rooms offer another thread: O'Connell lets her well-chosen furniture provide the visual accents. "When you are dealing with ceilings 26 feet high, you do not want distraction," says O'Connell. Keeping the walls bare also enhanced the sense of height: it allowed the former schoolhouse to become "a glorious cathedral." This linear quality is picked up again in the design of the beds and the elegant Chinese chairs, as well as in O'Connell's tendency to stack—chests, books, pillows.

The linearity enhances the minimalist Euro-Asian aesthetic, which blends well with the surroundings. "La Scuola was an exercise of discipline because the space is superb, the volume of the rooms quite perfect," says O'Connell. The villa is now available for rent, but O'Connell still makes good use of it. "It is my most perfect home," she says. "Marvelous when guests are around and peacefully divine when I am alone."

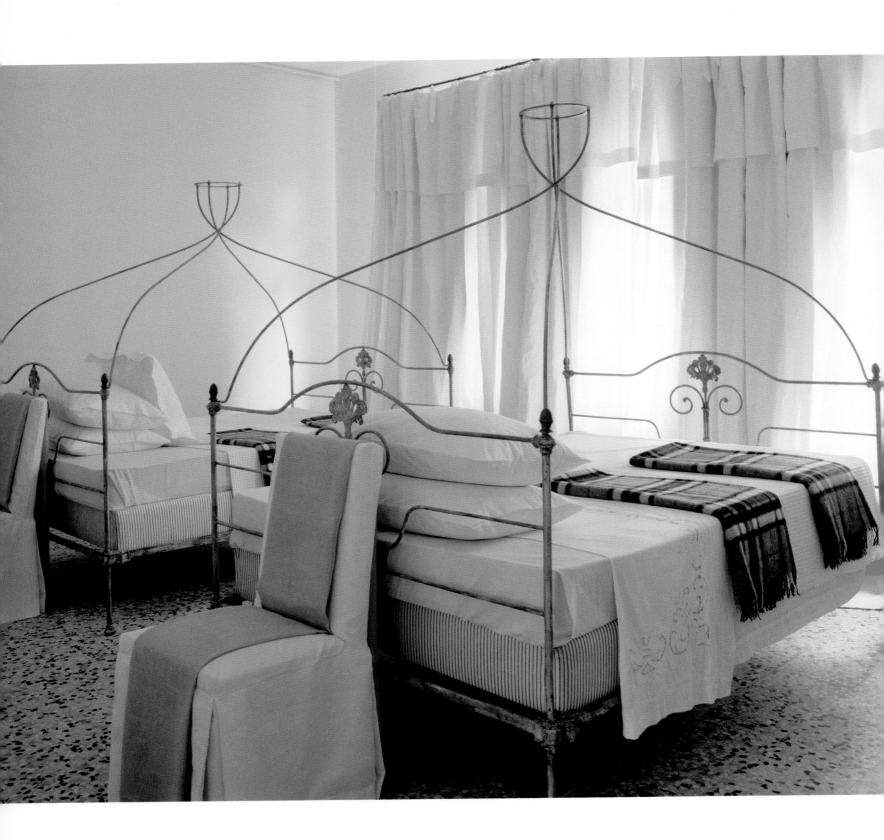

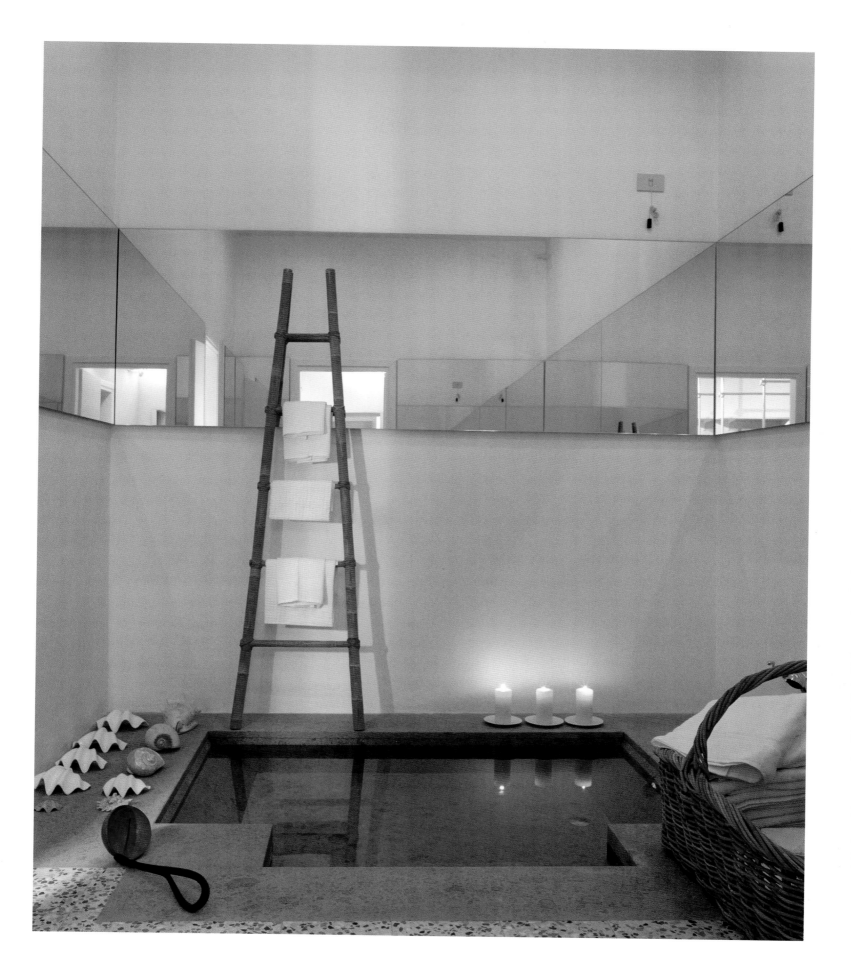

SERENITY

Ultimately, you want to create such a foundation of strength and balance in your home—and in yourself—that you are able to confront every curveball that comes your way with equanimity and grace, with serenity. One thing is clear: there is no need to give up a sense of sensual luxury to do so. You could even argue that sensual luxury can enhance a feeling of serenity.

For more than twenty-five years, Donna Karan has been creating clothes that are understated yet luxurious, formidable yet feminine—clothes determined to foster a sense of strength, confidence, and elegance.

In 2002, a year after her husband, Stephan Weiss, died from lung cancer, Karan renovated an apartment on Central Park West with the architectural firm Bonetti/Kozerski. The goal was to create a place of tranquility and peacefulness, away from both the constant motion of the city and her hectic life. "It's my personal sanctuary," she says. "The calm to my chaos."

While the apartment is frequently given over to fashion show after-parties and intimate dinners, it is primarily devoted to Karan's passion for physical and spiritual well-being. The master bedroom suite and its terrace look onto Central Park, while the dining room overlooks the energetic midtown skyline. Eastern light floods the bedroom, yoga room, and spa area in the morning. "We wanted Donna to start her day with as much light and serenity as possible," says Dominic Kozerski.

Minimal in structure, thoughtful in order, and restrained in palette—black and white warmed up with gold, red, and wood—the space is infused with sensual textiles: Italian

linen bedsheets line the walls; large moleskin-covered cushions (that transform into sleeping zones when her children and grandchildren descend) enhance the living area. And much of the furniture throughout the apartment was made from solid reclaimed swamp teak that has been heated and aged.

Light-filled areas flow easily into one another. "My apartment is all about flow and openness, with one room leading into another, the inside blurring into the outdoors," says Karan.

PAGE 157 The spa was placed on the south side of the apartment to capture the morning light.

ABOVE, LEFT Art and artifacts in the living room: Roberto Detesco's *The Wild Horses of Sable Island*; book art by Gregory Colbert.

ABOVE, RIGHT A travertine terrace with incredible views is fluidly connected to the inside of the apartment. The outdoor table and benches were designed by Bonetti/Kozerski.

RIGHT The inky tones of the dining room are warmed by a wooden bench that has been gilded in gold leaf.

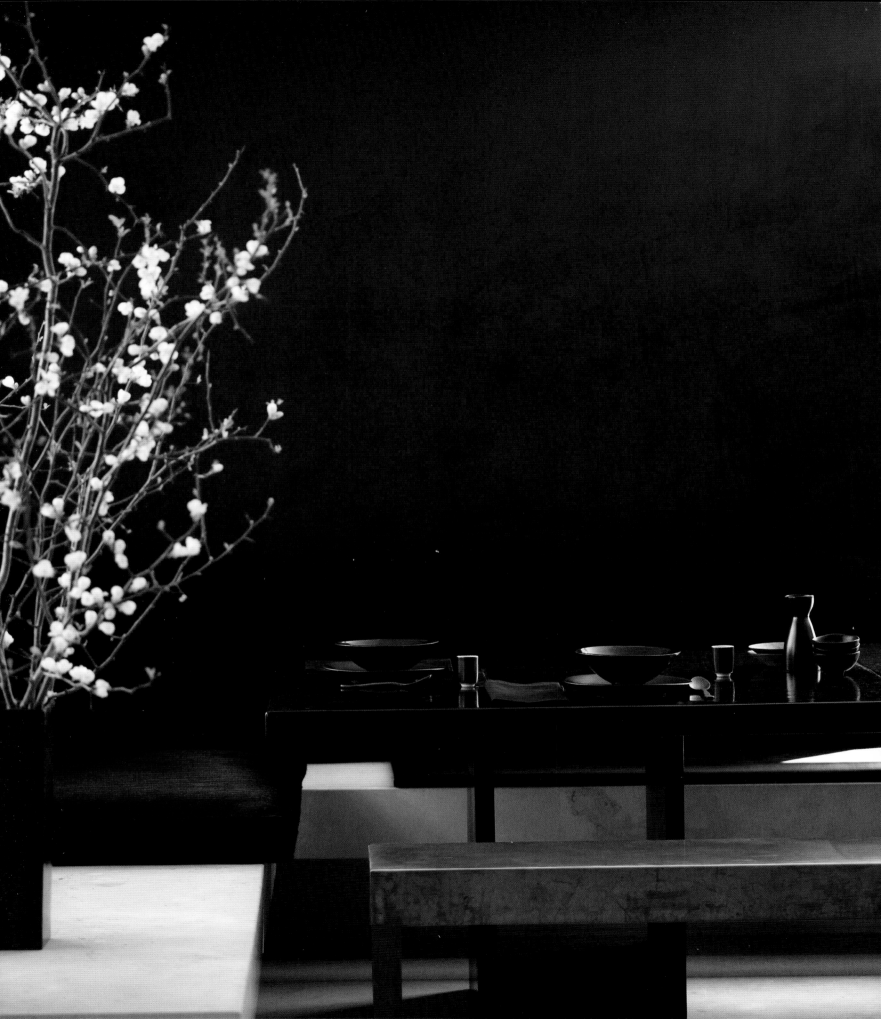

Indeed, the boundary between the interior and exterior is made fluid by sliding doors as well as a travertine platform that runs throughout the apartment—creating built-in seating—and leads seamlessly out to the terrace.

Along with an assortment of art and artifacts, photographs of spiritual teachers are displayed throughout the apartment, contributing to the feeling of tranquility and introspection. "My husband's presence is felt throughout, as he had always shared my passion to create environments that cultivate enlightenment and learning. . . . My home reflects my passions. It celebrates my family and friends, art and culture, and it holds the memories that are a part of who I am."

LEFT Moleskin cushions offer comfortable seating on a stone platform that flows onto the outside terrace. An old Chinese bed has been turned into a coffee table.

PAGE 162 Bonetti/Kozerski designed the bedroom furniture, all made from solid reclaimed swamp teak. Photo on wall is by Gregory Colbert.

PAGE 163 Karan's personal mementos on her bedside table, stained dark teak, with a silver-plated lamp by Tecnolumen.

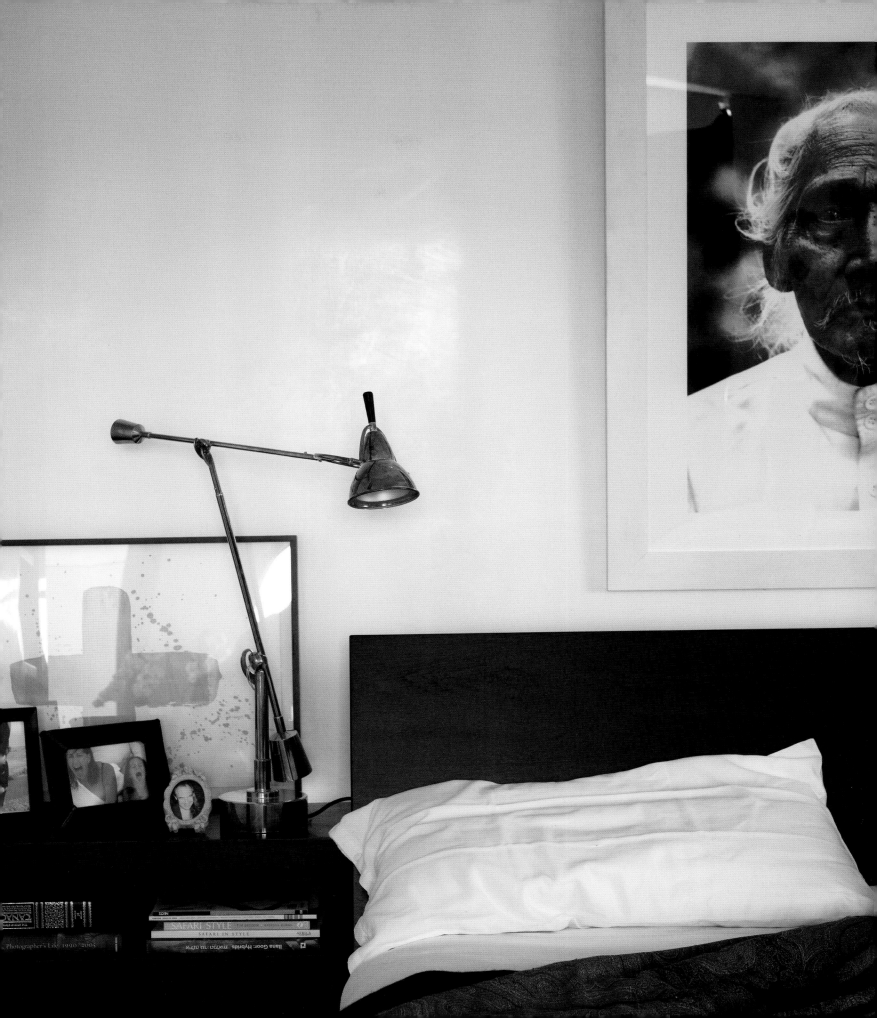

FOUR

SURPRISE

The goal is not to shock but to surprise.
—PAUL BOWLES

Much of nature's beauty is modest and subtle—the petal of a calla lily, the soft waves of a lake. Suddenly, a butterfly or peacock can happen into the picture and our senses take note. We are stirred, intrigued. Our moods pick up: delight—perhaps even hope—resurfaces.

The essential rhythms of the natural world are steady yet slightly unpredictable. The steadiness calms us, but it is the element of unpredictability—of surprise—that often infuses us with energy and optimism.

Not coincidentally, we are at our best when we adopt nature's work hard/play hard mentality. Monotonous routine or relentless struggle can be deadening to our spirits, while too much randomness or diversion, perhaps initially seductive, can sow the seeds for uncertainty and anxiety. We each need the strong foundation that structure and balance provide. But we also each need to be able to "go with the flow"—to embrace the surprises that life has to offer.

The same goes for our homes. Period rooms—whether nineteenth-century or Modernist—and overly "sanitized" rooms are typically quite predictable, and as a result can feel heavy, stale, and boring. Even certain pieces—the sterilely sleek, for instance, or gratuitously laden with ornament—can kill one's spirit: their dour nature can take all of the life out of a room.

On the other hand, it is a common mistake to think that to enliven our homes we must find art and furnishings that are "spectacular." But a

spectacular piece (by definition) makes a spectacle of itself. It can offer short-term sizzle for sure, but this is not sustainable, and then you will need to replace it with something equally spectacular.

A room full of discordant pairings can also be temporarily interesting. After a while, though, it's not going to look—or feel—particularly good. Tension, like everything else, comes in good and bad varieties. Good tension can add a certain frisson to your life, a sparkle; bad tension just adds stress.

Ultimately, you want your home to feel alive and evolving, but you also want it to have "good flow": a movement through the space that both calms and surprises. Inventive uses of color, texture, and pattern can create good flow, as can unusual (but not jarring) juxtapositions. But in the end it may be the pieces that radiate sunshine from a very deep place that are the most relevant. These "forces of life"—new or old, hand- or machine-made—are simultaneously full of zest and thoroughly self-contained. They have enough presence to be the center of attention and enough dignity not to need it. Ideally, these types of pieces would reflect a wide variety of cultures and periods and would be balanced with twentieth-century Modernist pieces, which you can think of as palette cleaners between courses.

PAGE 164 Antique wood flooring, an early nineteenth-century French mirror, and fixtures in plaster by Manuela Zervudachi lead the way down this narrow hallway to the living room in Juan Montoya's Paris apartment.

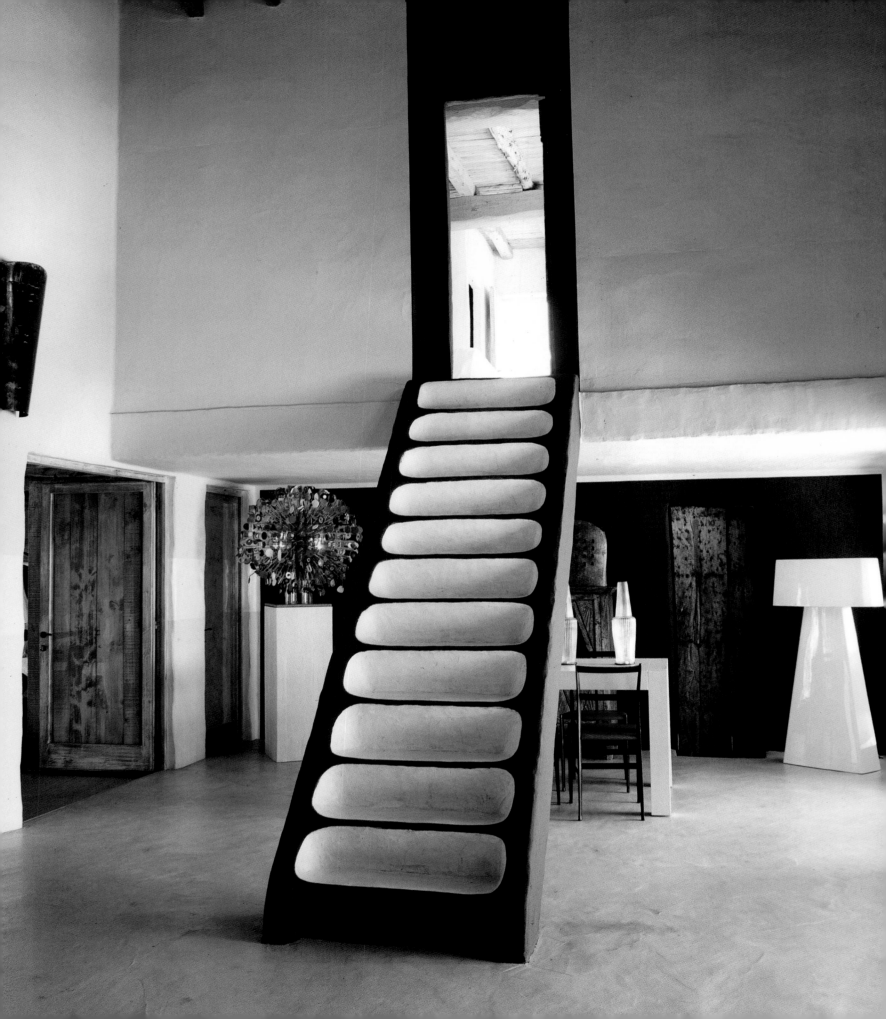

UNEXPECTED TWEAKS

While we can certainly feel the stillness of nature, it's never really sitting still. Nature is imperceptibly evolving—innovating—with a keen eye toward self-improvement.

One of the easiest ways to add spice to your home is by imaginatively playing with textures, colors, and patterns. Tweak something old: replace the vintage damask on a period chair or sofa with mohair, and then hang a swath of the damask in a sleek black frame. Tweak something new: add a splash of vibrant color on a tiled basin, or cover a contemporary ottoman in velvet. Push the limits of harmony: pair an eighteenth-century Chinese chest with mid-century Scandinavian candlesticks; juxtapose a nineteenth-century gilded mirror with an assortment of African masks.

But tweak in moderation. A room full of surprising tweaks can feel unsettling. And be careful with your juxtapositions: opposites attract, but—just as in any relationship—pieces can bring out the best in each other or the worst.

The boho-chic clothing label Marni is known for consistently creating collections that mix fairly classic lines with one or two intriguing tweaks—a splash of bright colors, tribal or Bauhaus patterns, unusual blends of sumptuous fabrics. The result: clothes that feel simultaneously elegant, avant-garde, and joyful.

PAGE 168 A staircase in the main salon, inspired by the architecture of Yemen. In the rear, a Plexiglas sphere designed by Castiglioni and Gio Ponti's Superleggera chairs.

RIGHT The patio at the entrance has a poster bed with cushions designed by Castiglioni and Mariangela Calisti, and a coffee table with two terra-cotta vases and a root "bowl."

Consuelo Castiglioni, founder and creative director of Marni, brought that same feeling to her family's vacation home on the Spanish island of Formentera. "We discovered the island years ago by chance and fell immediately in love with its Mediterranean landscape," recalls Castiglioni. She and her husband, Gianni, bought a piece of land not far from the rugged coastline and then proceeded to build a simple stone house.

"We wanted the house to be open, with big 'door-windows' on both sides, so that its living area could be seen from the terrace in the back all the way through to the garden out front," she says. During the spring and summer, they leave all of the door-windows open so that the house feels completely integrated with its environment.

As for the interiors, "my approach to design is modern," says Castiglioni. "Influences and inspiration mingle to create something interesting, to create an atmosphere. It's a constant process: a number of objects in my house are treasures that I discovered while traveling. I love to go to markets or tiny unknown stores to look for furniture, carpets, or objects;

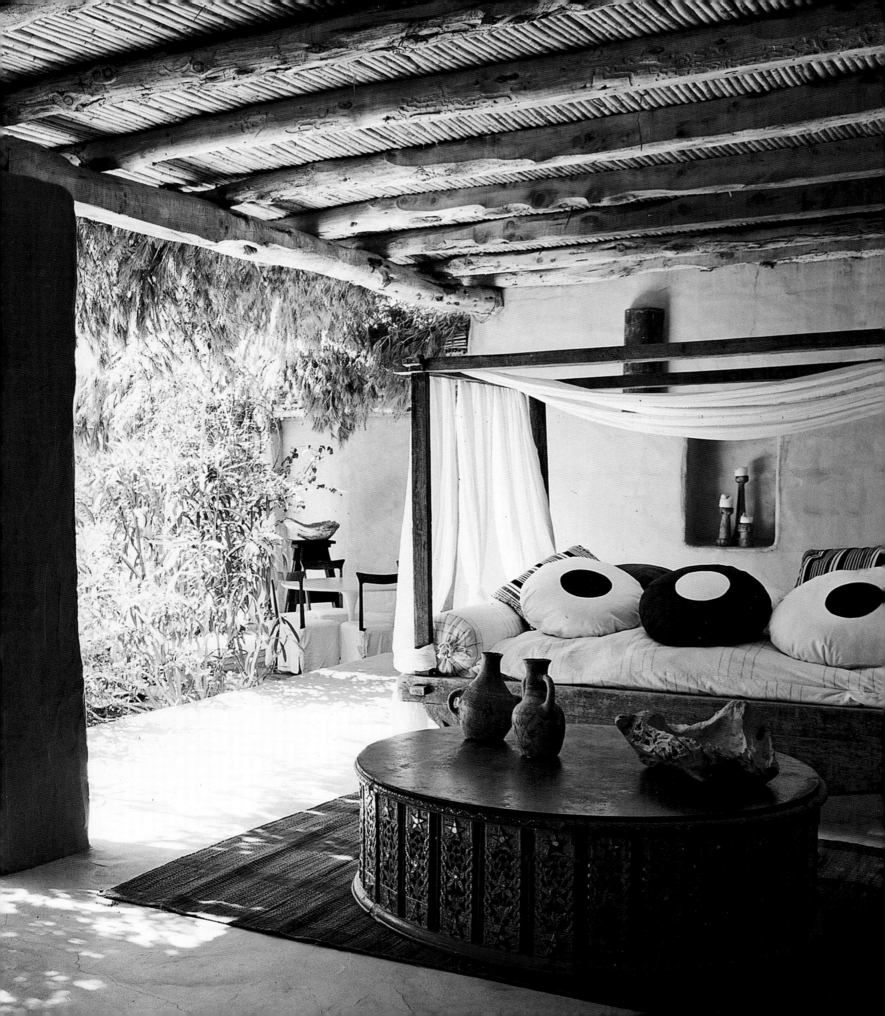

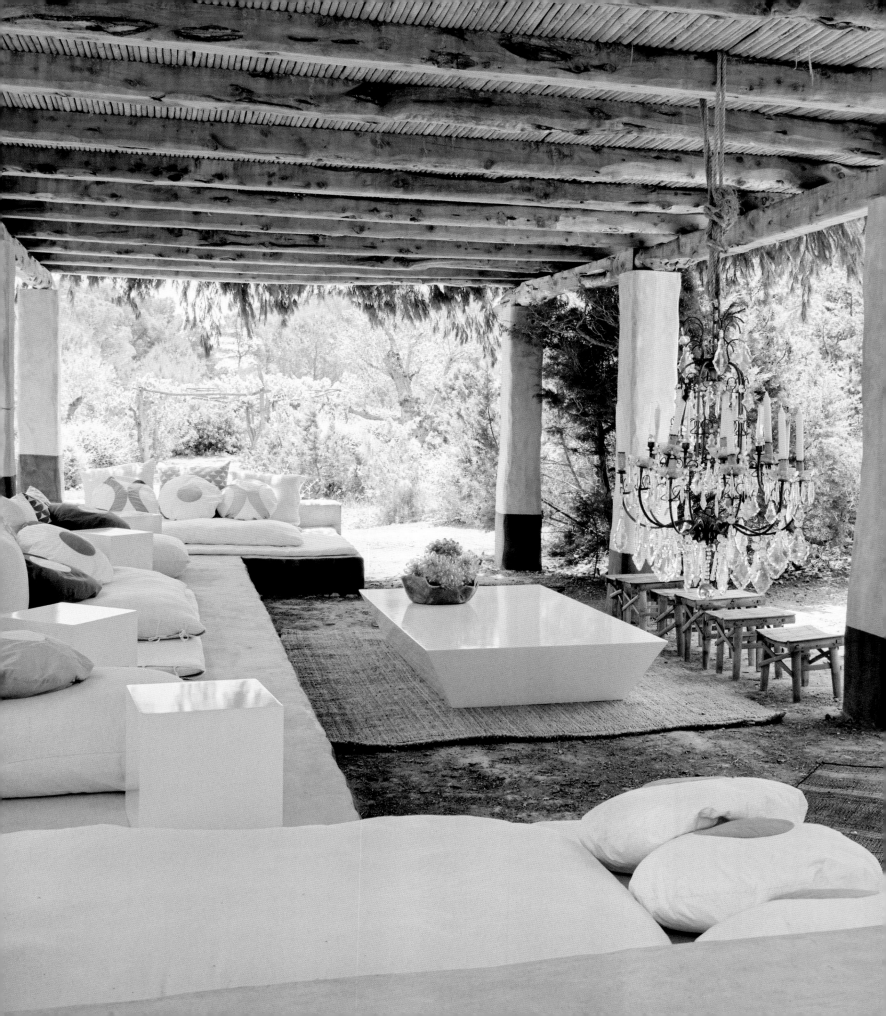

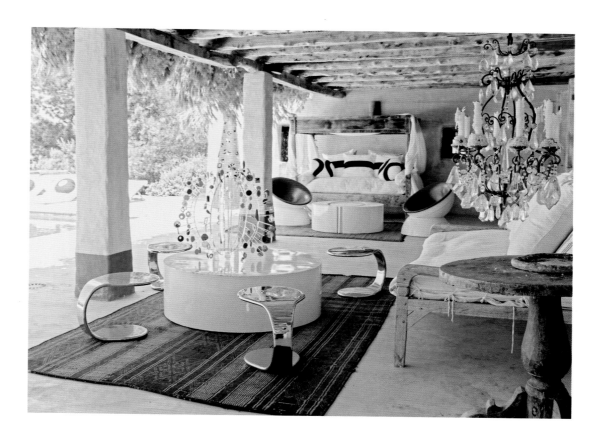

sometimes I personalize them." Mariangela Calisti, a close friend and interior designer and architect, helped Castiglioni with the process.

Furnishings and objects from Morocco and Java are offset by pieces from the 1950s and 1960s, as well as contemporary pieces by Calisti and Tom Dixon. All are punctuated by geometrically patterned pillows and headboards of Castiglioni's design. The result is a highly spirited fusion with the surrounding greenery—a space in which Castiglioni feels "free and completely relaxed."

LEFT The garden terrace contains a large concrete seating area, a nineteenth-century chandelier with candles, a white lacquered table, and textiles decorated with Castiglioni's signature forms.

ABOVE In the "living room" patio, there are chairs from the 1960s, stools designed for Marni boutiques, and a bed and a sofa brought back from Java.

RIGHT A terrace at the back of the house with chairs from the 1950s and an instrument from the Orient.

PAGE 176 Castiglioni painted a wall in a guest room with geometric figures from the 1960s and 1970s.

PAGE 177 A sand-colored cement bath in one of the rooms.

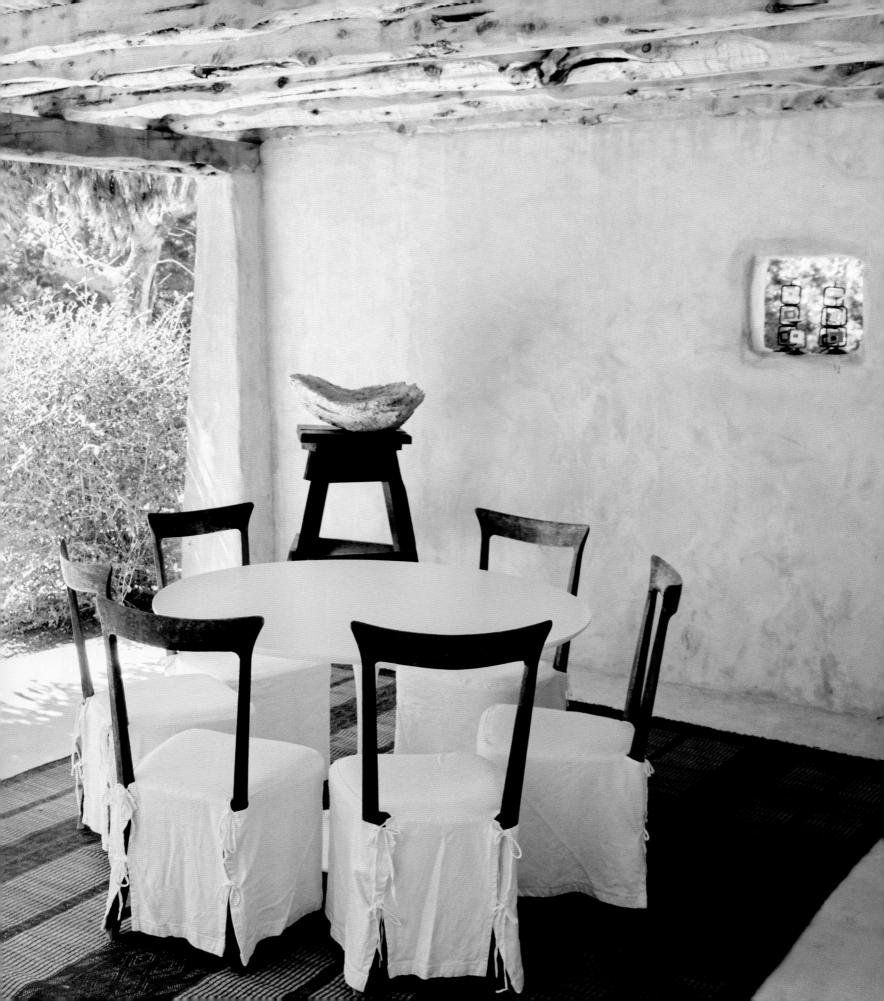

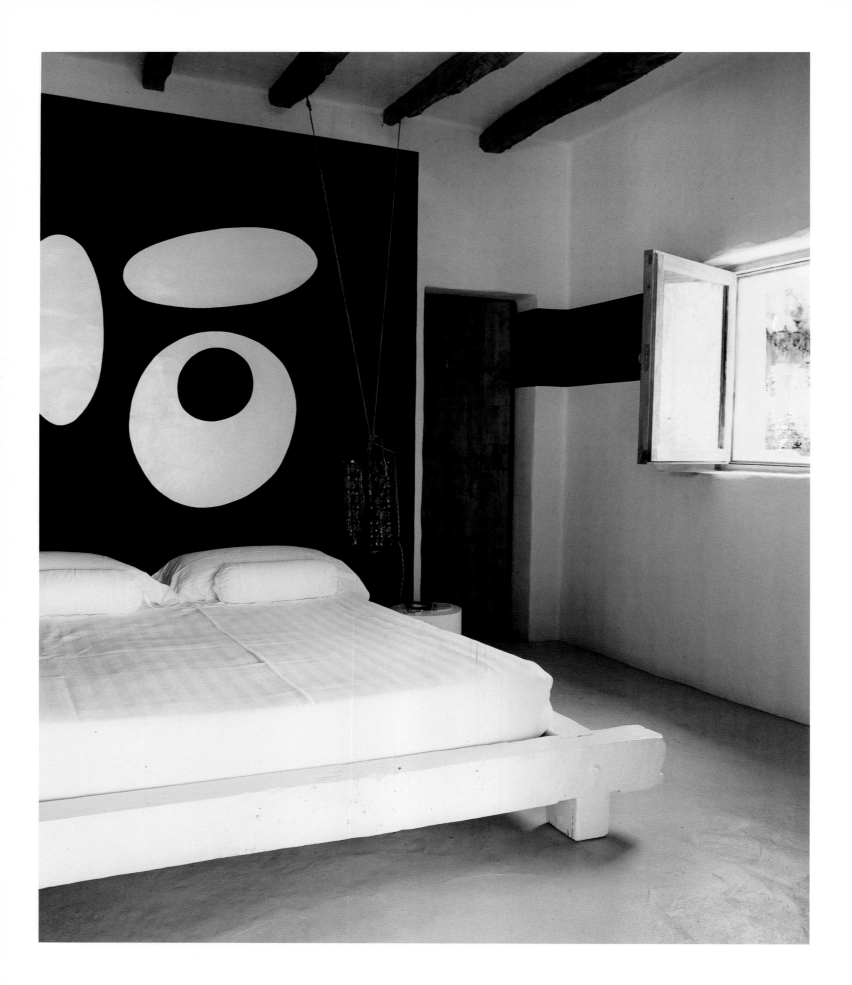

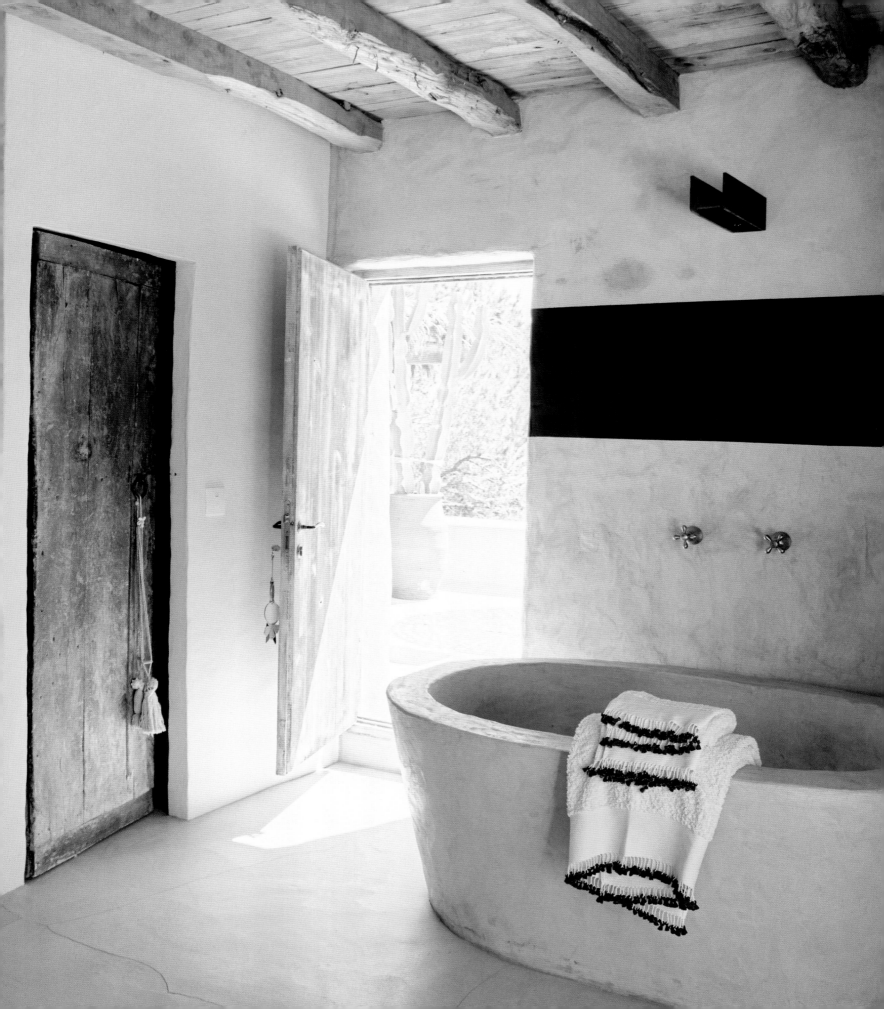

W H I M S Y

An interior with soul can also have a touch of whimsy: it can be fun, playful, and charismatic. If a tweak is a push against the principles of nature, whimsy is a break from them. But—as the cliché goes—you have to know the rules to be able to break them.

Any object of whimsy has to be a deeply personal choice. In fact, you could say that the more whimsical the object, the closer to your heart it has to be. Adding someone else's (e.g., a decorator's) idea of whimsy to your home will likely look—and feel—false.

Renowned stylist Lori Goldstein intuitively knows the rules of fashion—and just as intuitively knows how to break them. She is credited as being the first to mix high and low style—a Chanel jacket with jeans—and is known for her ability to make surprising combinations of colors, materials, and patterns "work." The images she creates for magazines are as high-spirited and unconventional as she is—yet all emit an underlying order and coherence that make them also feel timeless.

In 2001, Goldstein was looking for a loft with outdoor space. She had lived in Manhattan for twenty-five years, but never in a loft. "I love the open feeling of a loft: it makes a great canvas," says Goldstein. She found her dream place—on top of a flooring store on a busy Chelsea street. What sold her were the fabulous views and 1,400-square-foot terrace.

Goldstein called in interior designer Joe D'Urso and architect Brad Floyd to help modernize the kitchen with black granite and mahogany, build a fireplace, and add a partial wall to separate the entryway from the living room. But then Goldstein set to work making the

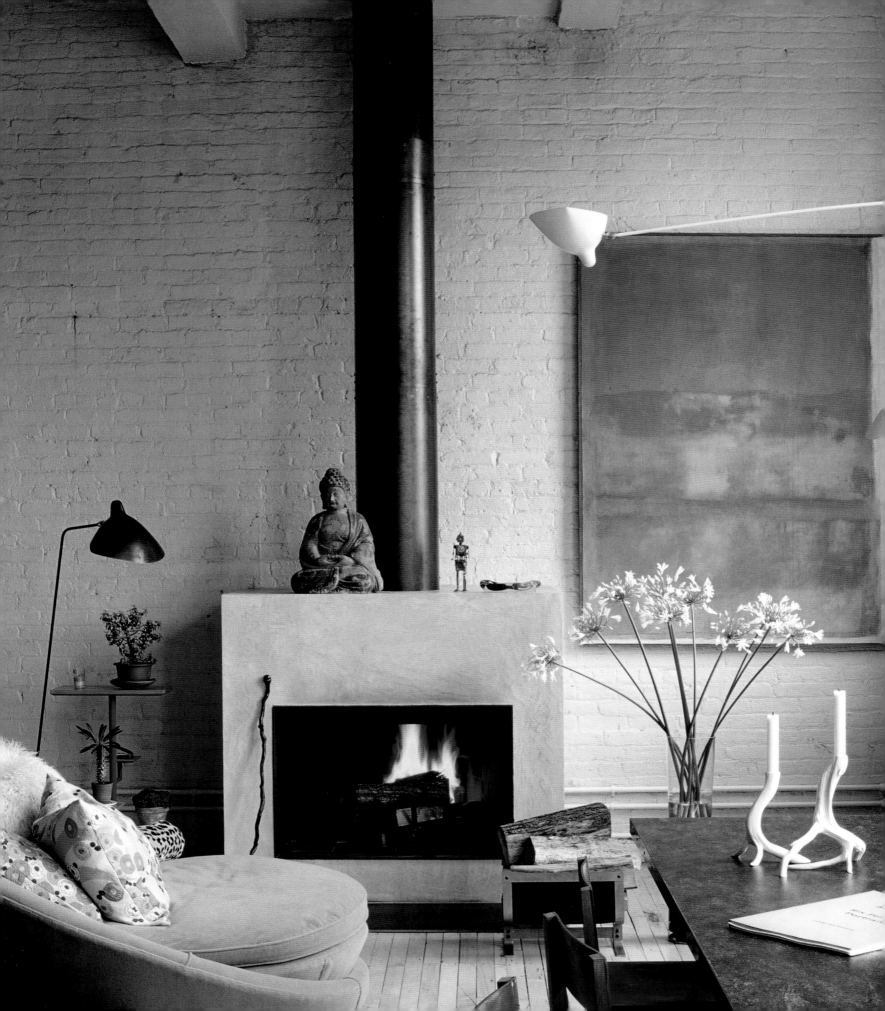

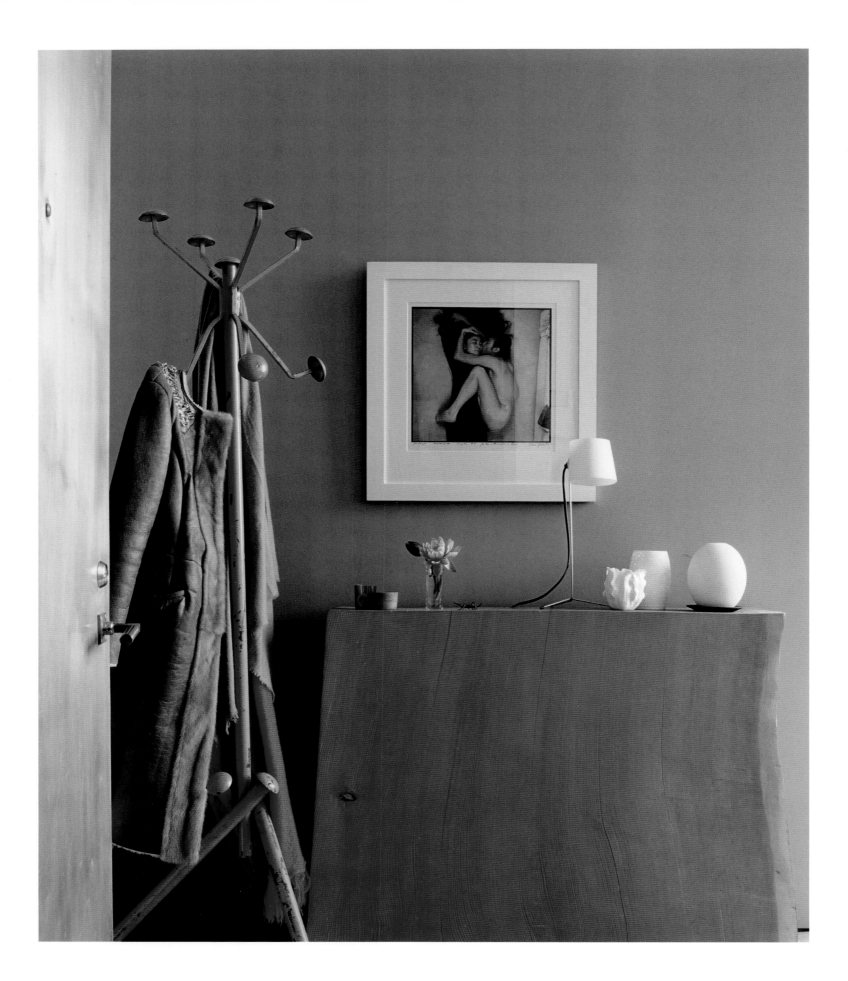

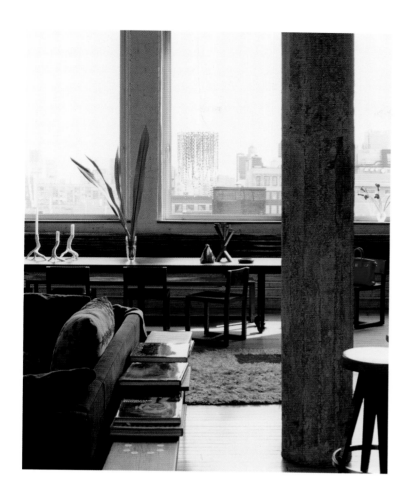
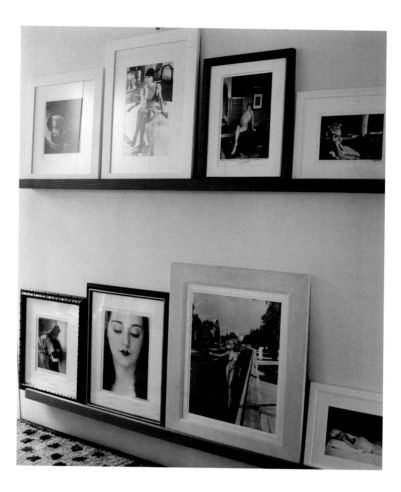

space fully her own—imaginatively mixing colors, forms, and materials with objects that resonate deeply: porcelain ceramics by Ted Muehling atop a chest-sized chunk of weathered wood; a beloved Prada shearling coat hanging from an early twentieth-century coat rack; the iconic Annie Leibovitz image of John Lennon curled up beside Yoko Ono, a gift to Goldstein from the photographer.

PAGE 179 A Buddha shares the fireplace mantel with a robot sculpture in the main room. The Rococo porcelain candleholders are by Ted Muehling, and the cast-bronze fire stoker is by Michele Oka Doner.

LEFT A beloved Prada shearling hangs on an early twentieth-century French coat rack in the entry; the iconic Annie Leibovitz image of John Lennon curled up beside Yoko Ono was a gift to Goldstein from the photographer.

ABOVE, LEFT A linoleum-and-bronze table by Joe D'Urso.

ABOVE, RIGHT A gallery of photographs by Horst, Jacques-Henri Lartigue, Helmut Newton, and Peter Lindbergh, among others.

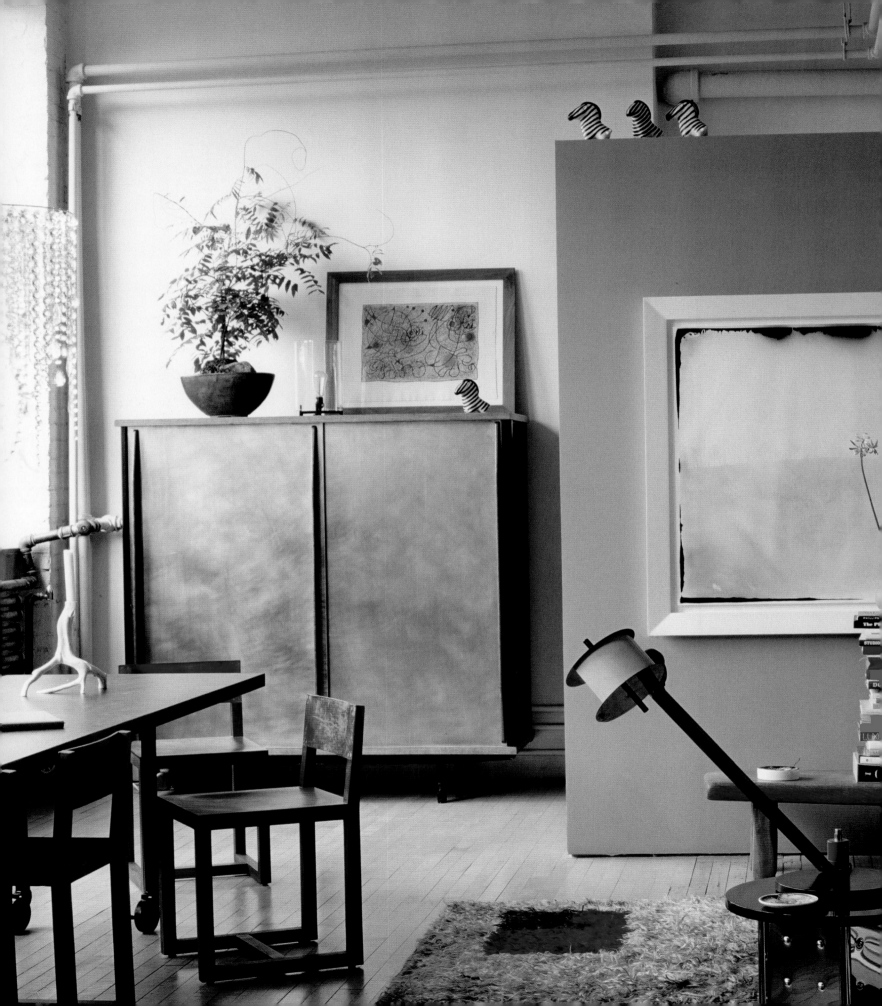

Her loft's mix of "proportion, harmony, and love," as Goldstein puts it, is peppered with her signature playfulness: Hans Wegner's Papa Bear chair was reupholstered in a Donghia fabric featuring little red dogs; a rug with Robert Indiana's "Love" logo serves as a bathmat; a vintage artichoke lamp by Poul Henningsen hangs in the kitchen; a Buddha shares the fireplace mantel with a robot sculpture.

"This is my domain, and it's for my delight. Hopefully others will feel that, too," says Goldstein. "My house is like a painting. But I can paint over certain areas that I feel the need to change. Some mornings I wake up and just start rearranging things, and it's a new home by the afternoon."

LEFT A 1960 lithograph by Joan Miró is propped on a vintage armoire by Jean Prouvé; on the wall is a 1996 photograph by Sally Mann.

STUNNING
DETAIL

Of course, not all of us have the luxury of large loft-like rooms to play around in. How do you create surprise in a smallish space? The key is not to overwhelm either the space or the eye.

One effective way is through the use of extraordinary detail—small sculptures, finely wrought furniture, exquisite artwork—that subtly delights and intrigues. But in an intimate environment you have to be even more conscious of maintaining unity—through color palette, flooring, or other measures.

When Juan Montoya first saw his Parisian pied-à-terre, situated at the heart of the legendary Saint-Germain-des-Prés district, it was "a shambles": no two walls were parallel, there was no kitchen or bathroom to speak of, and countless layers of paint obscured the original surfaces. And yet he realized that beneath it all he had found a *bijou*—a jewel—with 13-foot ceilings, beautiful hand-hewn exposed beams, and a pair of French doors opening onto a terrace that overlooks an inner courtyard.

But the fourth-floor walk-up measures no more than 600 square feet. How to create space—let alone surprise—where there is none? Montoya began by replacing the hodgepodge of floor surfaces with long vintage oak planks. In addition to being inherently beautiful, they lead the eye from the entryway to the French doors. "How you arrive in a space is very important," says Montoya. "What are the layers of discovery? You don't want to give everything away at once."

Montoya's long, narrow hallway sets the stage for what's to come. A convex French antique mirror, a fragile bronze standing sculpture, plaster fixtures in the shape of shells—all keep your brain intrigued as you make your way to the living room.

Once there, a striking graphite drawing on canvas "representing infinity" becomes the backdrop for a Louis XVI architect's desk; exquisitely proportioned eighteenth-century Scandinavian armchairs; and a slate-topped coffee table designed by Montoya that features delicate legs. "Good design is all about detail," says Montoya. "Whether it's a pied-à-terre or a palace, you have to pay attention to every decision, every gesture. It's what makes a home sing."

Montoya's cohesive color scheme, which runs from stark white to dramatic browns, allows all of the stunning details to quietly pop. "Every element—color, texture, scale, lighting—functions in relation to the others," says Montoya. "Especially in a small space, you need to make sure that you have a perfect integration of all of the parts."

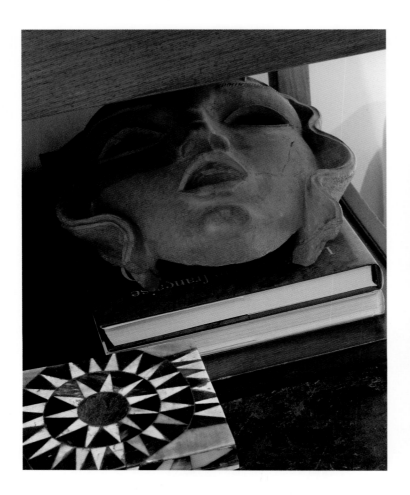

ABOVE, LEFT A French 1920s mask is used as a paperweight.

ABOVE, RIGHT A bronze sculpture by Raphael Scorbiac.

RIGHT A bronze-and-linen sculpture by Manuela Zervudachi.

RADIANCE

We have been taught that glamour can be bought. Wear the designer logos, drive the fancy car, join the most exclusive clubs—and you will "appear" to be leading an enviable life of glitz, glimmer, and gloss.

And of course on some level you will. But true glamour—radiance—starts within: within yourself, the people you surround yourself with, the beautiful home you create. Radiance has no need or desire to be replaced every three months with a glitzier version; radiance doesn't care what others think.

In collection after collection, Alberta Ferretti captivates the senses with her extraordinarily rich colors and sensuous fabrics. Her exuberance, however, never overwhelms elegant proportions, and she applies the same aesthetic discipline to her homes—even her "home on the water," as she calls *Prometej*, her 147-foot Russian icebreaker.

Now, a yacht without a nautical theme is certainly a surprise unto itself. But *Prometej*, which was used by Russian fleets during the Cold War to clear paths through the ice-covered seas of Russia's northern coast, has been transformed into a deeply glamorous vessel of authentic luxury.

Ferretti immediately fell in love with the boat's large spaces and elegant lines. But it took her two years to create the "emotional warmth that I like to have in all my houses." She says that in *Prometej*, which means "Goddess of Fire" in Croatian, she recognized fundamental elements of her personality: "On the outside, there is that practicality that comes from the

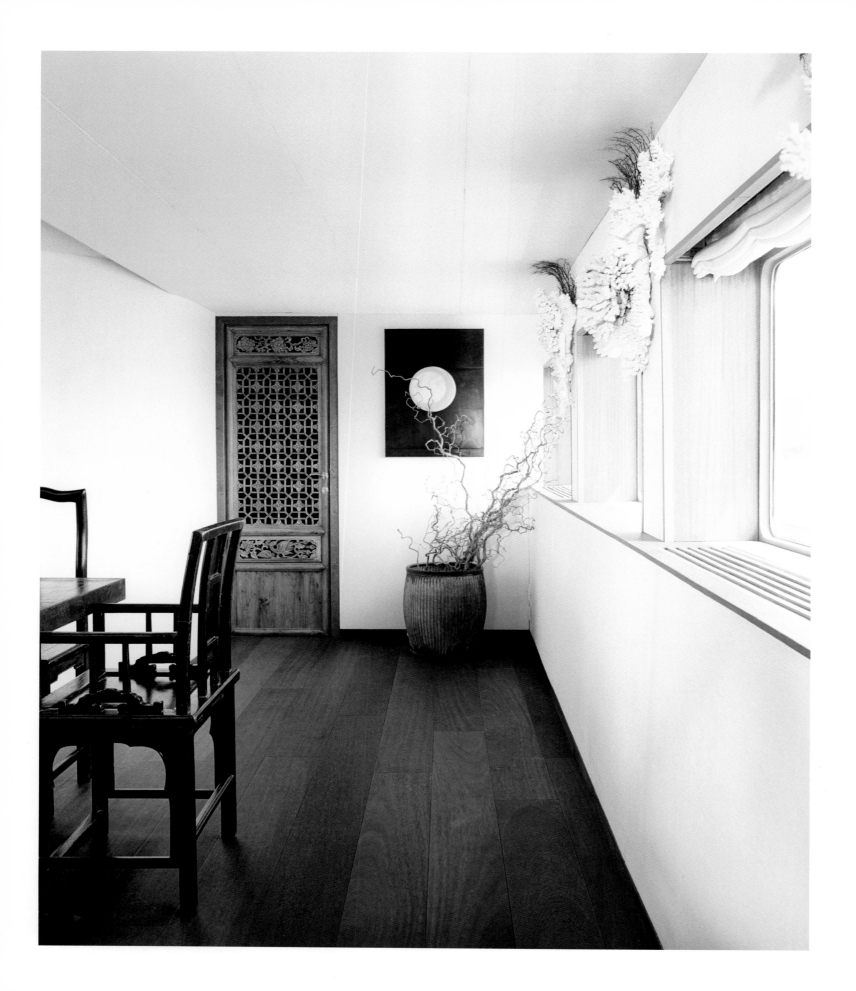

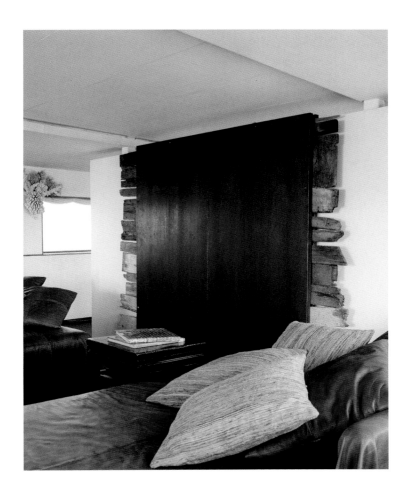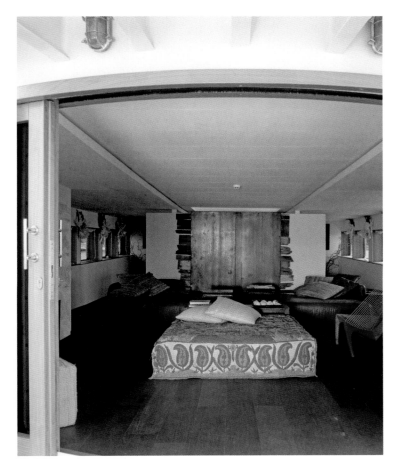

need to have my feet firmly on the ground. But on the inside, you find dreams, poetry, and magic—all the aspects of romanticism that characterize my personality and my work."

Those dreams, poetry, and magic mix to create a sensuous, often surprising glamour. "Every piece I chose for this boat is an expression of a particular feeling or moment in my life," she says.

The exquisitely elegant dining room is enlivened by marine-inspired coral decorations above the windows. Contemporary artwork is peppered throughout the ship, most dramatically in

PAGE 191 A chair by Jørgen Høvelskov (1968) in the living area.

LEFT In the dining room the windows are punctuated by marine-inspired coral decorations.

ABOVE, LEFT An installation by Jannis Kounellis is a subtle focal point in the living area.

ABOVE, RIGHT An antique French throw adds a shot of glamour.

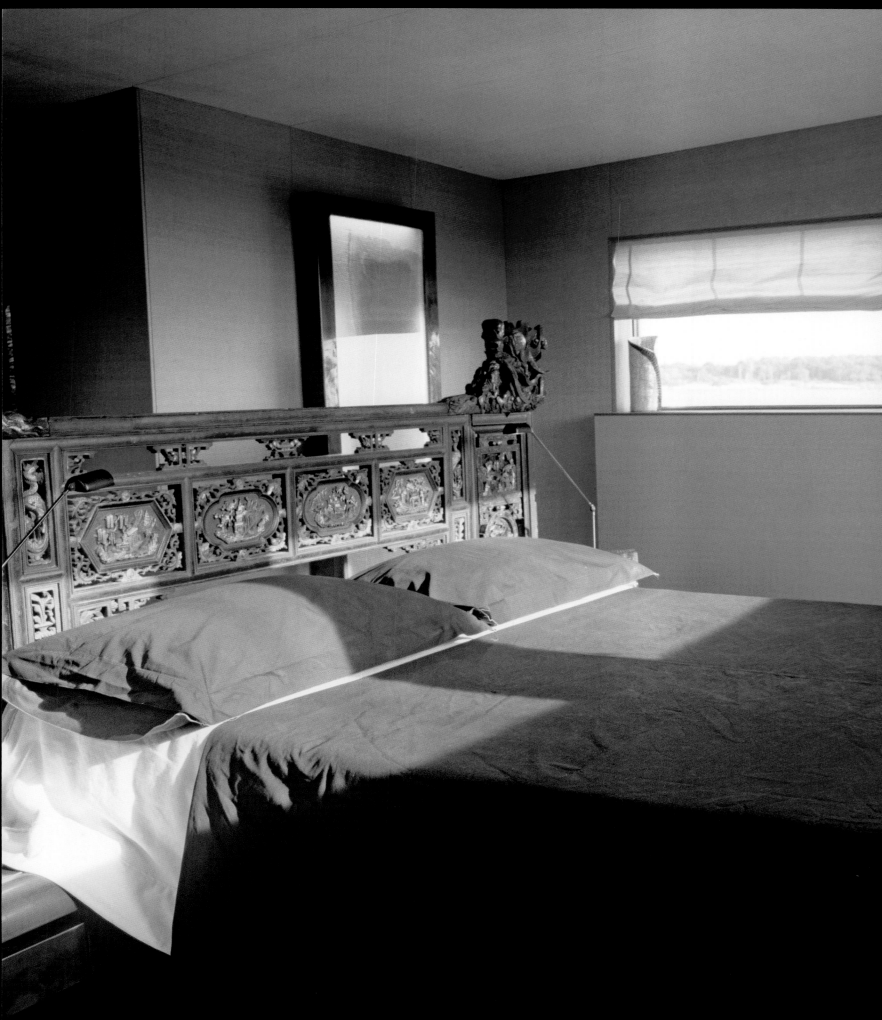

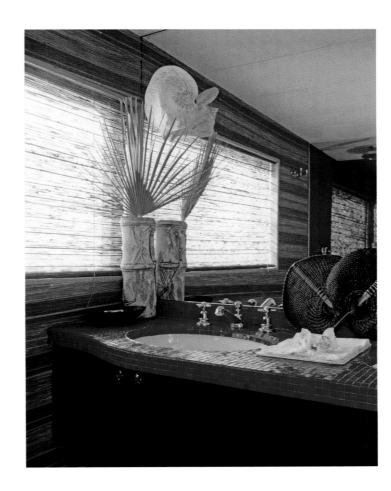

the installation Jannis Kounellis created for the living area. The walls of the cabins are covered in organic raw silks and linens, and provide a sensuous backdrop to an array of artifacts and antiques: gilded Balinese furniture; an antique Indian bed that Ferretti found during one of her travels; a Chinese piece from 1700 that became the headboard for the master cabin. Ferretti's passion continues into the vividly tiled bathrooms.

"I think the environment you live in is like a dress," says Ferretti. "It must follow your evolution and change with your feelings."

LEFT An antique Indian bed, discovered by Ferretti during one of her travels.

ABOVE A sink is installed in a bright mosaic-tiled base in front of a mirror wall in the master bathroom.

GRANDEUR

All great music touches the soul.
You are carried off for a brief time to a better world.
—ISAAC STERN

Across cultures and throughout the ages, architects have sought to create the most glorious cathedrals, the most majestic museums, the most stately government buildings. They understood that architecture could help us feel simultaneously in awe of the universe and connected to it. That our surroundings could temporarily transport us to "a better world."

Grandeur is a strong force. By connecting us to something more powerful than ourselves, it can provide a deep sense of comfort and security. We gain strength; we often gain wisdom. But perhaps most important, grandeur can inspire in us a desire to be our best selves.

Many of us have experienced grandeur through music. We temporarily "lose ourselves" listening to a majestic piece, whether stuck in traffic or sitting in a concert hall. We reemerge, not transformed into a different person but elevated and inspired, better able to deal with life's inevitable obstacles and better able to help others deal with them as well.

Our homes have the potential to take us to this place on a consistent basis. They can help us look within—for strength, perspective. When catastrophe hits, we typically respond with soul-searching and reordered priorities. But however strong our intentions, by the next day/week/month we are often back where we were, muddled in the petty, the superficial. An

elegant, restorative home can help to elevate us above the superficial; it can strengthen us to stay focused on the larger picture.

In recent years, grandeur has often been confused with grandiosity, the sort of aesthetic that results in gratuitous drama and ostentatious over-design. But grandeur is not about "fantasy spaces," which are essentially escapes from life, from ourselves. True grandeur in a home is actually quite subtle and deeply authentic. Proportions are balanced to create elegance and intimacy, stillness and majesty.

Grandeur is most easily achieved through scale—high ceilings, floor-to-ceiling windows, large chandeliers—or through geometric forms rooted in history and nature: round or pointed arches, stone columns, vaulted ceilings. But grandeur is also a feeling that can emanate from an artwork or a single piece of furniture—a feeling of being transported, of transcending time, place, and circumstance. A feeling of elevated equanimity.

PAGE 196 The front doors of this Eleanor Cummings–designed home are 1850s Italian oak. The Italian chandelier was originally a thurible in which incense was burned in a church.

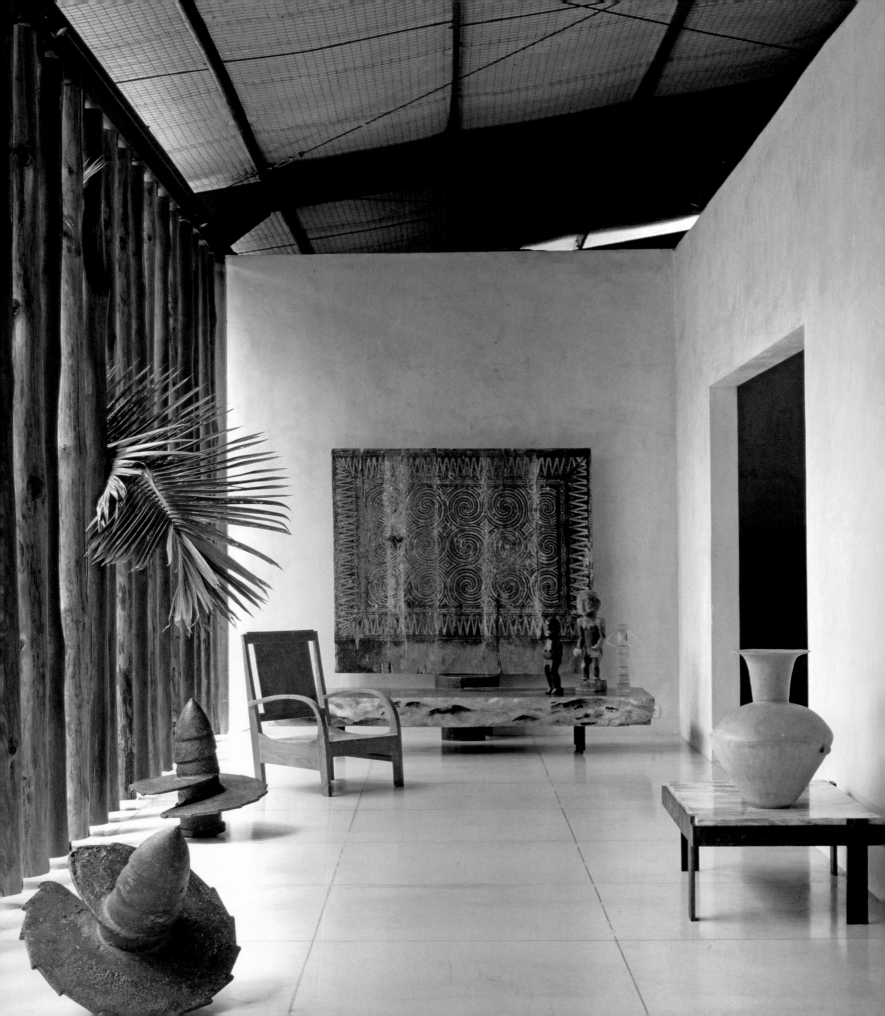

SCALE

We are hardwired to gain comfort and strength from grand pieces because the grandness of nature—mountains, coastlines, and fields—allows us to feel connected to something larger than ourselves. But when using grand pieces in your home, you need to be careful not to overwhelm. Proportion is key, but so is texture. Sensual materials humanize large spaces and objects.

In 1990 Parisian designer Jérôme Abel Seguin abandoned his career styling windows for Hermès, Louis Vuitton, and other luxury brands to produce furniture and sculpture from local materials found on the Indonesian island of Sumbawa. For more than a decade, Seguin spent half of every year on Sumbawa, transforming unique pieces of hardwood and industrial salvage into monumental objects. His pieces are doubly powerful—both massive and primal. "I want my work to make people dream," he says.

Tired of being so isolated and a bit exhausted from the globe-spanning commute, Seguin decided to move his home and business to Bali. Not seeing the kind of space he wanted to live and work in, he created it himself: a single-story, 4,000-square-foot hangar-like structure that contains three small enclosed rooms, asymmetrically arranged. "I cannot breathe in small spaces," says Seguin. "I worked to give this a feeling of a peaceful space, more horizontal than vertical."

Not coincidentally, it is the sensuality and exquisite gracefulness of his furnishings that make his majestic modern house feel like a home. A colonnade of salvaged telephone poles lines the entry, where two old iron drills lie near a Javanese colonial armchair and a wooden decorative panel from Sumatra. In the living area, a simple, all-white armless sofa, slipper

chairs, and a nineteenth-century Javanese teak bench surround a coffee table Seguin made from nineteenth-century teak beams framed with salvaged iron.

"Living in such a space—in fact, it's living *with* such a space—gives you a feeling of clarity, fluidity," says Seguin. "And living with natural elements—wood, iron, stone—provides an inexhaustible source of inspiration."

PAGE 200 A colonnade of salvaged telephone poles lines the entry, where two old iron drills sit near a Javanese colonial armchair and a wooden decorative panel from Sumatra.

RIGHT In the living area, a simple, all-white armless sofa, slipper chairs, and a nineteenth-century Javanese teak bench surround a coffee table Seguin made from nineteenth-century teak beams and salvaged iron.

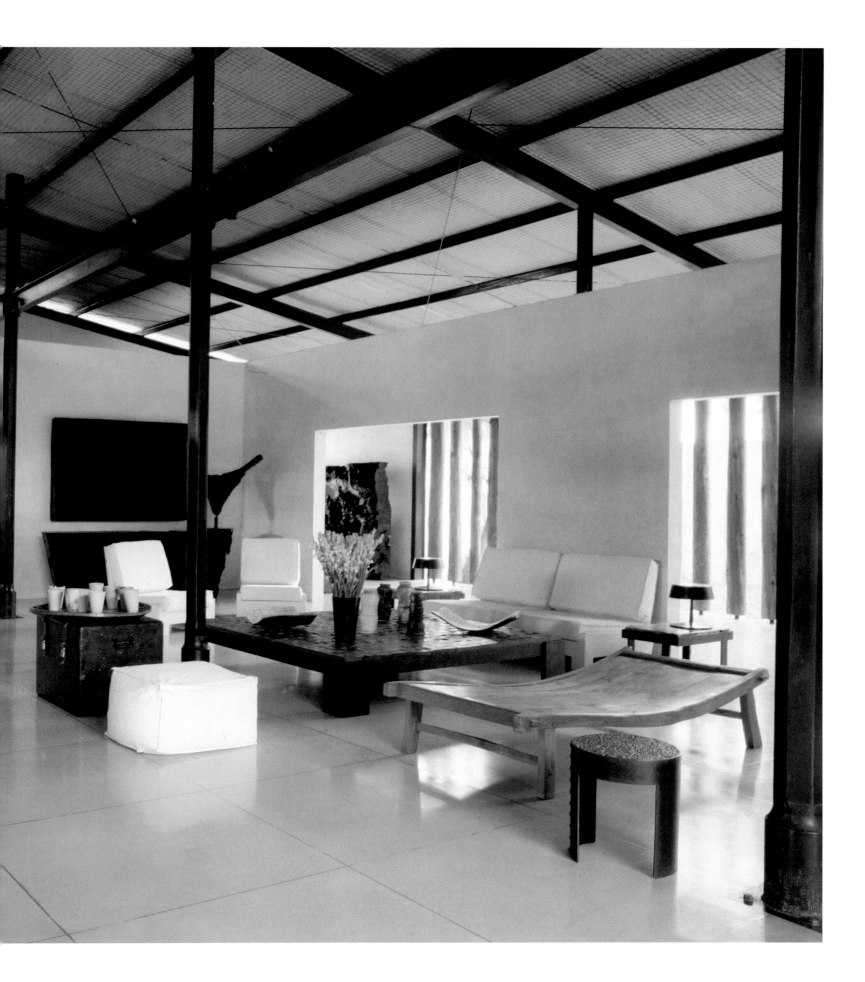

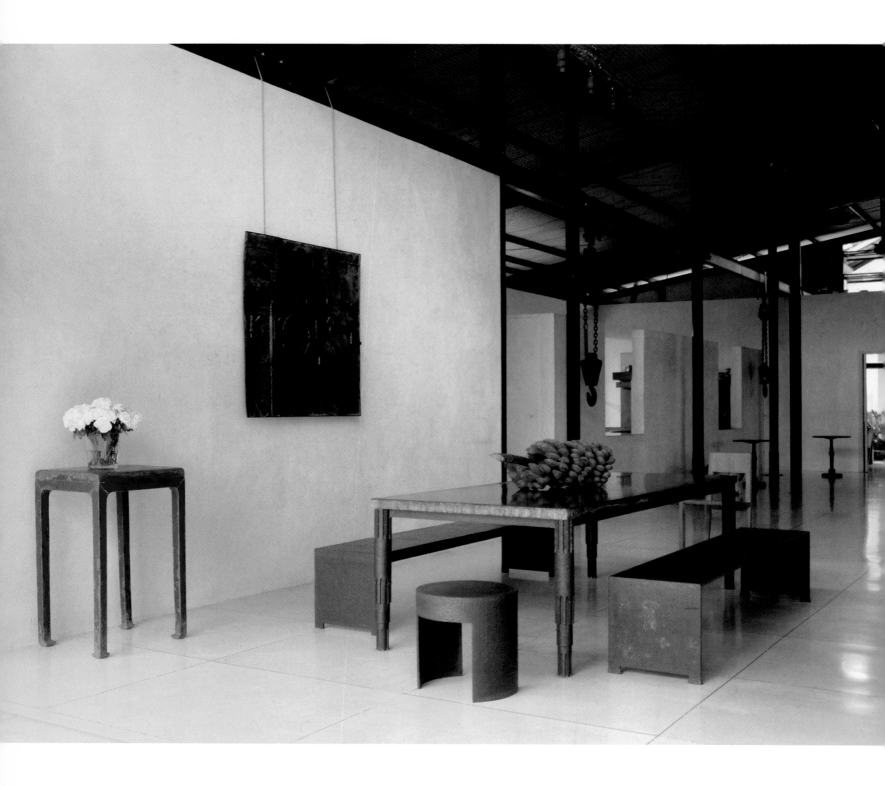

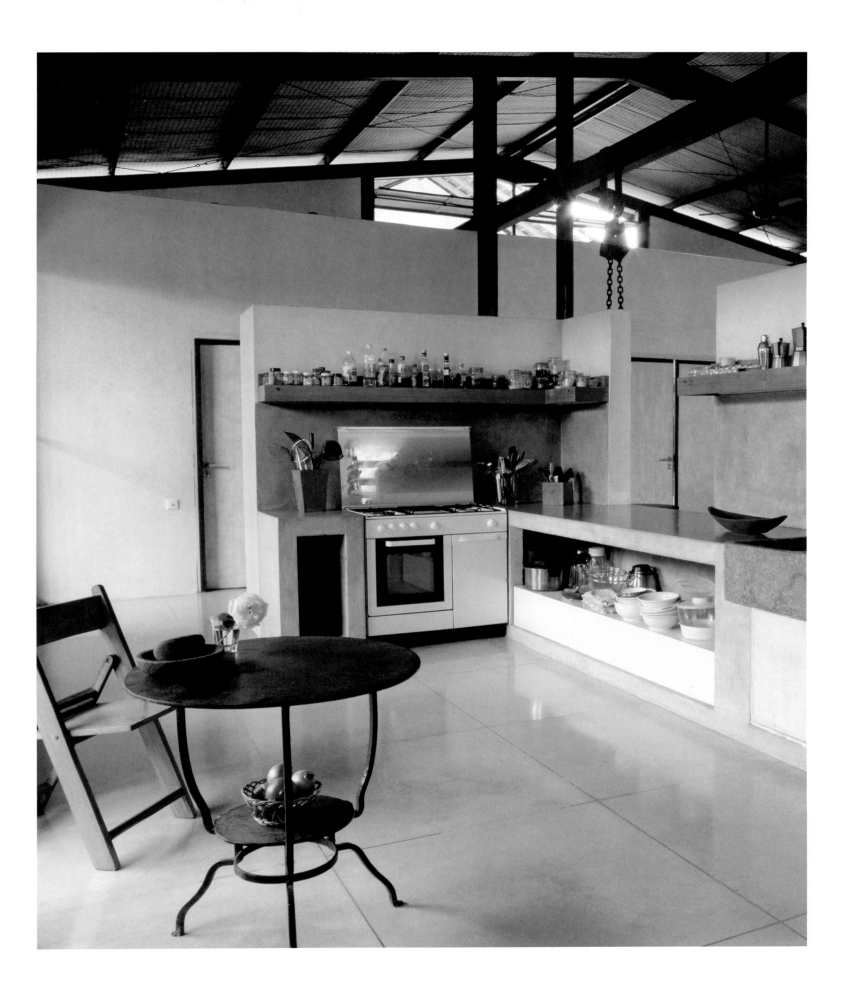

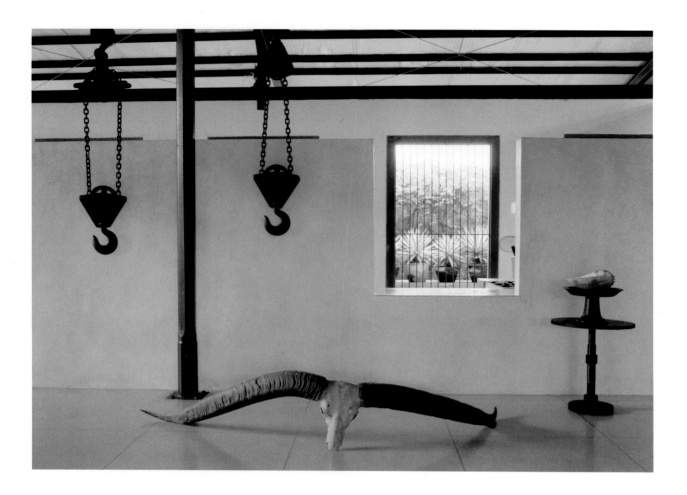

PAGE 204 In the dining area, benches and stools in recycled iron surround a table with a base of recycled iron and a top of granite brought to Java by the Dutch in the nineteenth century.

PAGE 205 In a kitchen of teak and polished concrete, an iron Dutch garden table circa 1920 contrasts with the terrazzo flooring.

ABOVE In a pass-through to the kitchen, a rare buffalo skull from the island of Sumba rests under vintage steel hooks and pulleys. To the right is Seguin's "Gueridon" table, made of salvaged iron; it holds a tray from Sumatra and a large shell.

RIGHT On the terrace, Seguin's iron table and console and three teak chairs from Java; the small boat is a model from Borneo.

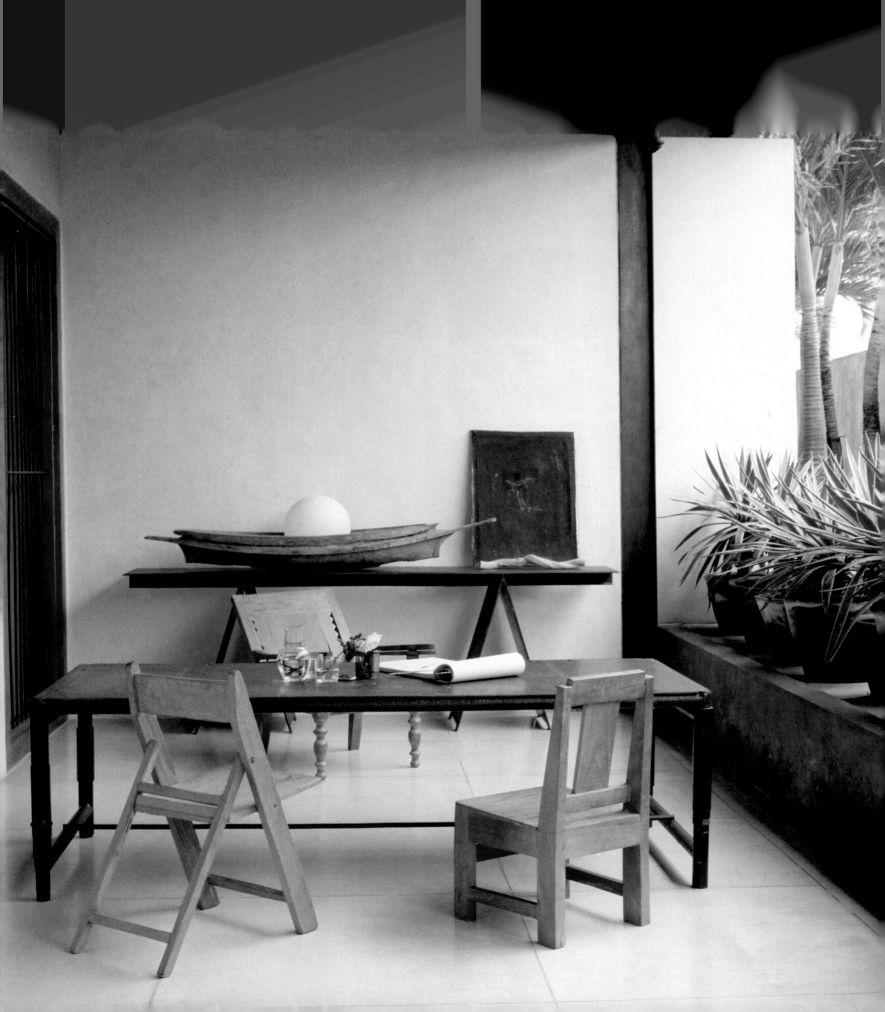

SYMMETRY

While too much symmetry can make a room look (and feel) static and uptight, a discerning use of it can be both grounding and elevating. "I love symmetry and use it a lot—with pairs of doors, sofas, or consoles," says Spanish designer Isabel López-Quesada. "But I also love to break it up, so you can 'read' the symmetry but the end result is not too stiff."

After decorating homes across Europe for more than twenty years, López-Quesada has mastered the art of balancing symmetry and asymmetry. "Symmetry gives you harmony, peace; asymmetry gives you joy," says López-Quesada. "Perfection is boring—and at the end, it's a lie! So it is better to combine both."

In the Segovia region of Spain, on an estate with mountains on one side and wheat fields and holm oaks on the other, López-Quesada worked with architect Pablo Carvajal and landscape designer Fernando Caruncho to design a grand farmhouse with a central courtyard, a style that is typical of rural Spain. On the ground floor of Casa Aldeallana (*aldea* means "little village"; *llana* means "flat"), there is a double-height drawing room opening onto a large arcaded veranda that overlooks the garden. An unpainted wood chimney serves as the centerpiece for symmetrical seating: sofas in aqua linen; oak tables that were originally beds for children; round white porcelain stools.

But the symmetry of the room is offset by creative groupings of books, candlesticks, and artifacts, as well as by a range of textures. "We looked for old, weathered furniture to go with the spirit of the house," says López-Quesada.

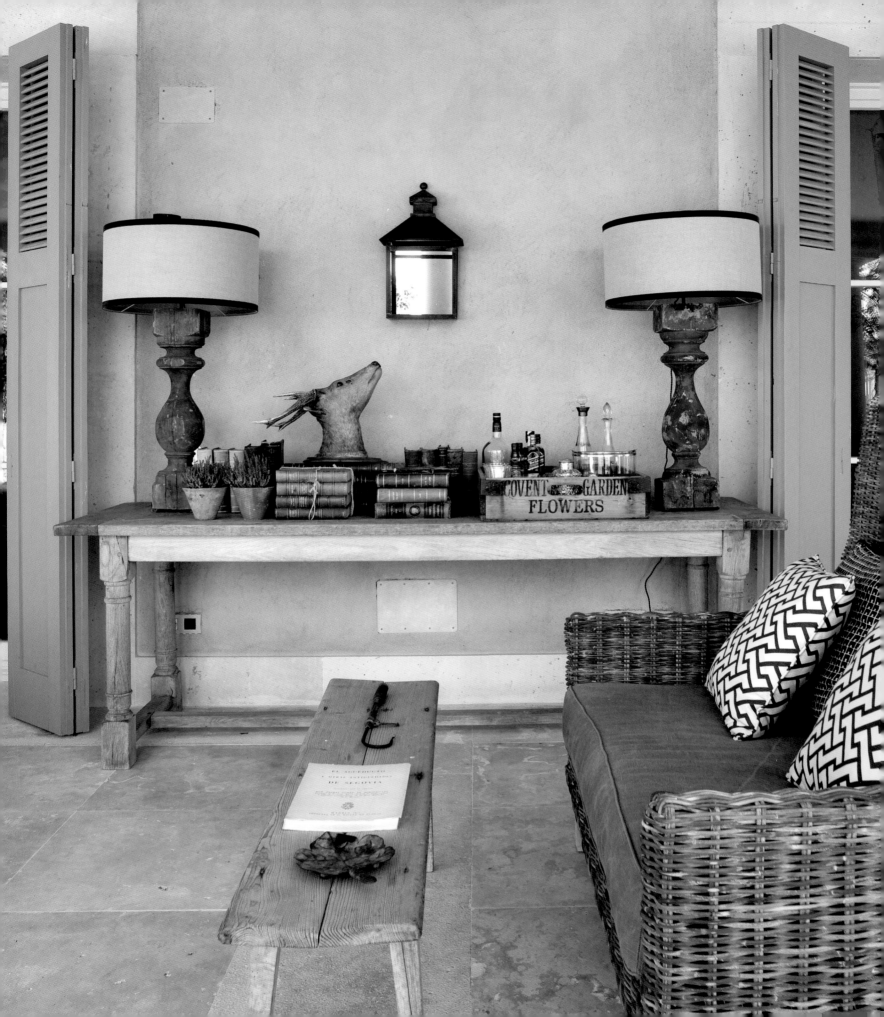

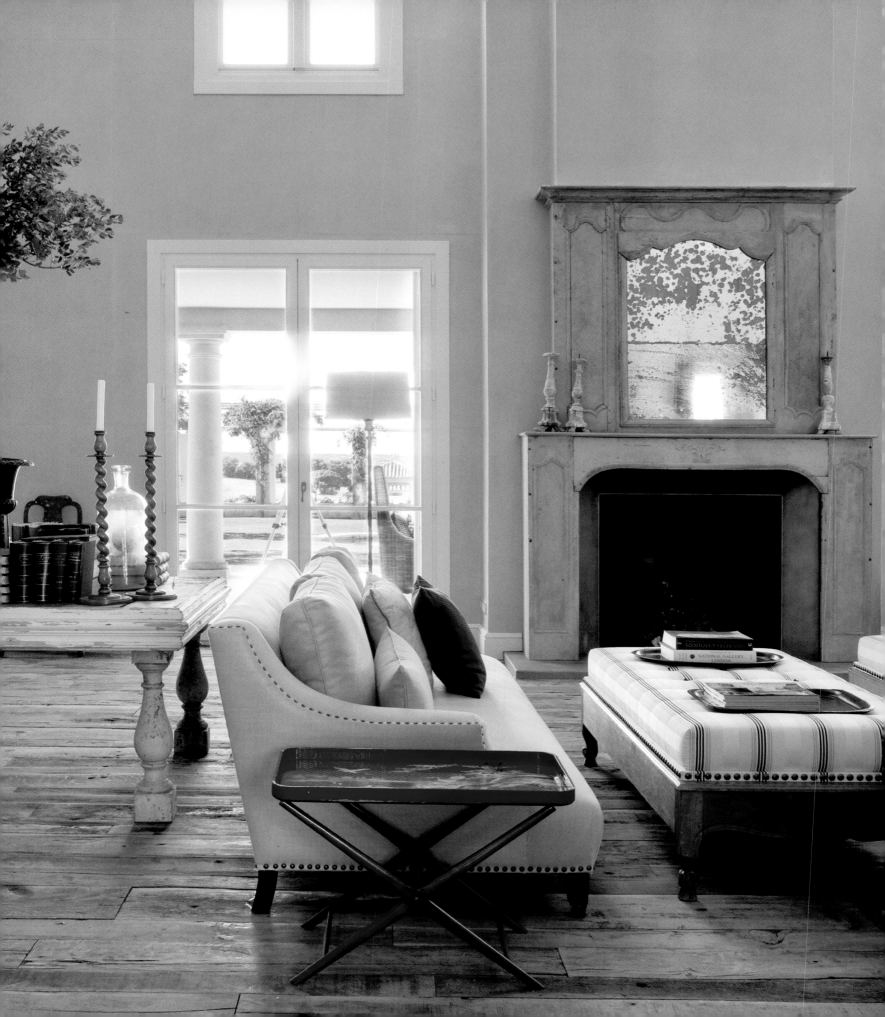

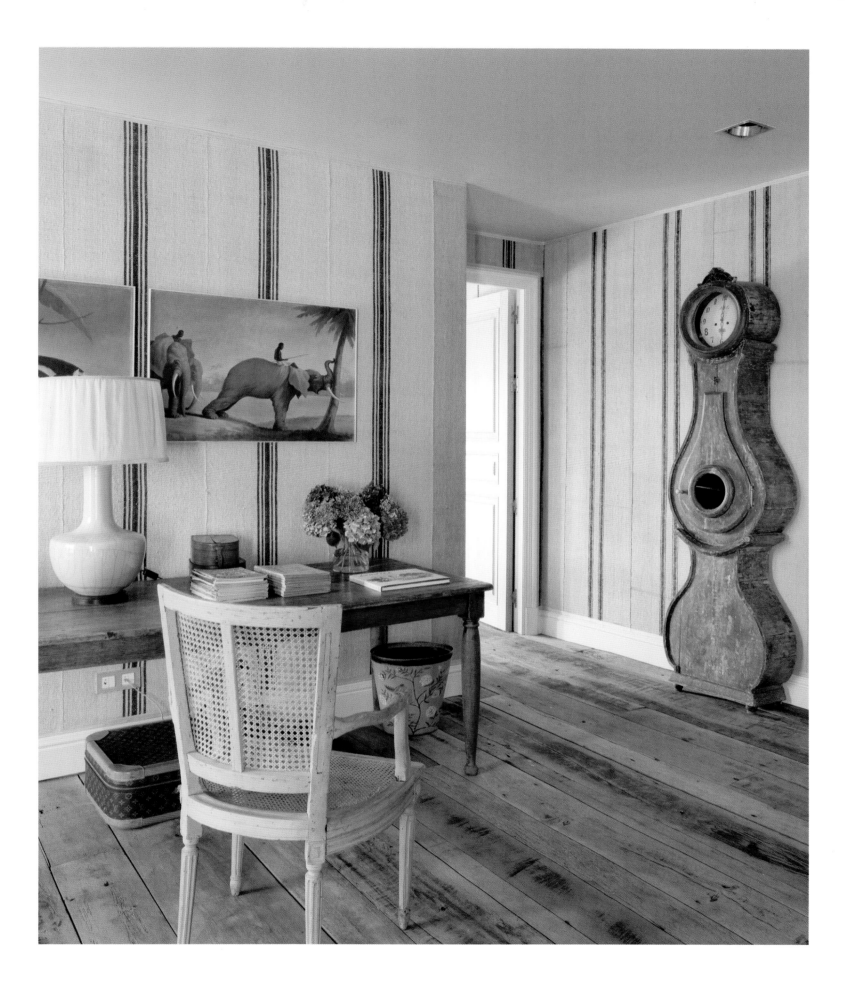

This combination of symmetry, purity of materials, and originality of design can be found throughout the house and creates an aura of what López-Quesada calls "good vibrations." Says the owner: "Even the most ordinary activities—setting the table for guests, cutting flowers from the garden and putting them in a vase—fill you with pleasure."

PAGE 209 On the back patio, two lamps made from old balusters, topped with raffia shades, create a subtle symmetry; a rattan sofa holds cushions covered in a spirited David Hicks fabric.

PAGE 210 In the double-height drawing room, seating is grouped around the unpainted wood chimneypiece, which came from the South of France. There are two coffee tables that were originally children's beds. The table behind the sofa is French, filled with a variety of collections.

PAGE 211 The sitting room's walls are lined with striped Transylvanian linen, echoing the old oak planks of the floor. An antique French table and chair serve as a desk, setting off an eighteenth-century Swedish clock.

RIGHT The breakfast room has a French stone chimneypiece; the rattan chairs around the wooden table are Belgian.

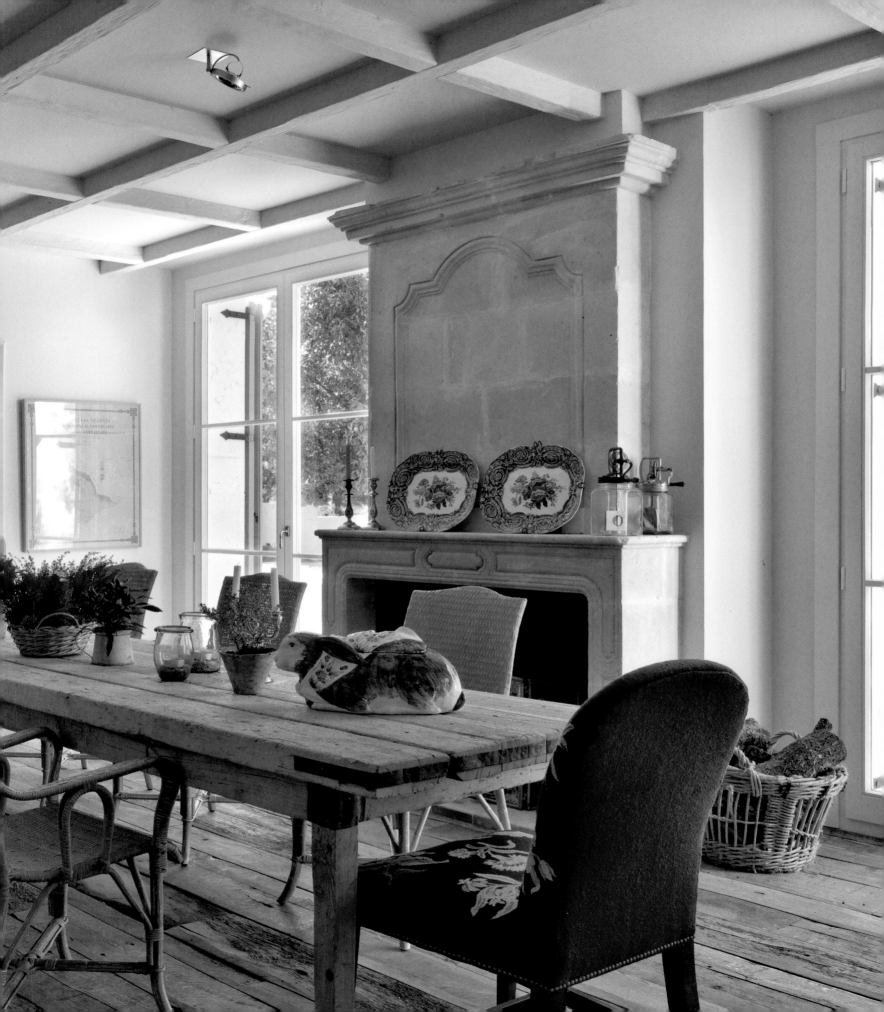

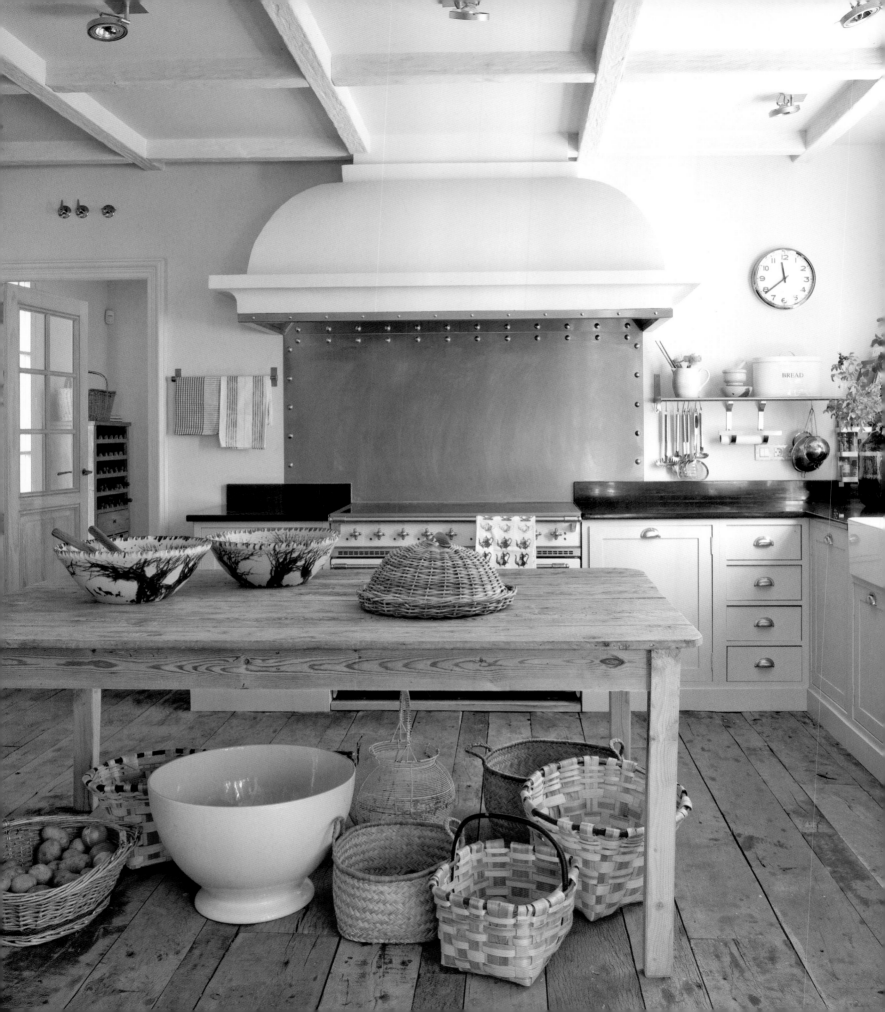

LEFT In the kitchen, the cooker hood and studded stainless-steel back panel were designed to be the focal points of the room.

BELOW, LEFT On the veranda outside the dining room is a pine table with two iron planters filled with heathers and ornamental cabbages.

BELOW, RIGHT In a corner of the drawing room, an English console that came from a conservatory sits behind a chaise longue from France. Stucco on the walls in a pale concrete color creates a contrast with the old oak of the floor.

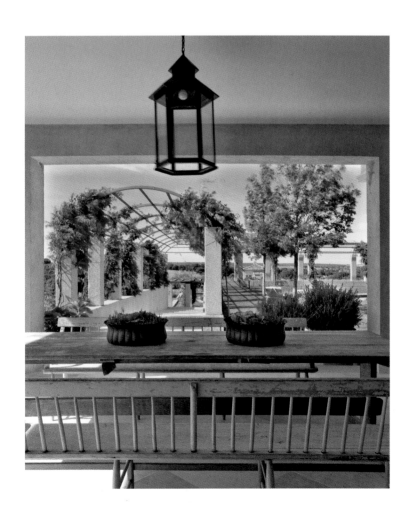

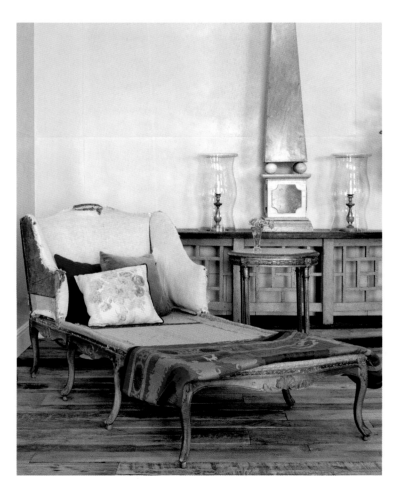

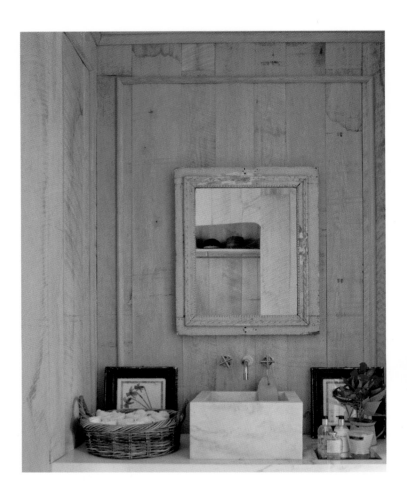

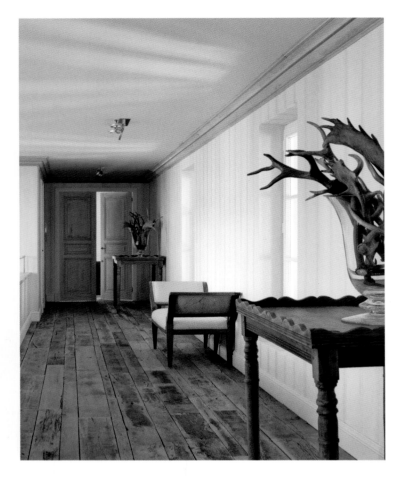

ABOVE, LEFT The guest bathroom walls are natural oak. A thick piece of marble allows for a simple sink.

ABOVE, RIGHT Two floral atelier tables create symmetry across the second-floor gallery, with a French bench in the middle. On the walls, painted stripes imitate antique paper.

RIGHT The floors in the main bedroom are made from reclaimed oak and chestnut; the walls are covered in Eastern European linen.

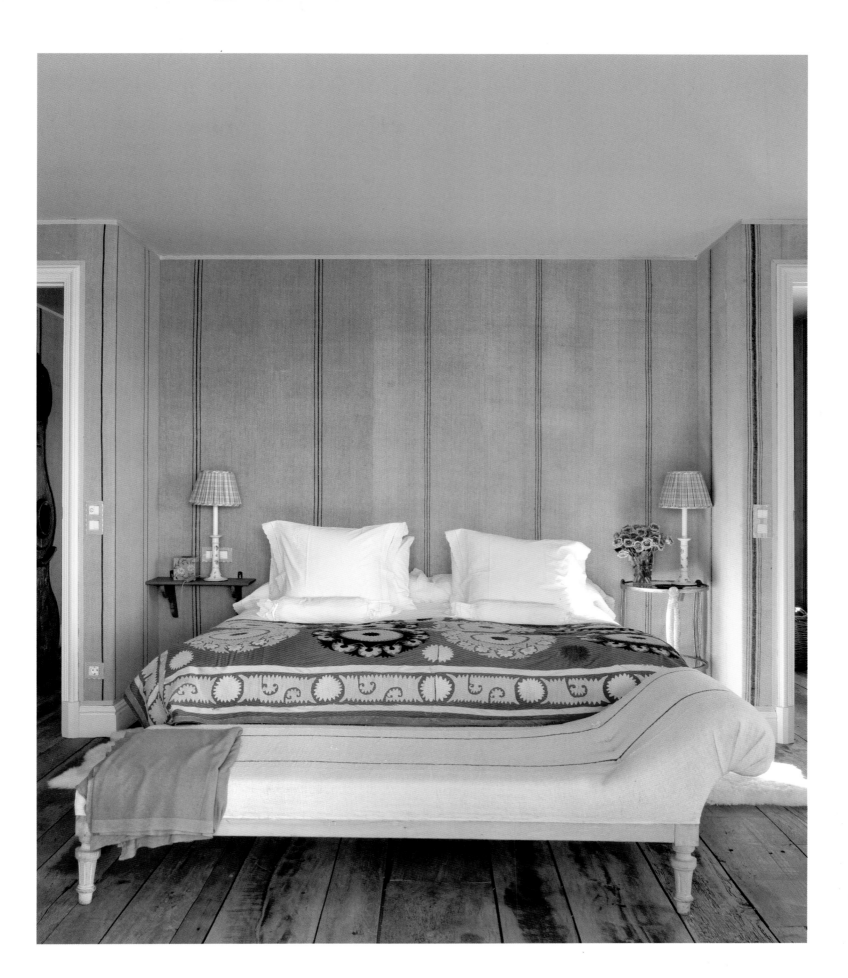

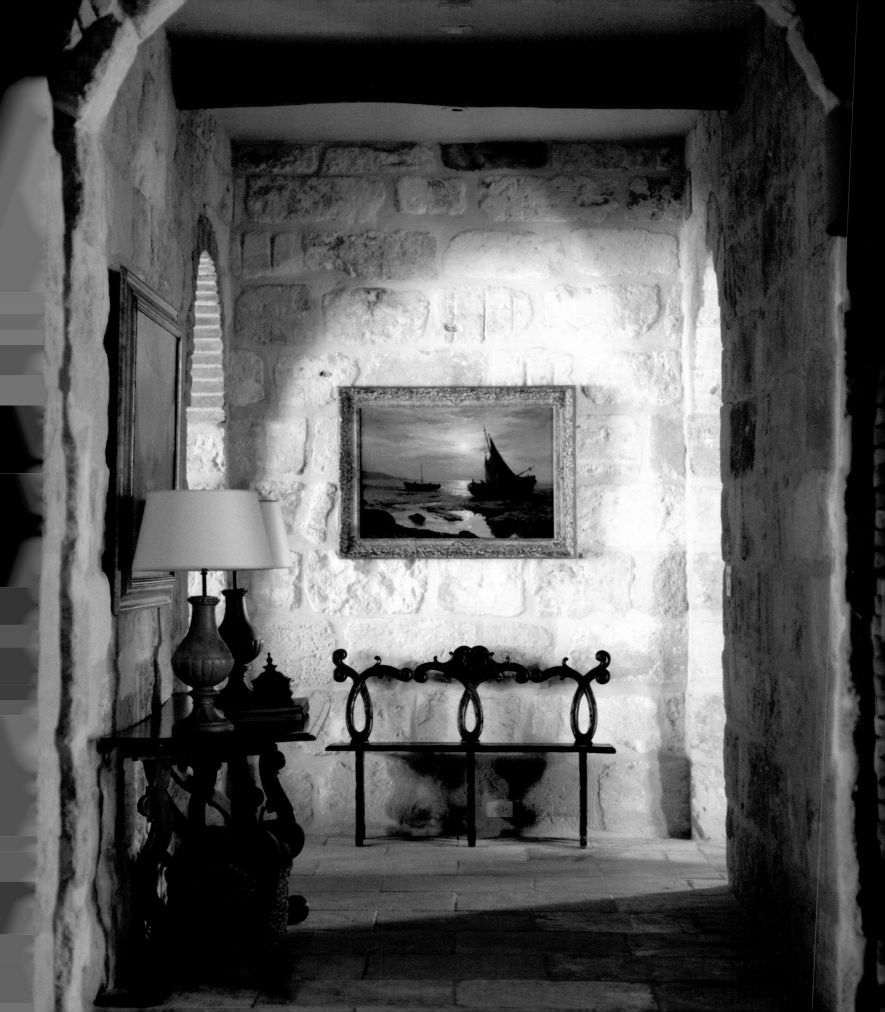

SENSE
OF HISTORY

Feeling connected to history—our own, the world's—is grounding, which is why it can feel so good to share your home with vintage photographs, antiques, and artifacts. Certain architectural elements that have been used across cultures and centuries—arches, beams, columns, moldings, grand staircases—can inspire as well. These elements affect us not just because they turn up repeatedly throughout history but also because they are rooted in the fundamental geometry of nature.

The key here is to imbue your home with a "sense" of history, not history itself. While a period room—seventeenth-, eighteenth-, or nineteenth-century—may look beautiful in a museum, it will feel stale and inauthentic in your home. (A room full of twentieth-century furniture may simply look dated.)

In 2008, designer Eleanor Cummings was given the challenge of creating an Italian country house—in the middle of Houston, Texas. The clients were a couple in their thirties with three young children, and it was the husband who drove the design. "It became his obsession," says Cummings.

Cummings was able to create a house that was grand yet graceful and intimate by combining rough-hewn reclaimed materials from Italy and France—stone flooring, brick arches, wood-beamed ceilings, stately oak doors—with luxurious floor-to-ceiling silk curtains, plush velvet settees, and delicate iron chandeliers. "Mixing in artifacts, antiques, and reclaimed materials

'humanizes' a house," says Cummings. "That sense of history and mystery—where something has been, how it was used, who walked on the floors—is really intriguing to me."

The walls and most of the ceilings are muted plasters, which add another layer of richness, another connection to the past. "Plaster has such a wonderful luminosity," says Cummings. "It changes color in different light." The furnishings are a mix of the clients' inherited antiques and contemporary pieces. "Not everything worked together, but when it did it gave the room a 'quirky' or 'slightly off' look that I think makes a room interesting."

The result is a relaxed grandeur that has a hint of otherworldliness. "I feel like I am always on vacation," says the homeowner.

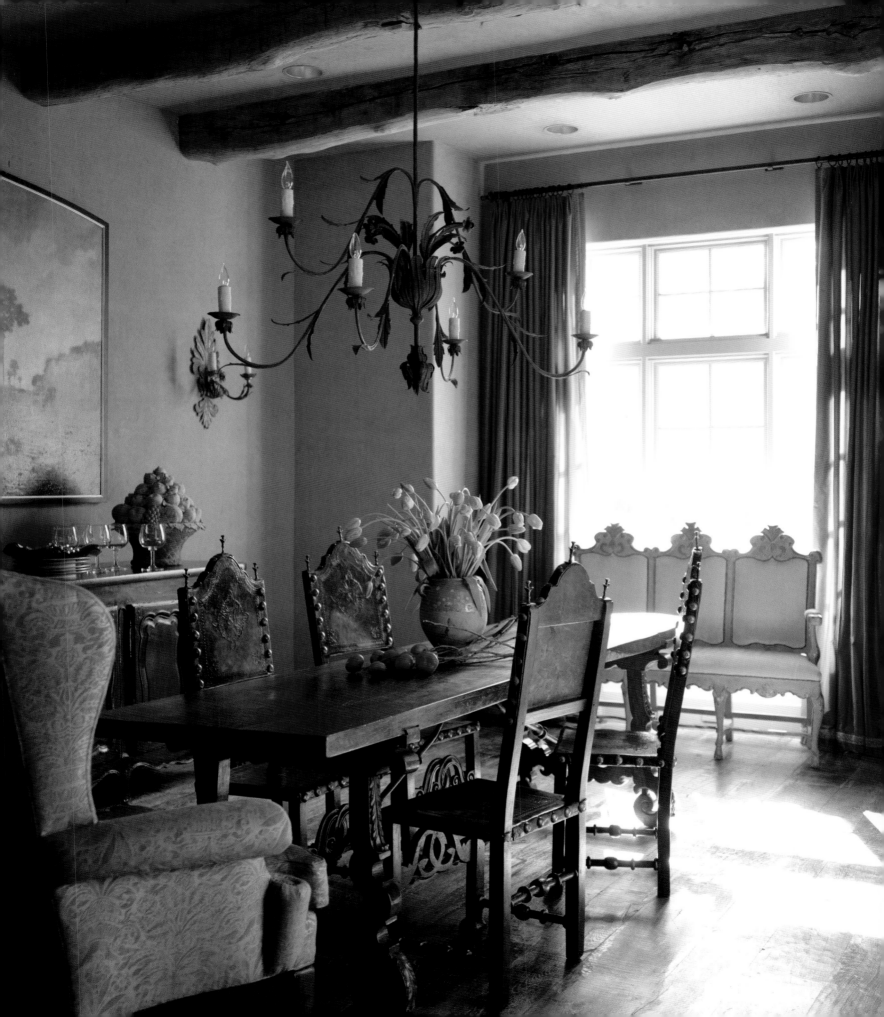

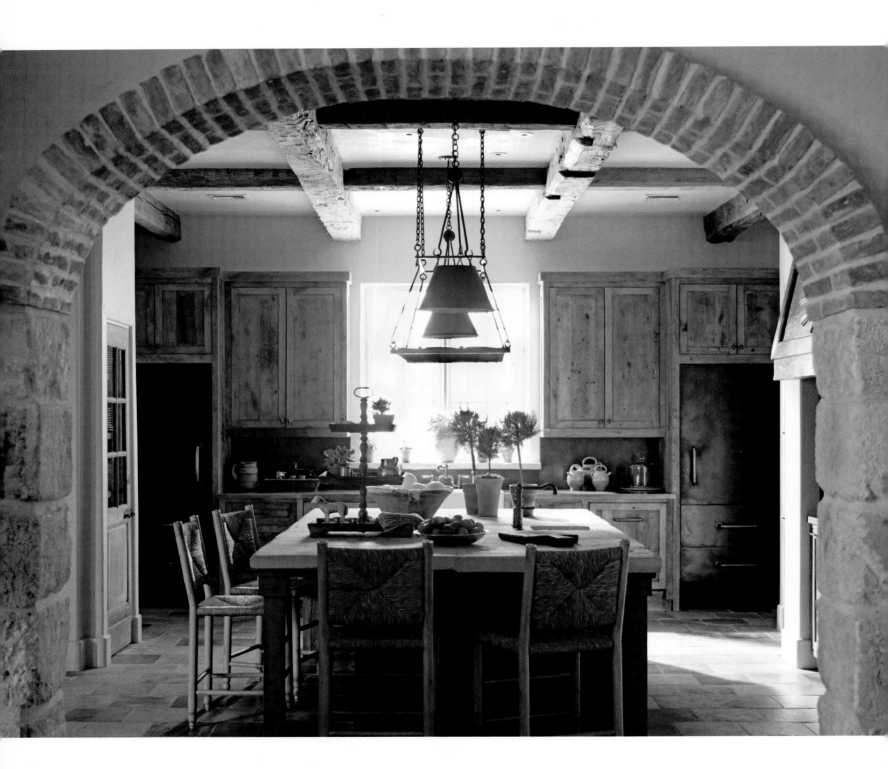

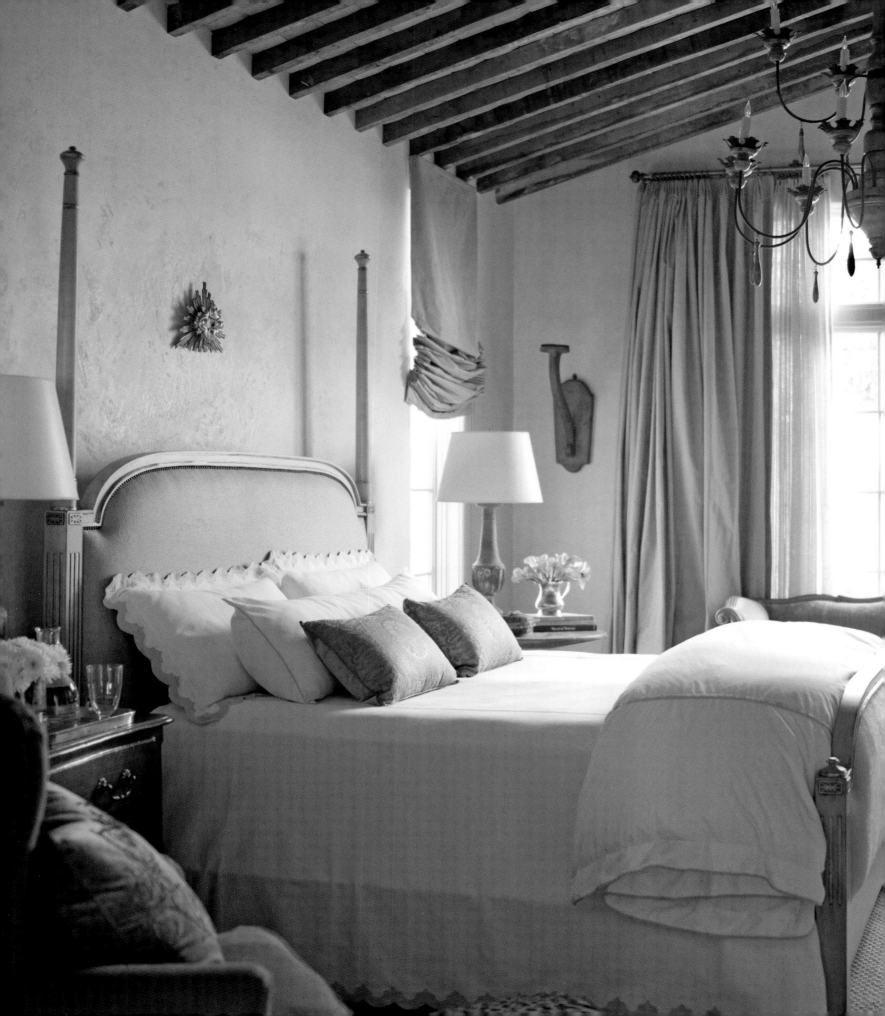

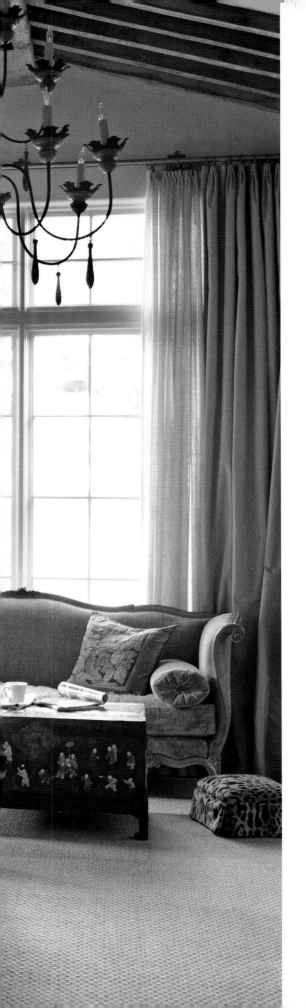

PAGE 218 In the hallway an Italian bench and console and terra-cotta lamps offset the reclaimed beams and stone.

PAGE 220, LEFT An antique French chair is framed by curtains in Rogers & Goffigon's Pirouette silk.

PAGE 220, RIGHT In the husband's study, the reclaimed French wood shutters are retrofitted on a steel header, which allows them to be rolled open.

PAGE 221 In the dining room, a graceful rusted-iron chandelier complements the narrow eighteenth-century Italian table.

PAGE 222 The warm tones of reclaimed wood and stone give the kitchen a cozy, inviting feeling.

PAGE 223 A bar is part of the family room.

LEFT Wood beams and antique Parefeuille tile are juxtaposed on the ceiling in the master bedroom.

BELOW In the guest bedroom, a Swedish bench with an antique tapestry pillow.

PAGE 226 The blue shutters in the master bath are one of the few painted surfaces in the house.

PAGE 227 The powder-room mirror is behind an antique Italian window grille.

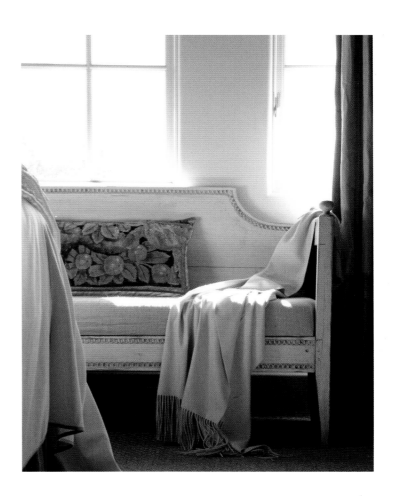

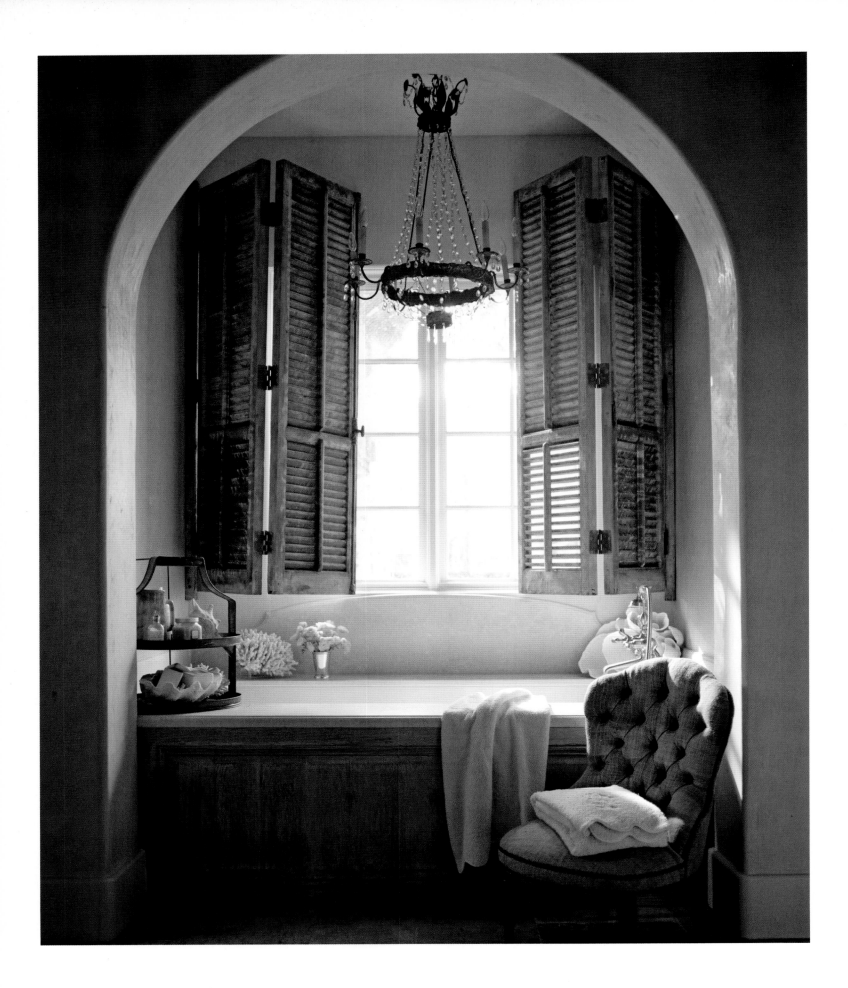

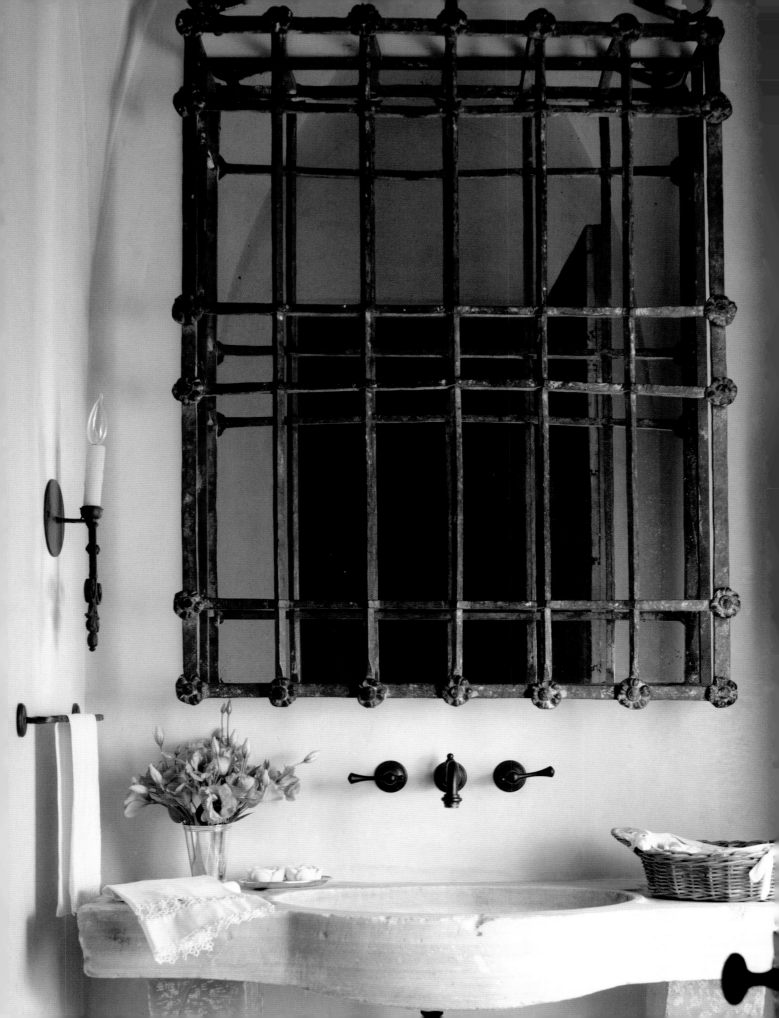

ELEGANCE

One of the more unfortunate misconceptions in the world of design is the equation of elegance with tradition, with "tradition" meaning something stuck in the past—the opposite of innovative and fresh.

That is not what elegance means. Elegance is not staid or stuffy and is in no way bound by any form of tradition. The epitome of simplicity, harmony, and proportion, elegance feels simultaneously fresh and grounded, innovative and grand. Graceful, refined, and dignified, elegance is the foundation of deep beauty.

Because nature is profoundly elegant, elegance can have an immediate and intense effect on our psyches. We are more apt to be courteous, polite, and gracious in an elegant suit or building. We can't help ourselves: elegance breeds elegance.

There are no formulas or shortcuts en route to creating an elegant home. "What you need," says Vicente Wolf, "is a very controlled hand and a very open mind."

Of all the homes Wolf has designed in the past three decades, the one that continues to get the most attention is the one he created for himself twenty-five years ago, and still lives in today. In 1988, Wolf bought 3,000 square feet of sun-drenched space in an old industrial building in the Hell's Kitchen section of Manhattan. Leaving the pipes and sprinklers of the original space—formerly a photography studio—visible and intact, Wolf began to push the

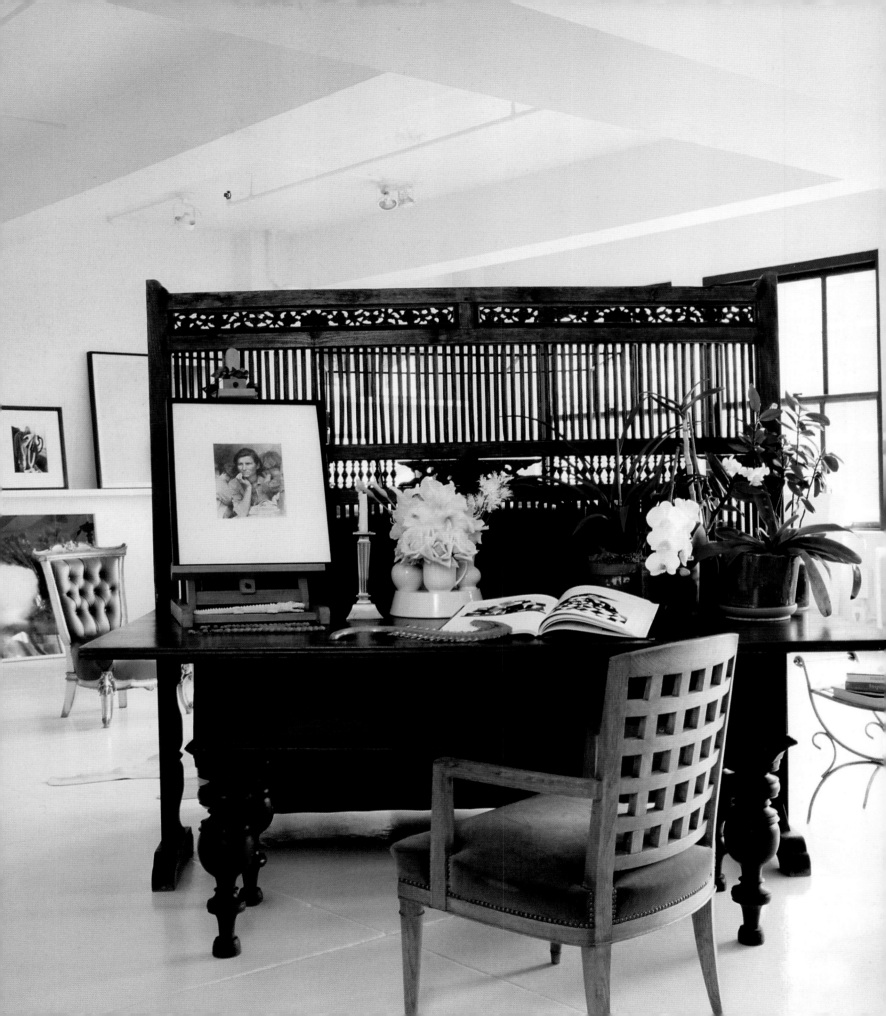

limits of what a loft can offer. He magnified the sense of space by using only sliding doors in the bedroom and bath; he enhanced the sense of openness by painting the walls, ceilings, and floors white.

All of which creates the perfect canvas for an extraordinary selection—and innovative placement—of antiques, artifacts, and contemporary pieces. In one corner, a Dutch Colonial daybed faces a gilt-edged Italian roundtable from the 1960s as well as chairs of Wolf's own design. Floating like sculpture in the middle of the room, a nineteenth-century teak screen from Indonesia provides the backboard for an antique Dutch Colonial desk on one side and a sofa and chair tableau on the other.

"I did not have any preconceived finished look," says Wolf. "Pieces just kept getting added on and taken out." The key, he believes, is the "spontaneity of the selection"—not trying to match the sofa. "Don't overthink it. Go with your gut. The moment you start thinking about something too much your fears come in, and you start questioning it."

At the same time, the choice and placement of pieces are hardly random. Wolf's instinctive sense of simplicity, harmony, and proportion—his innate sense of elegance—allowed him to experiment judiciously.

"The overall effect is truly modern yet timeless," says Wolf. Which is no doubt why it has inspired so many people over the years. It is modern, in that it pushes limits in its juxtapositions

PAGE 229 A nineteenth-century Dutch Colonial desk and teak screen, both from Indonesia, float like sculpture in the middle of the loft.

RIGHT A Dutch Colonial daybed faces a gilt-edged Italian roundtable from the 1960s, as well as chairs of Wolf's own design.

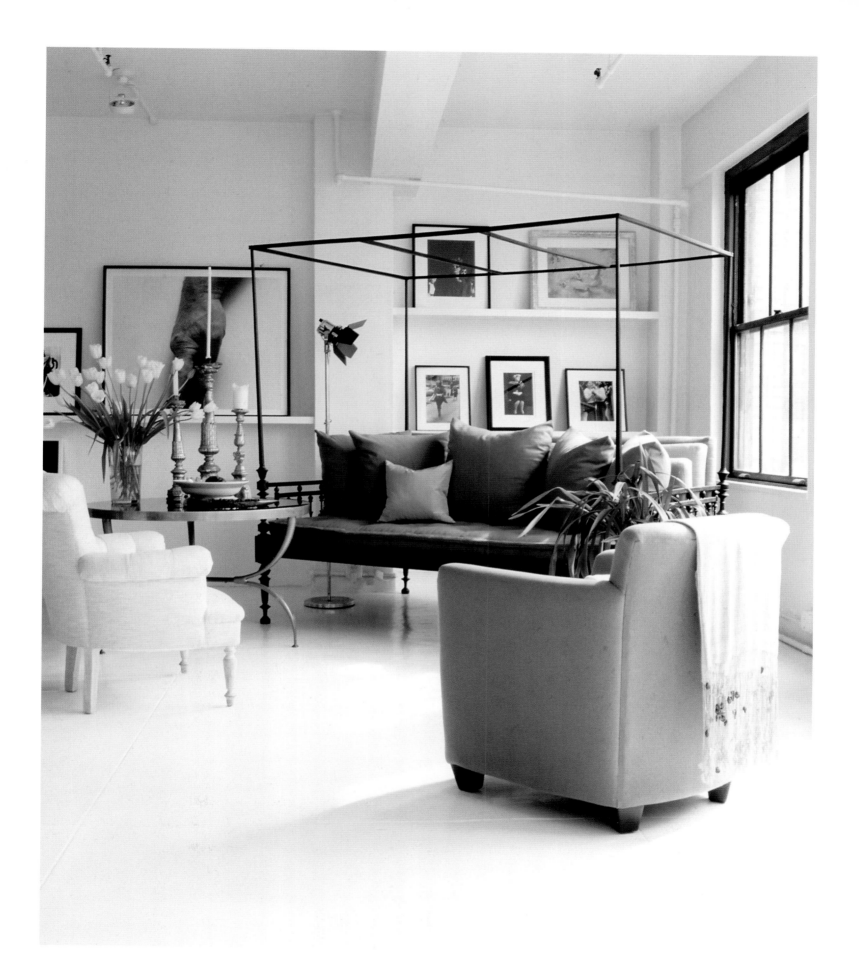

BELOW, LEFT A pair of Chinese chairs elegantly frames an Art Nouveau picture stand, a Martin Munkácsi photograph, and a Turkish silk rug.

BELOW, RIGHT A Thai teak Buddha sits peacefully on a shelf in the library.

RIGHT Burmese Buddhas and Robert Mapplethorpe photography provide the backdrop for an early nineteenth-century table and a Hans Wegner Papa Bear chair.

and tableaux: it has "a sense of unpretentiousness and an edge of irreverence"; and timeless in the selection of pieces—both contemporary and antique—and overall composition.

But how do you train your eyes to create such innovative beauty, such elegance? "How do you train yourself to be a good cook?" he asks. "By experimenting. By never putting too much of one element in the pot. By stepping back and tasting. By being aware of the big picture. When you do that, you're traveling time already."

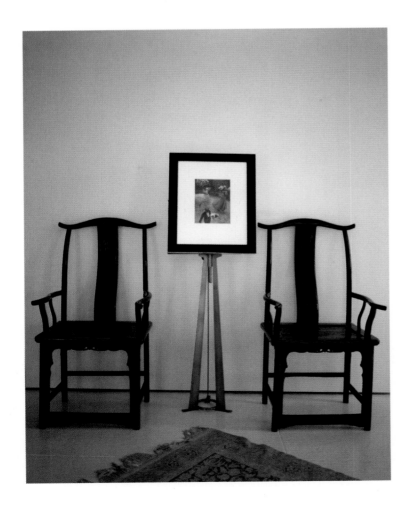

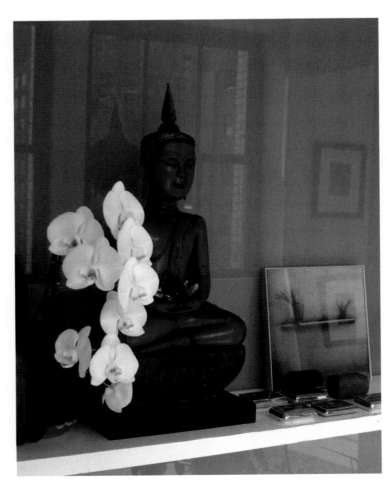

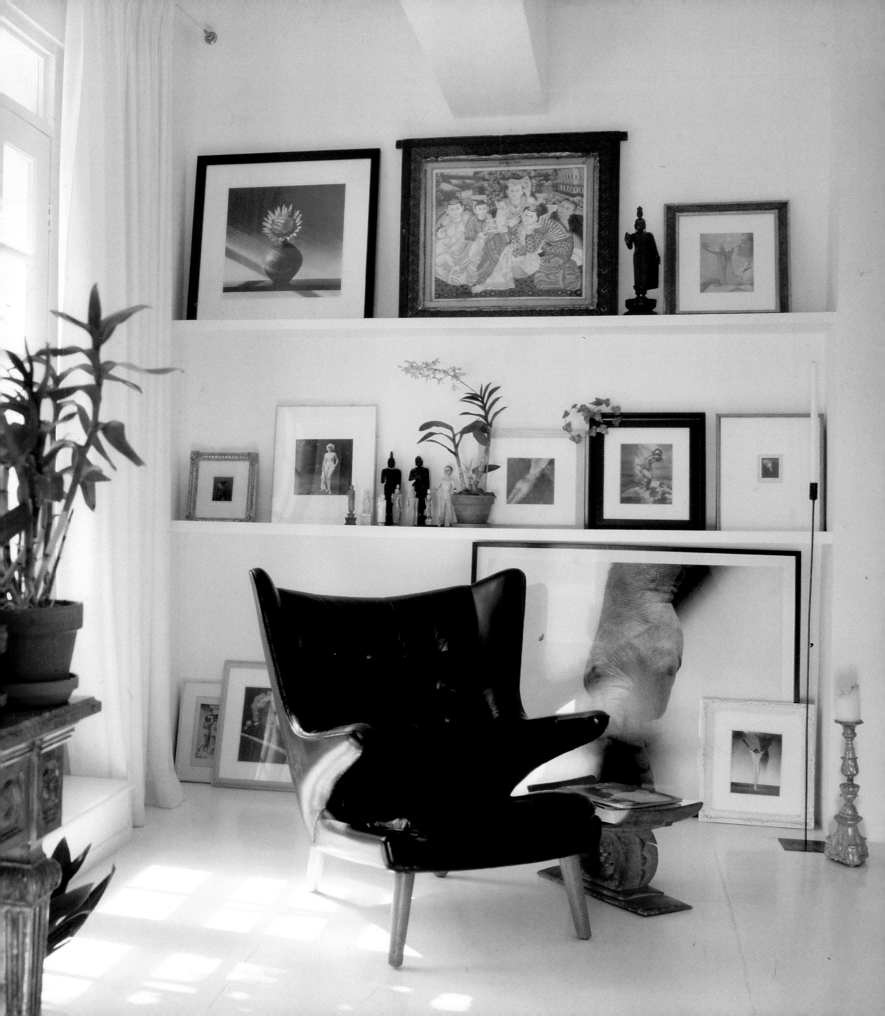

BELOW The bathroom mixes an old-fashioned desk with a modern sink.

RIGHT Wolf's mohair bed angles out among an eighteenth-century Italian table, a 1960s Hans Wegner chair, an Ashanti stool, and an Eero Saarinen table.

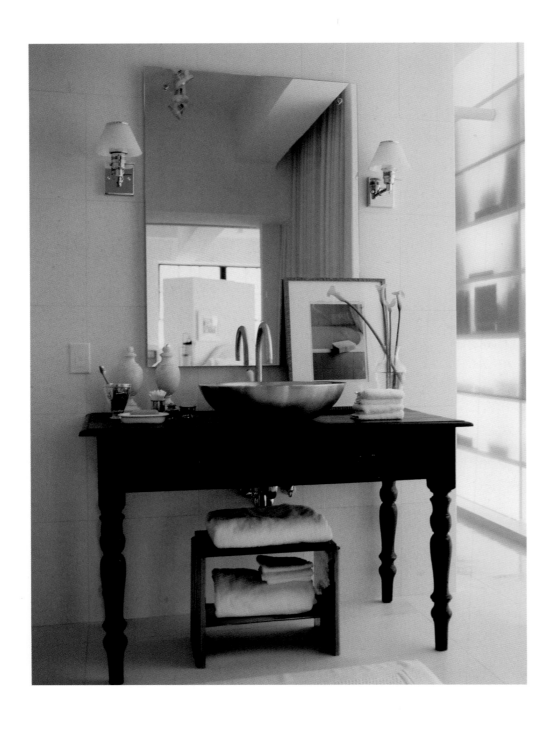

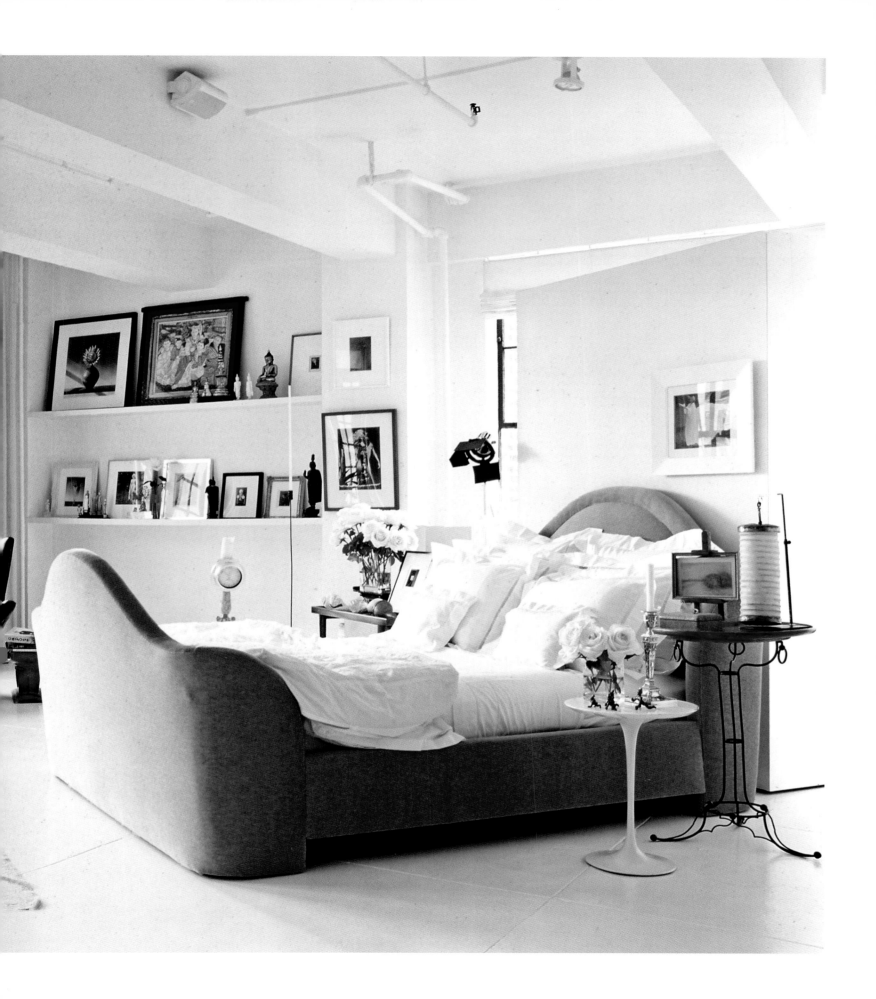

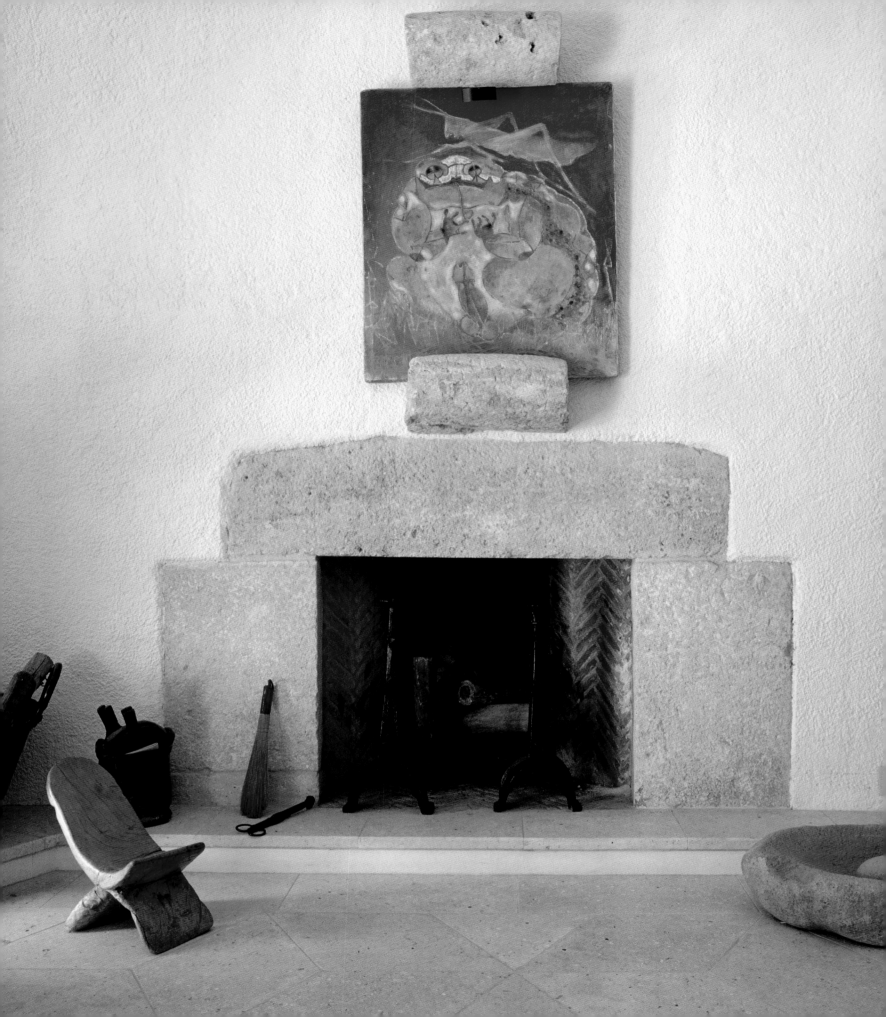

LIGHT

There is deep beauty, and then there is the deepest beauty of all: a poem or song or photograph that touches us so profoundly we are thrown into emotional overload. We have to turn away, shut it off, leave the room. The work imparts such an extraordinary feeling of purity, harmony, and grace—of exquisite light—it's as if you can feel the hand of God.

A room, a home, can also radiate an exquisite light—almost to the point of feeling "too beautiful." The light emanating from the soul of your home can be a constant source of inspiration and hope: it can continually remind us to find and create beauty in the world. If authentic, it will impart an optimism tempered by realism: things go wrong; the sun doesn't always shine. If it truly replicates nature's deepest beauty, it can guide you through life's inevitable disappointments, and help you to fully appreciate life's deepest joys.

In 1993 Mexico City–born architect Alex Pössenbacher built a house in Careyes, Mexico, for—and with—his parents. His father, Michael Pössenbacher, is a retired antiques dealer who has dealt with art and proportions all his life. "This combination makes him a fantastic choreographer of spaces and objects," says Alex.

What they were trying to create, he says, is "a tropical lifestyle, one in which you seamlessly integrate the exterior and interior living spaces, the contemporary geometric furnishings and the art objects that are in harmony with the grandeur of the Pacific Ocean." The result is an extraordinary interplay of nature and modernity, antiquity and impermanence, darkness and light.

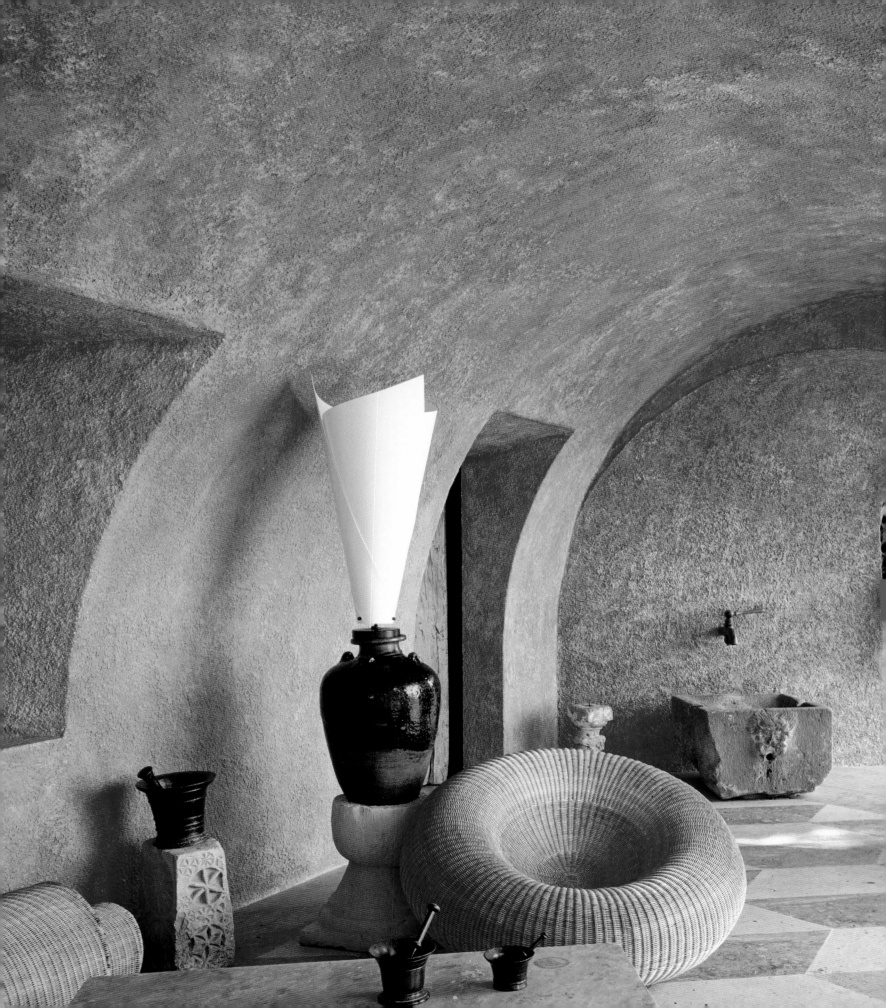

The heart of the house is the open-air thatched *palapa*—essentially a terrace with a big straw hat—that overlooks the ocean and provides the main living and dining areas. The spacious master bedroom is a separate structure, with a series of vaulted stucco ceilings inspired by Romanesque architecture. All of this creates harmonic proportions both within the space and between the interior and the exterior. "Every angle of the house was studied for its aesthetic, function, and relationship to the whole," says Alex.

The antiques, artifacts, and geological treasures that have been incorporated into the design of the house, some of which—an Italian Renaissance relief, a pair of ornate Mexican cruciform stirrups—have an evident "dark side," provide the perfect counterpoint for the exquisite natural light and pristine surroundings. "Each of the art objects in the house has a soul," says Alex, an inherent wisdom built into their many layers. "What you are seeing is a lifelong collection of special pieces that range from antique stone to works of art created by nature itself, each thoughtfully combined in spaces conceived for them."

"We also put our own souls into this home," he adds, confirming the notion that the more deeply you create from within, the more likely your home will touch and inspire others as well.

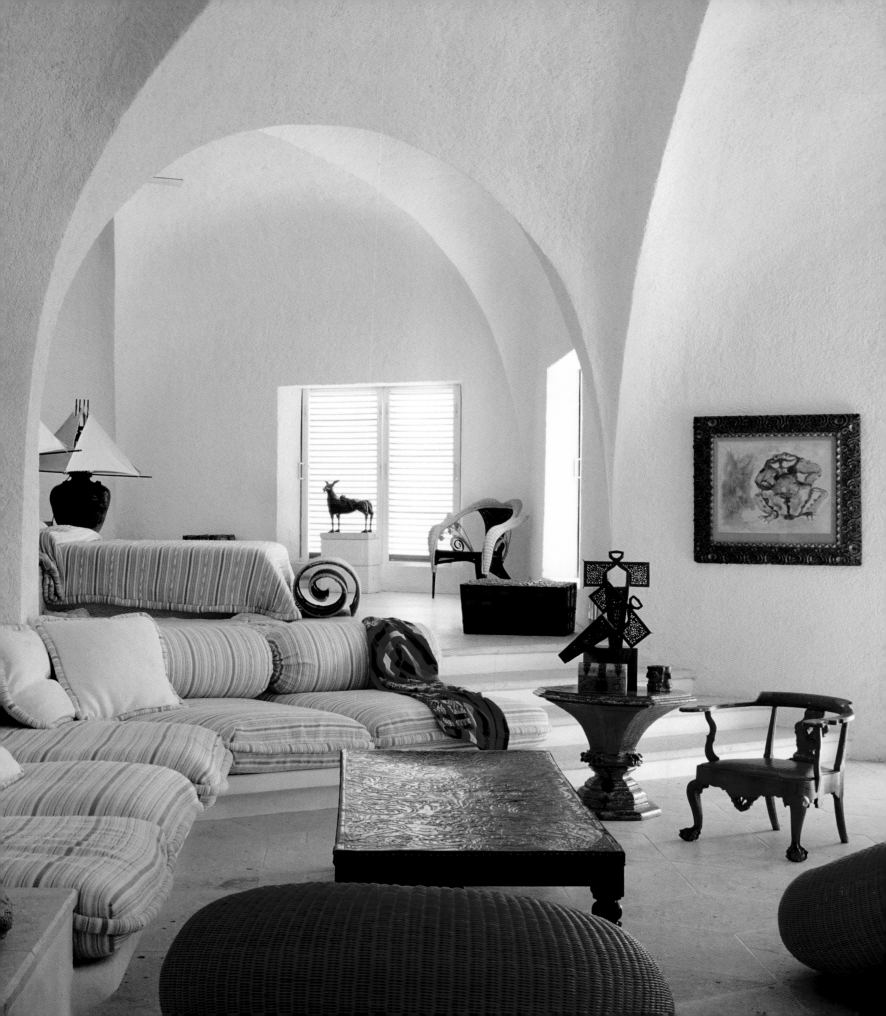

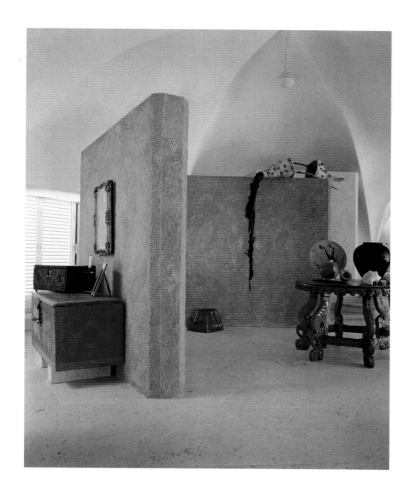
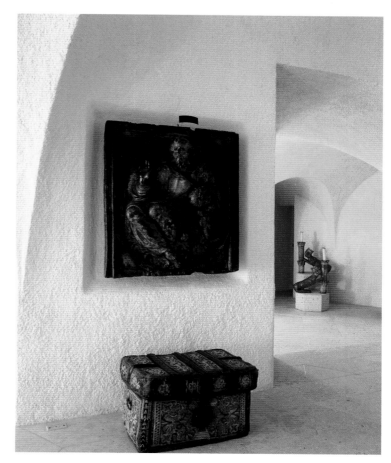

PAGE 236 A diminutive wooden Mexican chair sits in front of a stone fireplace, above which hangs a painting by Francisco Toledo.

PAGE 238 The covered terrace is comfortably furnished with round wicker chairs designed by Michael Pössenbacher.

LEFT The spacious master bedroom has a vaulted ceiling and a comfortable seating area.

ABOVE, LEFT The space in the vaulted master bedroom has been divided by three-quarter-height partition walls painted orange.

ABOVE, RIGHT An embroidered leather Mexican chest and an Italian Renaissance relief are used to furnish the hall.

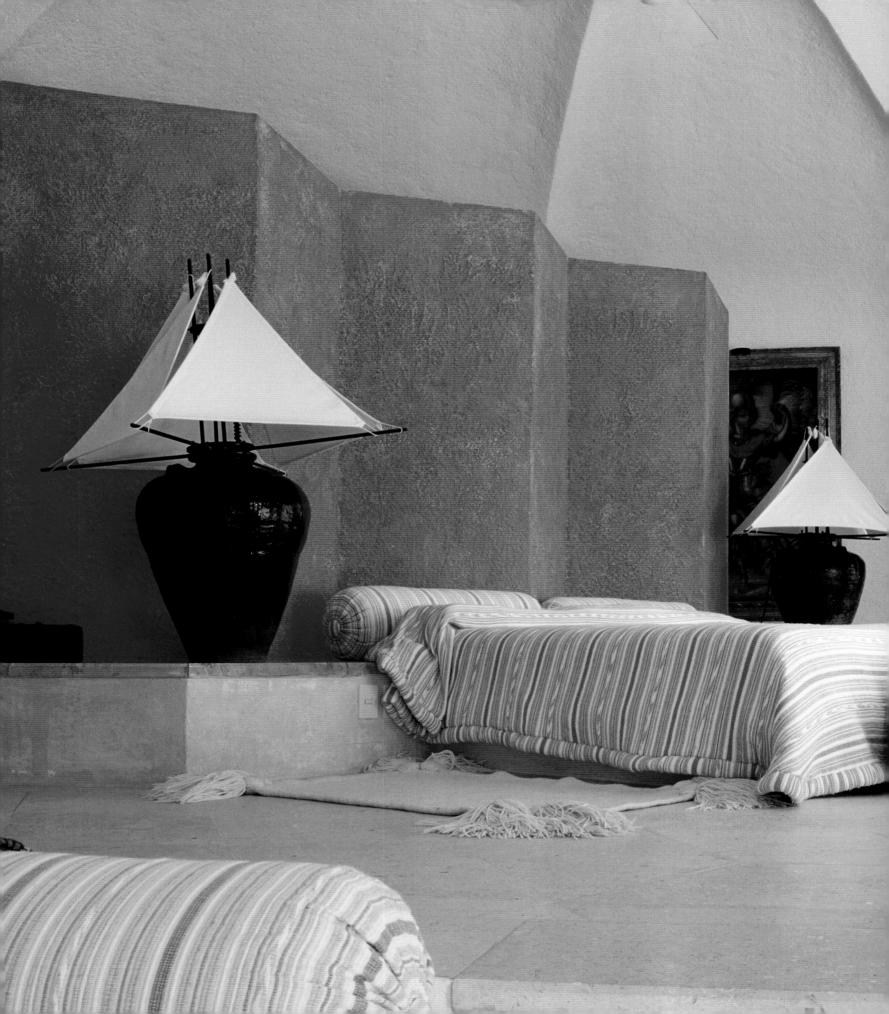

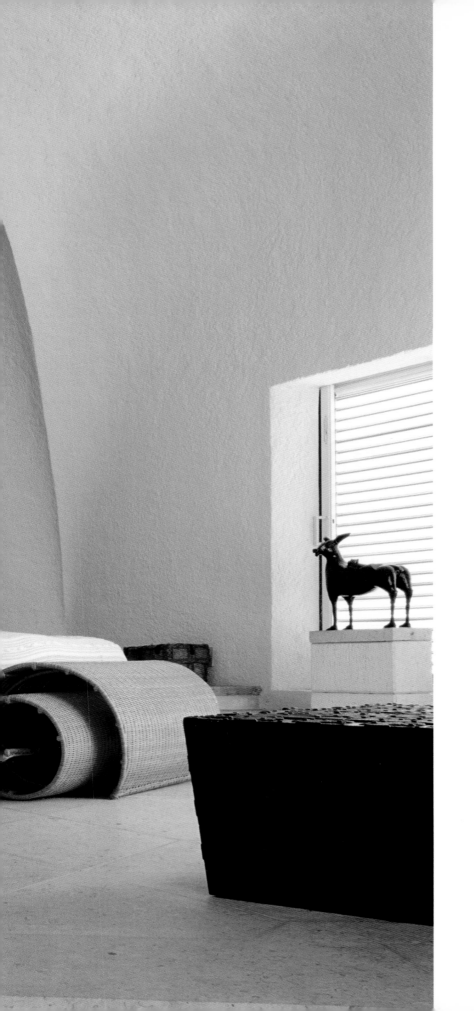

LEFT Michael Pössenbacher designed lampshades that resemble sails, using fifteenth-century Asian vases as bases.

ACKNOWLEDGMENTS

I would first like to thank Donna Karan for agreeing to write the Foreword—and for being such an incredible source of inspiration and beauty.

All of the designers and photographers who agreed to be part of this book. A special thanks to Vicente Wolf, who not only helped to clarify many of the book's concepts, but who also made a special trip to Bali to reshoot the home of Jérôme Abel Seguin.

Julia Abramoff, whose unwavering support in the essential idea of this book and whose insightful editing has truly given me new hope in the future of publishing.

My closest friends, who had to read endless iterations of this idea when "beauty" was still a dirty word. A special thanks to Judah Deutsch, who helped me to articulate the emotional and spiritual aspects of art and nature, and to Bruce Feiler, whose own strength and dignity through the toughest of times showed me the true foundation of beauty.

My husband, Bradley, who has had to listen to my theories about beauty since our first date at the Metropolitan Museum of Art, and whose continual love and encouragement truly allowed this book to become a reality.

My son, Alexander, who has joyously provided the greatest gift: the opportunity to nurture another soul.

Finally, I would like to thank my parents for their enduring support, and particularly my mother for teaching me how to feel and express the deepest beauty of all. I found out that I would be writing this book on the day of her funeral. Coincidence? Perhaps. But a true interior with soul will always find the means to live on.

PHOTOGRAPHY CREDITS

AUTHENTICITY

Purity: Giorgio Baroni

Poetry: Don Freeman

Meaning: Jean-Marc Wullschleger/Living
 Agency

Sensuality: David Gagnebin-de-Bons and
 Benoît Pointet/mc²

Layering: Vicente Wolf

Non-Decoration: Ken Hayden

SIMPLICITY

Reduction: Don Freeman

Restraint: Gianni Basso

Tight Palette: Jean-Marc Wullschleger/
 Living Agency and Tim Street-Porter

Stillness: Nathalie Krag/Taverne Agency

BALANCE

Proportion: Simon Upton/The Interior
 Archive

Harmony: Vicente Wolf

Unity: Fritz von der Schulenburg/The
 Interior Archive

Serenity: Richard Powers

SURPRISE

Unexpected Tweaks: Julien Oppenheim

Whimsy: William Abranowicz / Art +
 Commerce

Stunning Detail: Eric Laignel

Radiance: Simon Upton/The Interior
 Archive

GRANDEUR

Scale: Vicente Wolf

Symmetry: Montse Garriga

Sense of History: Eric Piasecki

Elegance: Vicente Wolf

Light: Mark Luscombe-Whyte/The Interior
 Archive

PAGE 246 An alabaster Buddha from Burma and a bronze box from North Vietnam sit on a lacquerware table from Baltus in Catherine Weyeneth Bezençon's home.

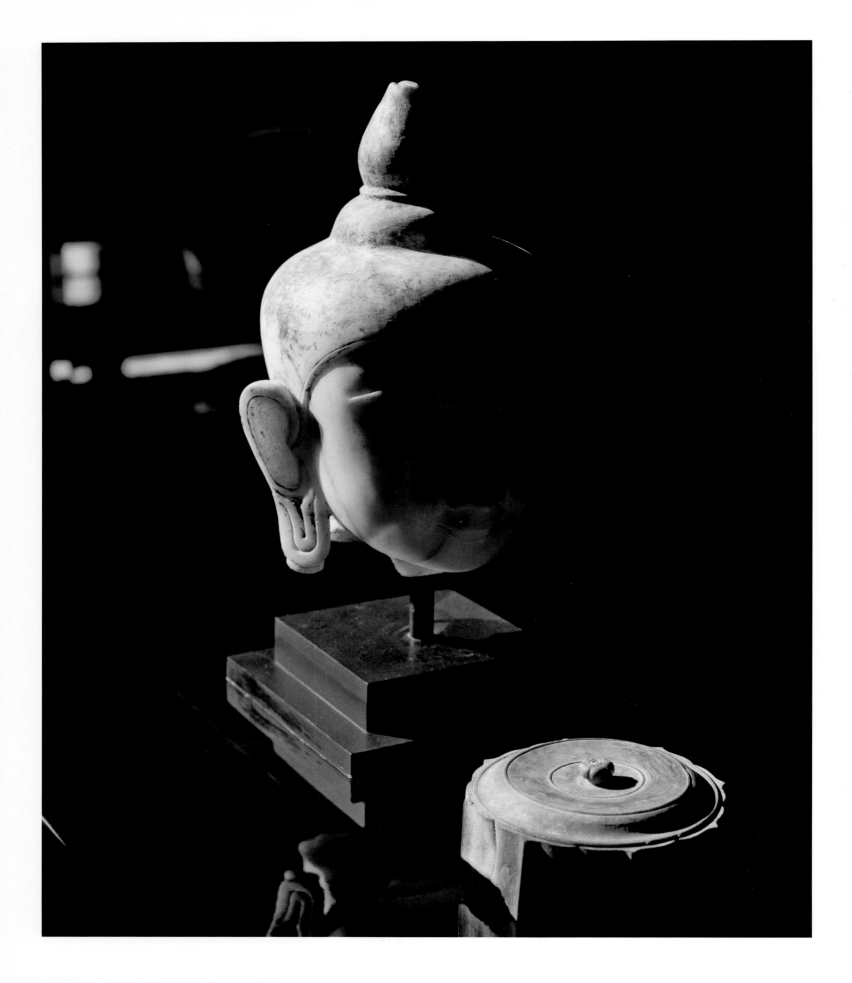